The North Carolina Museum of Art

Publication of this revised edition of *Introduction to the*

Collections was made possible by generous contributions

from Museum Members to the 1992 Annual Appeal.

This publication is supported by funds administered by

the North Carolina Museum of Art Foundation.

ISBN 0-88259-960-7

ISBN 0-88259-965-8 pbk.

Library of Congress Catalog Card Number: 90-70152

Introduction to the Collections

Revised Edition

North Carolina Museum of Art

Raleigh, North Carolina

Contents

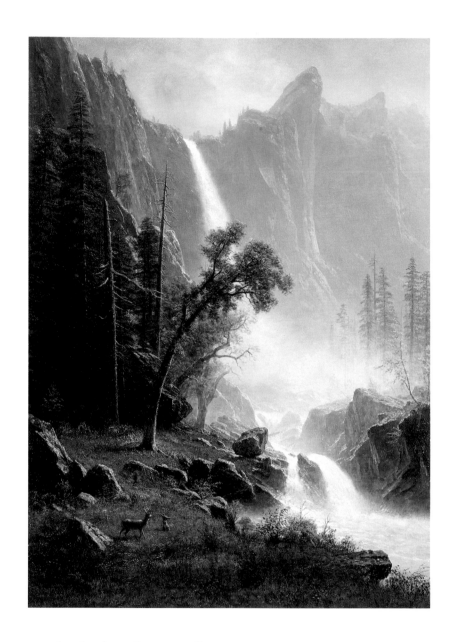

ALBERT BIERSTADT *American,* born Germany, 1830-1902

Bridal Veil Falls, Yosemite, C. 1871-73

OIL ON CANVAS, 36⅛ x 26⅜ IN. (91.7 x 67.0 CM.)
PURCHASED WITH FUNDS FROM THE NORTH CAROLINA ART SOCIETY (ROBERT F. PHIFER BEQUEST)
AND VARIOUS DONORS, BY EXCHANGE
87.9

Preface and Acknowledgments

The first edition of *Introduction to the Collections* was published in conjunction with the opening of the new Museum building in 1983. The book, like the new building, was designed to showcase the Museum's masterpieces. This new edition includes many new acquisitions as well as new information about various works that has been brought to light since the publication of the first edition.

The intervening years have been marked by reflection, refinement, and deliberate growth. The more established collections for which the Museum is distinguished have been augmented by several important acquisitions. Ubaldo Gandolfi's *Mercury Lulling Argus to Sleep* and *Mercury about to Behead Argus* (pp. 204-205), Joseph Charles Marin's *Bacchante Carrying a Child on Her Shoulder* (p. 136), Pierre Peyron's *The Death of Alcestis* (p. 132), and the *Venus Italica* from the studio of Antonio Canova (p. 207) enhance the outstanding collection of European art. Three recently acquired paintings, Albert Bierstadt's *Bridal Veil Falls, Yosemite* (pp. vi, 232), Martin Johnson Heade's *Salt Marsh at Southport, Connecticut* (p. 237), and Louis Rémy Mignot's *Landscape in Ecuador* (p. 233) have significantly strengthened the Museum's nineteenth-century American holdings. Five notable works have been added to the ancient collection: the Cycladic *Female Figurine* (p. 9), the *Torso of a Roman Emperor* (p. 28), the *Emperor Caracalla in the Guise of Helios* (p. 34), the Attic *Neck Amphora* (p. 14), and the *Portrait of the Emperor Marcus Aurelius* (p. 33).

The contemporary art collection is expanding rapidly. Notable acquisitions that extend the range of the twentieth-century paintings collections include: Roger Brown's *American Landscape with Revolutionary Heroes* (p. 287), Gilbert and George's *Cabbage Worship* (p. 286), Moshe Kupferman's *Untitled* (p. 281), Alex Katz's *Six Women* (p. 282), William T. Williams's *Double Dare* (p. 285), and Elizabeth Murray's *Pigeon* (p. 289). The Museum has also been purchasing significant examples of modern sculpture. Ronald Bladen's *Three Elements* (p. 276) and Joel Shapiro's *Untitled* (p. 288) are the first two works acquired as part of this program.

In 1986, the Museum opened a gallery devoted to African, New World, and Oceanic art. A number of the most significant works in these collections were donated by Mr. and Mrs. Gordon Hanes, longtime benefactors of the Museum, including the New Hebridean *Slit Gong* (p. 64), the *Helmet Mask* from New Ireland (p. 66), and the Vera Cruz *Priestess* (pp. xxii, 55). These gifts have been complemented by the purchases of the *Egbukele Society Headdress Mask* (p. 47), the *Antelope Headpieces* (p. 43), the *Twin Figures* (p. 48), and the *Oath-Taking and Healing Image* (p. 51).

The Museum has embarked on an ambitious "Art + Landscape" project that will dramatically transform its grounds—and programs—over the next several years. The landscape surrounding the building will be developed as a laboratory for adventurous comtemporary art and as an outdoor gallery for monumental sculpture.

A great deal of scholarly investigation on the collections has been accomplished during the nine years since the publication of the first edition, and the present book includes many additions and revisions that have resulted from this research. The African collection was thoroughly studied with the assistance of Allen Wardwell, an authority on ethnographic art. In 1986, the Museum published a catalogue of its Spanish collection by noted scholar Edward Sullivan. This marked the first step toward the Museum's goal of fully studying and documenting the complete collections. Research is underway toward a catalogue of the Italian paintings, and a catalogue of the collection of Dutch and Flemish paintings is also planned. In 1990 the Museum's scholarly *Bulletin* was revived, thanks to generous grants from the Samuel H. Kress Foundation and the Newington-Cropsey Foundation.

Great emphasis has also been placed on conservation projects. Chief Conservator David Goist and his staff have performed major treatments on such works as the pair of still lifes by Meléndez (pp. 214-215), Homer's *Weaning the Calf* (p. 235), Moran's *"Fiercely the red sun descending..."* (p. 236), Inness's *Under the Greenwood* (p. 239), Monet's *The Cliff, Etretat, Sunset* (p. 141), Canaletto's *Capriccio* (p. 203), Giordano's *The Finding of Moses* (p. 190), Solimena's *Christ Appearing in a Dream to St. Martin* (p. 196), Snyders's *Market Scene on a Quay* (p. 118), and Sterne's *Dance of the Elements, Bali* (p. 254).

I am grateful to Chief Curator Anthony Janson; John Coffey, Curator of American and Modern Art; Mary Ellen Soles, Curator of Ancient Art; David Steel, Curator of European Art; and Huston Paschal, Associate Curator of Modern Art, for their research on newly acquired works. This book would not have been possible without the assistance of Registrar Peggy Jo Kirby and her staff, including former Head Photographer Glenn Tucker and his successor Bill Gage. Special thanks also go to Communications Officer Anna Upchurch, Ann Waterfall, former Assistant Communications Officer, and Katharine Douglass, Head Graphic Designer, who undertook the coordination of the myriad details involved in overseeing such a complex project. Much of the scholarly effort that prompted the revisions included in this edition has been sustained by a grant from the Andrew W. Mellon Foundation.

I would also like to express my appreciation to Museum Members who supported publication of this revised edition with their contributions to the 1992 Annual Appeal and to the North Carolina Museum of Art Foundation for providing additional funds that were needed.

It is gratifying that *Introduction to the Collections* merits a revised edition. This publication supports our efforts to share the Museum's rich collections with an ever-wider audience.

Richard S. Schneiderman

Director

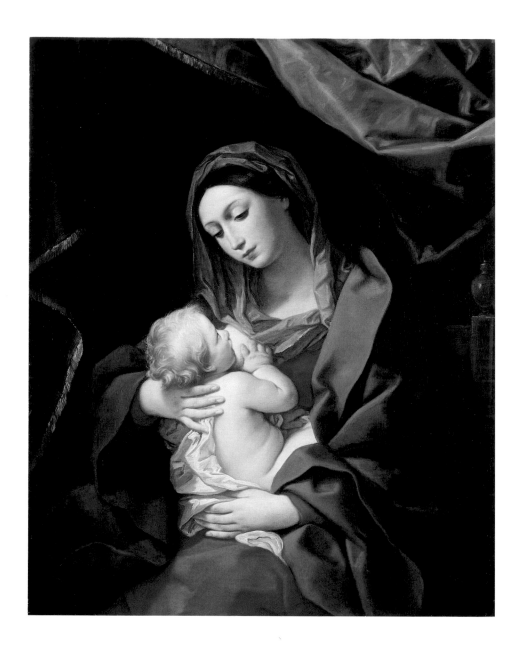

GUIDO RENI *Italian, 1575-1642*

Madonna and Child, C. 1628-30

OIL ON CANVAS, 45 X 36 IN. (114.3 X 91.4 CM.)
GIFT OF MR. AND MRS. ROBERT LEE HUMBER, IN MEMORY OF THEIR DAUGHTER, EILEEN GENEVIEVE
55.12.1

The North Carolina Museum of Art and Its Collections

When its General Assembly appropriated a million dollars in 1947 for the purchase of old master paintings, North Carolina became the first state in the nation to set aside public funds to create an art collection for its people. That the funds were available at all was due to the unprecedented surplus accumulated in the state treasury during World War II, when the economy flourished and substantial tax revenues were raised but limited building materials and manpower prevented expenditures for major public works projects. Even so, that a relatively small, agrarian southern state liberated such an enormous sum for the foundation of an art collection assures a unique place for the North Carolina Museum of Art in the history of American art museums.

The story of the Museum's founding has been recorded on numerous occasions.[1] The organized effort to create an art museum for the state can be traced to 1924, when the North Carolina State Art Society was formed with the intention "to promote an interest in providing a State Art Museum in Raleigh." Lacking a permanent collection of its own, the Art Society organized exhibitions of loans from M. Knoedler and Company, Grand Central Galleries, and Robert Vose Gallery, including works by El Greco, Rembrandt, Albert Pinkham Ryder, and Thomas Eakins. The Art Society also brought speakers and critics to the state and promoted educational activities, and after it received its charter of incorporation on 7 October 1927, efforts were redoubled to establish a state museum of art. In 1928, the Art Society received by bequest a collection of approximately seventy-five paintings assembled by Robert F. Phifer (1849-1928), a native of Concord, North Carolina, who had lived in New York for many years. Although Phifer's collection consisted largely of minor works by members of the Salmagundi Club,[2] it contained a few notable pictures (William Merritt Chase, *The Artist's Daughter, Alice,* p. 244) and remained for many years the principal art collection on view in Raleigh. In 1929, the year in which the General Assembly placed the Art Society under state patronage and control, a temporary art museum was provided in the Agricultural Building for the exhibition of

The text of this 1983 essay has been updated and revised to reflect the present collections of the North Carolina Museum of Art and current curatorial opinion regarding individual works of art.

1. The basic published sources are Betty Chamberlain, "How to Get and Spend a Million Dollars for Art," *Art News* 55 (April 1956): 37-44, 95-97; Ola Maie Foushee, *Art in North Carolina: Episodes and Developments, 1585-1970* (Chapel Hill, 1972), pp. 21-43, 104-30; Margaret Sterne, *The Passionate Eye: The Life of William R. Valentiner* (Detroit, 1980), pp. 334-56; and *North Carolina Museum of Art: A Brief History* (Raleigh, 1986).

2. North Carolina Museum of Art, *Robert F. Phifer*

forty-eight paintings from the Phifer bequest and a few others that the society had acquired.

Of greater significance than Phifer's personal art collection was his monetary bequest to the society, which, although it became available only at intervals on the death of his heirs, sustained the organization through the Depression and provided additional leverage in support of efforts to create what was to become a museum for the state. In the past thirty years, the Phifer funds have been substantially increased through sound financial investment and have enabled the Art Society to provide the Museum with the resources to acquire a number of significant works for its collections.

The Depression effectively stifled subsequent attempts to create a permanent, public art museum for North Carolina, but in the late 1930s the state provided improvised quarters in the former Supreme Court building for exhibition galleries and Art Society offices. The State Art Society Gallery, which was partly financed by the Federal Art Project, opened in 1939 with an exhibition of American paintings assembled from New York galleries and organized during the next fourteen years more than 125 special exhibitions. These included many exhibitions of work by North Carolina artists but also encompassed medieval manuscripts and Matisse lithographs; paintings by Rubens, Picasso, and John Marin; and drawings, photographs, furniture, and textiles. The activity and success of the State Art Gallery were due in great measure to the initiatives of its director, Lucy Cherry Crisp (1899-1977), who sought to establish, "even though in miniature, as many as possible of the major functions and services of a public Art Museum, in order that [the] beginnings, at least, of all these things might have been made when the goal of a great Museum of Art should finally be achieved."[3] In these same years, the Art Society's efforts were boosted by Governor J. Melville Broughton's appointment in 1943 of a Citizens Committee for a State Art Gallery, which voted unanimously to launch a movement for the construction of a North Carolina State Art Gallery in Raleigh as a memorial to North Carolinians who had served in the first and second world wars. However, the committee could not raise the $50,000 in private donations thought to be sufficient and the project was abandoned.

Collection [exhibition catalogue] (Raleigh, 1973),
p. 94.

3. Foushee, *Art in North Carolina*, p. 32.

The individual to whom is owed the largest measure of credit for the founding of the North Carolina Museum of Art is Robert Lee Humber (1898-1970),[4] a former Rhodes scholar, international lawyer, cofounder of the United World Federalists, and state senator. Upon his return from Paris to his native Greenville in 1940, Humber immediately became active in the Art Society and began to explore the possibilities of establishing an art museum in Raleigh. Convinced that at least $1,000,000 would be required for the project, he went to New York in search of possible sources of support. Through Carl Hamilton, a New York dealer and collector, Humber met Stephen S. Pichetto, conservator to Samuel H. Kress, the merchant and collector.[5] In 1943, Humber approached Kress to assist with the efforts being made in North Carolina to found an art museum for the state, and in 1947 Kress agreed to provide a million dollars on the condition that neither his name nor that of the Samuel H. Kress Foundation would be disclosed and that his commitment remain verbal in order to avoid solicitation from other states in which he operated S. H. Kress & Company stores.[6] Humber accepted these terms, and the agreement served as the basis for the legislative action of 1947, when the General Assembly conditionally appropriated a million dollars to the North Carolina State Art Society for the purchase of old master paintings, contingent upon the sum being matched by private donations.

In 1950, Governor W. Kerr Scott appointed a State Art Commission to acquire works of art with the appropriated revenues. Joining the representatives of the Art Society – Mrs. Katherine Pendleton Arrington (1876-1955), its president since 1927; Clarence Poe (1881-1969), editor of *The Progressive Farmer,* the most widely read agricultural magazine in the South; and Humber – were Clemens Sommer (1891-1962), a professor of the history of art at the University of North Carolina at Chapel Hill, and Edwin Gill (1899-1978), formerly federal collector of the Department of Internal Revenue, then treasurer of North Carolina, and a strong advocate for the foundation of a state art collection. With the exception of Sommer, a former curator with the city museum in Freiburg, Germany, and a specialist in late medieval and early Italian Renaissance sculpture, none of the members of the Art Commission was particularly knowledgeable about the history of art or, for that matter, the museum profession or the art market. The

4. For a brief biography, see *North Carolina Museum of Art Bulletin* 10 (June 1971): 16-20.

5. For a concise account of the Samuel H. Kress Foundation and the regional galleries of paintings it established in the United States in the 1940s and 1950s, see the introduction by Guy Emerson in *Art Treasures for America: An Anthology of Paintings and Sculpture in The Samuel H. Kress Collection* (London, 1961), pp. vii-xviii.

6. Foushee, *Art in North Carolina,* p. 108, quoting a letter from Humber of 29 June 1967.

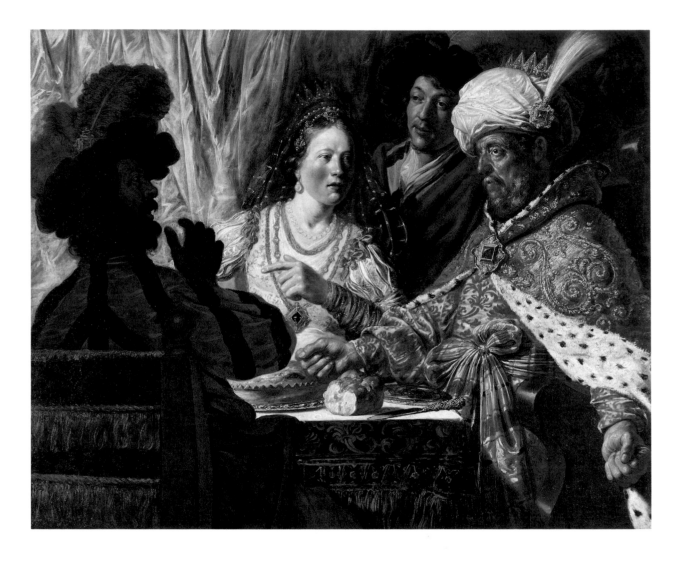

Jan Lievens *Dutch*, 1607-1674

The Feast of Esther, c. 1625-26

Oil on canvas, 53 x 65 in. (134.6 x 165.1 cm.)
Purchased with funds from the State of North Carolina
52.9.55

commission therefore appointed Carl Hamilton (1886-1967) as its consultant and adviser. A curious, and at times controversial, figure on the American art scene since the 1920s,[7] Hamilton has never received sufficient credit for the critical role he played in the formation of the collections of the North Carolina Museum of Art. In the early 1950s, it was he who directed the Art Commission to the nucleus of dealers who provided the bulk of the works of art purchased from the original million-dollar appropriation, at prices ranging from a few hundred dollars to a maximum of about $65,000. They were acquired from a handful of New York dealers, the majority from David M. Koetser Gallery, Newhouse Galleries, M. Knoedler and Company, E. and A. Silberman Galleries, Schaeffer Galleries, Victor Spark, and Julius Weitzner.

The goal of the Art Commission was to assemble a complete survey of Western painting from its origins in the fourteenth century to the end of the nineteenth century. In forming a collection of paintings from the hundreds available on the art market, the members of the Art Commission were confronted immediately with the choice of spending all of the funds at their disposal on a relatively few "masterpieces" or providing a more balanced survey of the history of art with works by artists of lesser rank. As W. R. Valentiner put it in the introduction to the Museum's first catalogue, "In representing the great period of Dutch seventeenth-century art, should they spend all their funds to acquire one famous portrait by Rembrandt at an exorbitant price or should they try to find one of his lesser-known paintings with a historical subject and add to it a collection of paintings which represent the main fields of Dutch art and give an idea of the wealth of new thoughts expressed in this period, in Holland, by innumerable lesser-known artists?"[8] They chose the latter course and acquired the dramatic and provocative *The Feast of Esther* (pp. xiv, 87), which came on the market in 1936 as an unknown Rembrandt painting, as the pivotal work in a selection of twenty-three Dutch pictures that would give the public a well-rounded view of the period and possess "greater popular appeal in their many story- telling subjects than one portrait by Rembrandt alone." Although most recent opinions have supported an attribution of *The Feast of Esther* to Jan Lievens,[9] who was, together with Rembrandt, one of the foremost artists in Leiden in the 1620s, the painting

7. For an account of Hamilton, whom Mary Berenson thought "a mixture of Dionysus and St. Francis, a mysterious awe-inspiring and love-compelling force and a kind of mystic genius," see Meryle Secrest, *Being Bernard Berenson* (Harmondsworth, England, 1979), pp. 320-23; see also Sterne, *The Passionate Eye*, pp. 338-40.

8. W. R. Valentiner, *Catalogue of Paintings including Three sets of*

Tapestries (Raleigh, 1956), p. 12.

9. National Gallery of Art, *Gods, Saints and Heroes: Dutch Painting in the Age of Rembrandt* [exhibition catalogue] (Washington, D.C., 1980-81), no. 31, as by Jan Lievens.

provided the rationale for the acquisition of a group of excellent pictures (pp. 84 - 107) representing the specialties of Dutch painting of the period – portraiture, genre, landscape, still life, and history painting.

The Art Commission purchased 139 paintings from the original million-dollar appropriation, divided among schools as follows: American (sixteen), Flemish (twenty-three), Dutch (twenty-three), Italian (seventeen), British (twenty-one), Spanish (nineteen), French (ten), and German (ten). In part as the result of the inflated prices of the seven pictures acquired as by Rubens and two others as by Rembrandt and Frans Hals, the bulk of the funds was spent on Flemish ($300,300) and Dutch paintings ($190,600).[10] On the other hand, a number of paintings were acquired relatively inexpensively, even allowing for the extraordinary inflation of art prices since 1950; among these acquisitions were Jan Brueghel's *Harbor Scene with St. Paul's Departure from Caesarea* (p. 111; $3,000) and Balthasar van der Ast's *Still Life with a Grasshopper* (p. 86; $2,000). In spite of the inevitable changes of attribution of several well-known paintings during the past thirty years, the collection of old master paintings acquired with the original state appropriation remains, by any standard, one of the finest in the United States. Its nucleus is formed by the works of Rubens (pp. 116, 119), Snyders (pp. 115, 118, 119), Claude Lorrain (p. 124), Mignard (p. 125), Bellotto (pp. 200-201), Ribera (p. 210), Murillo (p. 211), Beechey (p. 80), Copley (p. 219), and Homer (p. 235).

The acquisition funds available to the Art Commission were not restricted, however, to the 1947 legislative appropriation. In 1952, one of the Phifer heirs died and approximately $300,000 from the Phifer trust fund became available for the purchase of works of art; among the paintings acquired with these funds were: Stefan Lochner's *St. Jerome in His Study* (p. 146); Jacob Jordaens's *The Holy Family* (p. 113); Jean-Baptiste Oudry's *Swan Frightened by a Dog* (p. 128); Thomas Gainsborough's *Ralph Bell* (p. 79); and Jean-François Millet's *Peasant Spreading Manure* (p. 137). In recent years, the North Carolina Art Society has further enriched the Museum's collections by making available funds from the Phifer Bequest for the purchase of such significant works as the marble *Aphrodite of Cyrene* (p. 26) a Roman copy after a Hellenistic Greek original; Tilmann Riemenschneider's *Female Saint* (p. 149); Georgia O'Keeffe's *Cebolla Church*

10. The original list of purchases and prices, compiled from records of the state auditor, was published in the Raleigh *News and Observer,* 28 November 1954, sec. 4, p. 2.

(p. 263); and Severin Roesen's *Still Life with Fruit* (p. 231).

The original purchase funds were augmented in the early 1950s with contributions from foundations and private citizens. In 1956 alone, the total of these gifts amounted to approximately one-third of the capital invested in the collection by the state, and this total, if added to donations received before the opening of the Museum, amounted to about 40 percent more than the original investment. Even in 1959, three years after the Museum had opened to the public, gifts worth more than a half a million dollars were granted or promised to it— $200,000 in promised gifts and $300,462 in actual works of art, an amount equal to twice the Museum's annual budget.

In 1953, the General Assembly had appropriated funds to transform the former State Highway Building into a facility for the exhibition of the collections. The renovation proceeded under the direction of the Art Commission and Carl Hamilton until the appointment in 1955 of the Museum's first director, William R. Valentiner (1880-1958).[11] Valentiner, an internationally known scholar in the fields of Italian Renaissance sculpture, Dutch seventeenth-century painting, and German expressionist art, had served from 1924 to 1945 as director of the Detroit Institute of Arts, where he assembled one of the significant art collections in the United States. He had also been codirector of the Los Angeles County Museum from 1946 to 1949 and consultant to the board of trustees of that museum from 1949 to 1953 and, shortly before coming to Raleigh, director of the J. Paul Getty Museum in Malibu. Valentiner's reputation, connoisseurship, experience, and knowledge of modern professional practices instantly legitimized North Carolina's efforts to establish a credible museum. To the fledgling institution, Valentiner brought a high level of scholarship as well as a trained eye, and through his writings and example, he elevated the community's standards of connoisseurship. Contrary to widely held belief, Valentiner did not play a major role in the selection of the original purchases in the early 1950s, for after his arrival in Raleigh on 1 November 1955, less than 10 percent of the collection acquired with the original legislative appropriation was changed.[12] Nonetheless, he was instrumental in the acquisition of many private gifts to the Museum, and it was because of his presence in Raleigh that others came to the Museum after his death

11. In addition to Sterne, *The Passionate Eye*, pp. 334-56, see North Carolina Museum of Art, *Masterpieces of Art* [exhibition catalogue] (Raleigh, 1959), an exhibition organized to honor Valentiner's achievements during fifty years of activity in American museums, and a supplement published in the *North Carolina Museum of Art Bulletin* 3 (1959): 1-52.

12. In 1951, North Carolina Attorney General Harry McMullan persuaded the General Assembly to add two amendments to the bill authorizing acceptance of the gift by Kress of works of art in lieu of cash as a compliance with the terms of the 1947 appropriation for the purchase of works of art. One of these specified that every purchase be approved by,

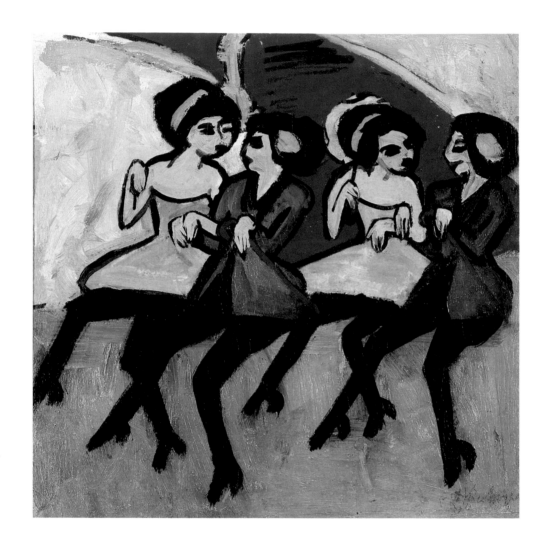

ERNST LUDWIG KIRCHNER *German, 1880-1938*

Panama Girls, 1910

OIL ON CANVAS, 19⁷/8 X 19⁷/8 IN. (50.5 X 50.5 CM.)
BEQUEST OF W. R. VALENTINER
65.10.30

(Berlinghiero, *Madonna and Child,* p. 154; Lodovico Carracci, *The Assumption of the Virgin,* p. 182; Antonis Mor, *Portrait of a Gentleman,* p. 84; Theodor Rombouts, *The Backgammon Players,* p. 117; Lyonel Feininger, *The Green Bridge II,* p. 258; and Milton Avery, *Blue Landscape,* p. 267.

Valentiner sought to shape the nascent museum – which was actually a picture gallery in the traditional European sense of the term – into "an educational institution destined to teach the complete art history of the world."[13] He installed the collections in the new museum building in the manner of the great European collections with which he was familiar – chronologically, according to schools. Immediately following the inauguration of the North Carolina Museum of Art and the opening of the Morgan Street building on 6 April 1956, he initiated an assessment of the strengths of the collections and established a policy for expansion that in one way or another has guided the Museum's growth until the present. "Still missing," he wrote at the time to Robert Lee Humber, "are the great painters of the nineteenth century (Romantics, Realists, Impressionists, Post-impressionists, Expressionists) and the best painters of our time. We hope to show their works in forthcoming loan exhibitions. Perhaps donors could be found to buy for our collection one or more outstanding paintings from these exhibitions. In order to silence the constant and justifiable claim of artists in our state that modern art should be represented, a small amount should be set aside each year (about $5,000) for the acquisition of contemporary paintings."[14]

In the same letter Valentiner outlined a proposal to establish, in an adjacent building, "a *museum of sculpture* to which should be added a walled garden with lawns, pool and shrubbery to contain outdoor sculptures....The advantage of such a museum would be that it would enable us to extend our educational program far beyond the limits of our present collection. We could then teach the whole history of the art of mankind from its beginning in prehistoric times to the comparatively late epoch when panel paintings started (about 1400). The contents of this museum of sculpture should, to a great extent, precede in date the art represented in our museum of painting." In the two separate buildings devoted to painting and sculpture, Valentiner envisioned adding decorative arts;

among others, the director or chief curator of the National Gallery of Art in Washington. The National Gallery, however, declined the responsibility of passing on the acquisitions. This refusal, under the laws that stood, made any purchase impossible. Valentiner was eventually approved as a substitute authority to pass on the prospective purchases and he was paid $2,050 for his appraisal late in that year of the purchases made to date. (The other amendment required "dominant emphasis" on acquiring "masterpieces of the American, British, French, Spanish, Flemish and Dutch Schools" in spending the state's $1,000,000.)

13. *North Carolina Museum of Art Bulletin* 1 (Spring 1957): 21.

those that are allied with two-dimensional design – textiles, rugs, and tapestries – would be placed with the paintings and those that have plastic form like pottery and porcelain would be exhibited with the sculpture. Valentiner's scheme was never realized, but he did manage to expand the Museum's collections and collecting policies and in July 1957 opened five additional galleries devoted to Egyptian art, Greek and Roman art, Coptic textiles, and Renaissance bronzes. In his brief but influential tenure as director of the North Carolina Museum of Art, Valentiner also aggrandized the institution's position among American art museums by the exhibitions he organized. In 1956, the Museum was the focus of international attention as a result of a loan exhibition of paintings by Rembrandt and his pupils, and, in 1958, for an exhibition of oil paintings, watercolors, and prints of the German expressionist Ernst Ludwig Kirchner. In 1957, Valentiner initiated the *North Carolina Museum of Art Bulletin,* and in its early issues he himself supplied most of the articles, focusing on major works in the collection.

Before his death in 1958, Valentiner prepared a report for the Art Commission recommending the acceptance of forty-seven paintings from the Samuel H. Kress Foundation. Seven years earlier, in 1951, the 1947 statute had been modified to permit the required matching gift to be made in works of art, and the Samuel H. Kress Foundation had agreed to include Raleigh in its program for endowing regional museums throughout the United States with paintings from the Kress Collection and to present the state Art Society with "outstanding Italian Renaissance Art and other similar paintings of a value of at least one million dollars."[15] Between 1958 and 1961, following negotiations and exchanges, the number of paintings was increased to sixty-nine and two sculptures were added, making the Kress gift to North Carolina the largest and most important of any except that given to the National Gallery of Art in Washington, D.C. The advantage of having had the promise of the Kress gift before the purchase of the Museum's original collection was the assurance that the field of early Italian painting would be eventually well represented. Funds that ordinarily would have been used to acquire Italian paintings from the fourteenth and fifteenth centuries were thus freed for the purchase of other works. The Kress Collection at Raleigh[16] has given the Museum a particularly prestigious position among

14. Letter to Robert Lee Humber, 26 April 1956, North Carolina State Archives, Raleigh, N.C.

15. N.C. General Assembly, *Session Laws and Resolutions of 1951 Passed by the General Assembly...,* Chapter 1168, p. 1212.

16. See North Carolina Museum of Art, *The Samuel H. Kress Collection* (Raleigh, 1960), the revision by Fern Rusk Shapley, *Paintings from the Samuel H. Kress Collection: Italian Schools XIII–XV Century* (London, 1966), and subsequent volumes in this series.

American museums for its collection of early Italian paintings that is centered around one of the monuments of Trecento painting, the "Peruzzi Altarpiece" by Giotto and assistants (pp. 158-59), believed to have been painted for the Franciscan church of Santa Croce in Florence about 1322. In addition to a splendid survey of Italian Trecento and Quattrocento pictures that includes such notable pictures as Segna di Bonaventura's *Madonna and Child* (p. 156), the tondo by Botticelli and assistants (p. 169), the Francia *Madonna and Child with Two Angels* (p. 170), the cassone panels by Neroccio de' Landi (pp. 166-67), and the marriage salver from the workshop of Apollonio di Giovanni (p. 168), the Kress gift added major works from the sixteenth, seventeenth, and eighteenth centuries. The large altarpiece of 1552 painted for a Dominican confraternity by Bernardino Lanino (p. 176) and that by Domenichino (p. 183) for Fano, a town on the east coast of Italy where the artist worked in 1618-19, are but two works in a sequence that leads through Massimo Stanzione's powerful and arresting *The Assumption of the Virgin* (p. 187), one of the most important Neapolitan baroque paintings in America; includes the two very different canvases by Magnasco (pp. 193, 197), each of unusually fine quality; and culminates in Batoni's large and ambitious *The Triumph of Venice* (p. 198), his first nonreligious commission, painted in 1737 for Marco Foscarini, the Venetian ambassador to the Holy See. In addition, ten paintings from the French, Dutch, Flemish, and German schools further enriched the Museum's collections, notably the exceptionally rare triptych from a fifteenth-century French atelier, assigned to the Master of the Latour d'Auvergne Triptych (p. 123), the double portrait of Martin Luther and Philipp Melanchthon by Lucas Cranach the Younger (p. 152), ter Brugghen's *David Praised by the Israelite Women* (p. 89), with its strongly Caravaggesque features, and the brilliantly executed *Portrait of a Young Man with a Sword* (p. 93), attributed to Rembrandt's pupil Govert Flinck.

The first phase of growth of the North Carolina Museum of Art, during which it accumulated very rapidly an impressive basic collection by means of the original state appropriation, the Robert F. Phifer Bequest, and the Samuel H. Kress Foundation gift, ended in 1960. In 1961, the General Assembly separated the Museum from the North Carolina State Art Society, conferred upon it the

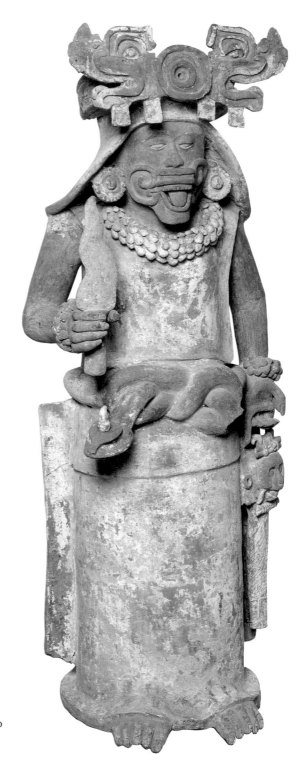

New World, Mexico, Vera Cruz, Classic Period

Priestess, c. 500-900

Terracotta and paint, 57¼ x 22⅜ in. (145.4 x 56.8 cm.)
Gift of Mr. and Mrs. Gordon Hanes
86.8

status of a state agency, and transferred to it title of the works of art and all other property of the Museum.[17] In that same year, Justus Bier (1899-1990),[18] was appointed the Museum's director. The collections continued to expand in the 1960s, but certainly not at the dizzying pace of the previous decade. The major acquisitions included an important document of the work of the young Raphael, *St. Jerome Punishing the Heretic Sabinian* (p. 172), a scene from the predella of the Mond Crucifixion in the National Gallery, London; Chardin's *Still Life with Ray Fish and a Basket of Onions* (p. 127); and Raeburn's *Thomas Robert Hay, 11th Earl of Kinnoull* (p. 82). Dr. Bier's profound knowledge of late Gothic German sculpture is reflected in his acquisition of the beautiful *Female Saint* by Tilmann Riemenschneider (p. 149) and *Madonna and Child Sheltering Supplicants under Her Cloak* (p. 148), attributed to Peter Koellin, although his catholic tastes and love of the plastic arts in general led him also to the acquisition of other sculptures of a very different kind, such as the mobile by Alexander Calder, *Tricolor on Pyramid* (p. 279). Before coming to Raleigh, Bier had been a distinguished scholar and art historian for many years at the Allen R. Hite Art Institute, which he founded at the University of Louisville; so it was inevitable that he would follow Valentiner's example and work to raise the status of the North Carolina Museum of Art as an educational institution. The *Bulletin* was revived with important contributions from recognized scholars focusing on the Museum's holdings[19] and educational programs of tours, lectures, and concerts were greatly expanded.

The development of the Museum's collections in the 1970s depended primarily upon purchase funds allocated by the General Assembly (ranging from $10,000 in 1958 to $200,000 in 1973 to $25,000 in 1982), the support of the North Carolina Art Society, and the generosity of corporations and private donors. In this decade, Moussa M. Domit, director from 1974 to 1980, aggressively pursued the expansion of the Egyptian, Greek, and Roman (pp. 3-35), and African, New World, and Oceanic collections (pp. 37-67),[20] following Valentiner's conception of the Museum as an encyclopedia of diverse world cultures and historical periods. This period in the Museum's history was marked by the emergence of major new patrons in Mr. and Mrs. Gordon Hanes and the James G. Hanes Foundation of Winston-Salem, by whose benefaction the Egyptian, Greek, and

17. Under the Executive Organization Act of 1971, the Museum became an agency of what is now the Department of Cultural Resources.

18. For a biography and bibliography of the writings of Justus Bier, see *North Carolina Museum of Art Bulletin* 12, no. 4(1974): 9-41.

19. For example, Anthony M. Clark, "Batoni's *Triumph of Venice*," *North Carolina Museum of Art Bulletin* 4, no. 1(1963): 5-11, and Creighton Gilbert, "A Miracle by Raphael," *ibid.* 6, no. 1(1965): 3-35.

20. Most of the Ancient, African, New World, and Oceanic collections are described in the *North*

Roman, and the African, New World, and Oceanic collections were measurably enriched. In these same years, the new emphasis on nontraditional areas of collecting also led to the formation of a collection of Jewish ceremonial artifacts under the auspices of Dr. Abram Kanof.

Another major area of the collections strengthened in the 1970s was twentieth-century American painting. The acquisitions included Andrew Wyeth's *Winter, 1946* (p. 268); Georgia O'Keeffe's *Cebolla Church* (p. 263); Marsden Hartley's *Indian Fantasy* (p. 256); and Frederick Carl Frieseke's *The Garden Parasol* (p. 246). Notable acquisitions of European art in the 1970s included paintings by Bonnard (p. 145), Boudin (p. 140), and Pissarro (p. 142), the latter two paintings gifts of the North Carolina National Bank and the Wachovia Bank and Trust Company, respectively.

The Art Commission, appointed in 1950 to acquire an art collection for North Carolina with legislatively approved funds, selected exclusively American and European paintings from the fifteenth through the late nineteenth centuries. It explicitly avoided the "controversial subject of modern art,"[21] and, as a result, the twentieth-century collections of the Museum consisted for many years largely of the work of North Carolina artists who have participated in the exhibitions cosponsored by the North Carolina Art Society. There have been exceptions, of course, and the collections have been enriched with occasional gifts of the work of artists of national importance such as the paintings by Milton Avery (p. 267), Franz Kline (p. 271), Josef Albers (p. 264), Richard Diebenkorn (p. xxvi, 270), and Neil Welliver (p. 283). The enlightened patronage of Mr. and Mrs. Gordon Hanes and their understanding of the Museum's needs in representing the art of postwar America with choice individual works has resulted in the acquisition of paintings by Kenneth Noland, Frank Stella (p. 280), and Morris Louis (p. 275), among others.

In 1967, the North Carolina General Assembly authorized the creation of a State Art Museum Building Commission to select a site and architect for a new museum building to replace the renovated office building that had long since proved inadequate. In 1973, the Building Commission, under the direction of Senator Thomas J. White, recommended a 164-acre tract on Blue Ridge

Carolina Museum of Art Bulletin 12, no. 3(1974): 31-38, 42-77; 13, no. 1(1975): 92-269; 13, no. 2(1975): 32-38.

21. For the dispute over possible purchases of modern art with legislatively appropriated funds, see Chamberlain, "How to Get and Spend a Million Dollars for Art," p. 96.

Road in west Raleigh and selected Edward Durell Stone and Associates, New York, and Holloway-Reeves, Raleigh, as the architects for the new building.[22] The General Assembly appropriated $10.75 million for the construction of the new building, and this was supplemented by a statewide fund-raising campaign chaired by Louis C. Stephens, Jr., and administered by the North Carolina Art Society, which raised an additional $5 million from nonpublic sources, including a $1.5 million challenge grant from the Z. Smith Reynolds Foundation of Winston-Salem. Bids for the project were received in July 1977 and construction began the same month. The building was dedicated on 28 May 1981 and opened to the public on 5 April 1983. The 181,300 square-foot facility includes exhibition galleries of approximately 50,000 square feet (against approximately 28,000 square feet in the Morgan Street building); a conservation laboratory of 3,000 square feet; expanded educational facilities, including a 272-seat auditorium; improved facilities for photography, technical workshops, offices, art storage, an art reference library, and a museum sales shop; and exhibition galleries accessible to the handicapped.

The major result of the opening of the new North Carolina Museum of Art is that its most important possessions may once again be seen by the public. For years, whole collections have been in storage or only partially visible owing to the limitations of the original quarters. These include the fine group of American nineteenth-century landscapes by Thomas Cole and Jasper Cropsey, (pp. 224, 225) acquired with the original state appropriation;[23] the important bequest of William R. Valentiner, which included sculptures by Wilhelm Lehmbruck and Barbara Hepworth; drawings by Max Beckmann, Henry Moore, Graham Sutherland, Paul Klee, and Wassily Kandinsky; as well as a number of German expressionist paintings. The fine collection of British eighteenth-century portraits acquired with the original state appropriation has not been adequately exhibited in recent years nor has the collection of African, New World, and Oceanic art. Moreover, many recent acquisitions have never been placed on view since entering the collections. This illustrated survey of the collections therefore fulfills an important responsibility of the Museum to make available its collections to a wider audience. The success of every art museum greatly

22. An official synopsis of the State Art Museum Building Commission's activities was compiled by its chairman, Thomas J. White, and published in the program issued on the occasion of the new building dedication, 28 May 1981; see, however, Karl E. Meyer, *The Art Museum: Power, Money, Ethics* (New York, 1979), pp. 144-47, and Phil Patton, "North Carolina's museum with a 'checkered history,' " *Artnews* 81 (October 1982): 84-88.

23. Nina Kasanof, "American Landscapes of the 19th century in the North Carolina Museum of Art," *North Carolina Museum of Art Bulletin* 8, no. 4 (June 1969): 2-15.

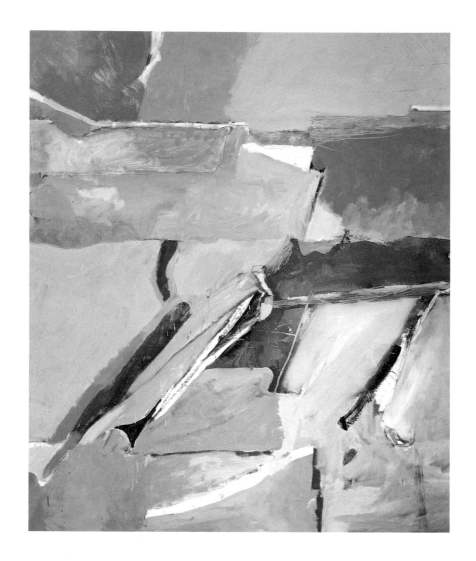

RICHARD DIEBENKORN *American,* born 1922

Berkeley No. 8, 1954

OIL ON CANVAS, 69⅛ X 59⅛ IN. (176.0 X 150.0 CM.)
GIFT OF W. R. VALENTINER
57·34·3

depends on its community's belief in the significance of the paintings, sculpture, and other objects that it collects, and the North Carolina Museum of Art is no exception. Everything shown in these pages belongs to the people of North Carolina and reflects their commitment to the quality and vitality of artistic life in this state. What has been accomplished in the years during which the North Carolina Museum of Art was founded and developed is exciting; even more so is the prospect of the Museum's future as one of the major cultural resources of this state and region.

Edgar Peters Bowron

Editorial Note

The works of art included here are divided into
sections representing the Museum's collections
and listed in approximate chronological order
within each section. The selections of European
art, however, have also been grouped according
to country. When the date of a work is not
documented, a general period is designated or an
approximate date is indicated by c. (circa).
Measurements throughout are in inches, with
their metric equivalents following in parentheses.
Height precedes width; depth, where it is
indicated, follows width.

The first two digits of the accession number
represent the year of acquisition. The
paintings purchased with the original legislative
appropriation were accessioned in 1952.

The Collections

Ancient

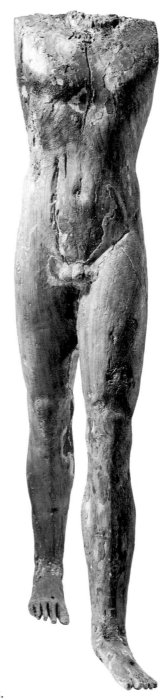

EGYPTIAN, OLD KINGDOM, DYNASTY V, C. 2490-2180 B.C.

Striding Man

WOOD WITH TRACES OF GESSO AND PAINT, H. 52¼ IN. (132.7 CM.)
GIFT OF MR. AND MRS. GORDON HANES
79.6.3

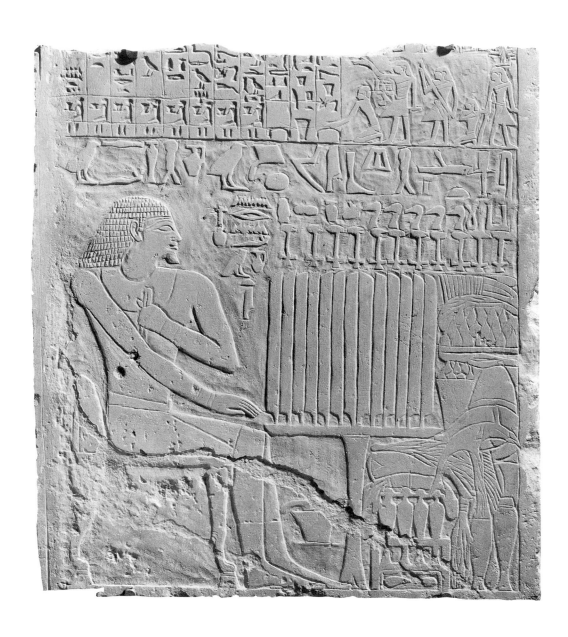

EGYPTIAN, OLD KINGDOM, DYNASTY VI, C. 2420-2258 B.C.

Relief from the Tomb of Khnumti in Saqqarah

LIMESTONE, 21¹⁄₂ X 18¹⁵⁄₁₆ IN. (54.4 X 48.0 CM.)
GIFT OF THE JAMES G. HANES MEMORIAL FUND
72.2.2

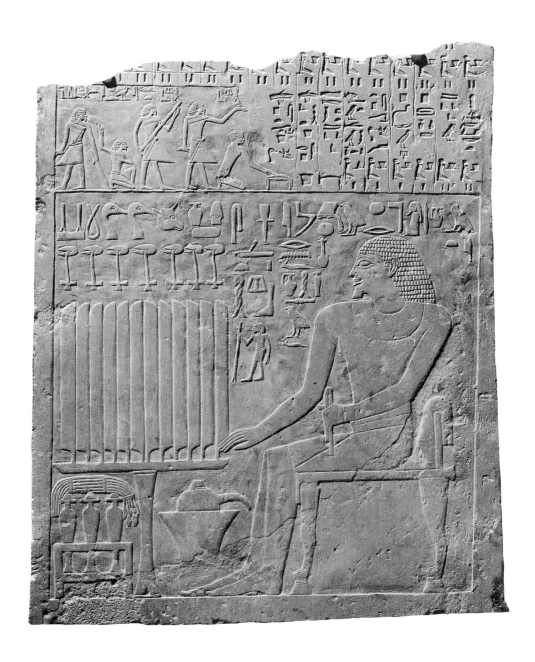

EGYPTIAN, OLD KINGDOM, DYNASTY VI, C. 2420-2258 B.C.

Relief from the Tomb of Khnumti in Saqqarah

LIMESTONE, 23⅞ x 19⅝ IN. (60.5 x 50.0 CM.)
GIFT OF THE JAMES G. HANES MEMORIAL FUND
72.2.1

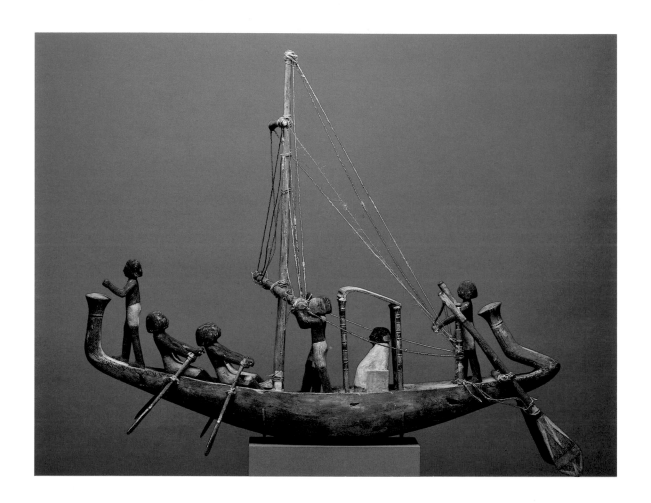

Egyptian, Middle Kingdom, Dynasty xii-xiii, c. 2052-1778 b.c.

Model Boat with Figures

Wood with gesso and paint, h. 30½ x w. 20½ x 1.41 in. (77.5 x 52.0 x 104.0 cm.)
Gift of Mr. and Mrs. Gordon Hanes
82.12

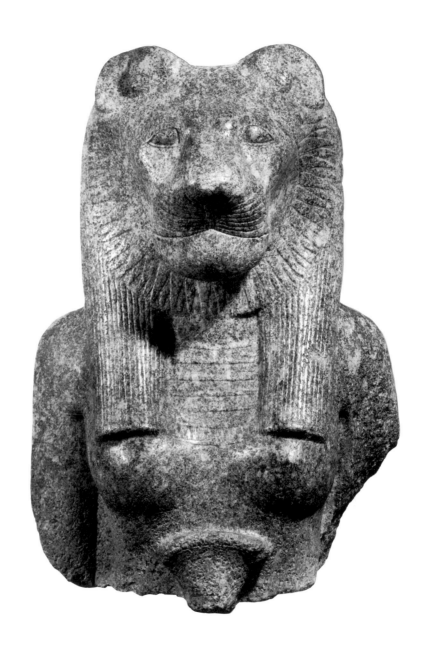

EGYPTIAN, NEW KINGDOM, DYNASTY XVIII, C. 1570-1340 B.C.

Bust of the Goddess Sekhmet

GRANITE, H. 23 IN. (58.5 CM.)
GIFT OF MR. AND MRS. GORDON HANES
82.11

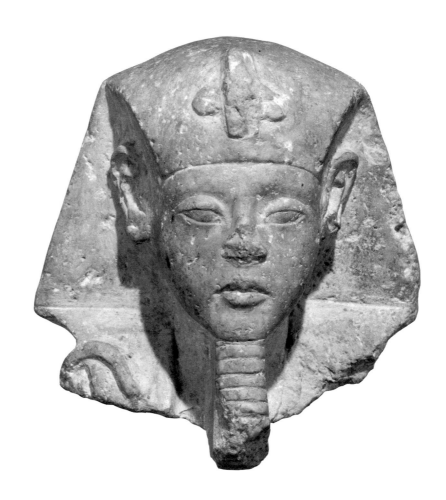

EGYPTIAN, NEW KINGDOM, DYNASTY XVIII, C. 1372-1355 B.C.

Head from a Shawabti Figure of Akhenaten

QUARTZITE, H. 2¾ IN. (7.0 CM.)
GIFT OF THE JAMES G. HANES MEMORIAL FUND
74.2.8

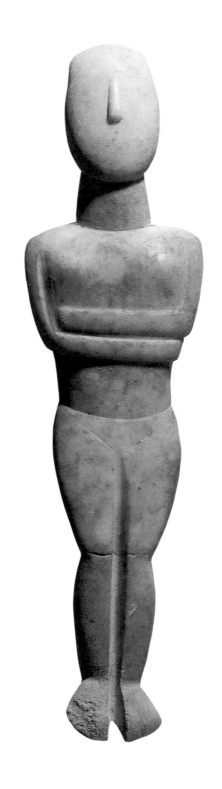

CYCLADIC, SYROS GROUP, STEINER MASTER

Female Figurine, c. 2800-2400 B.C.

MARBLE, 19⁷/₈ x 5¹/₂ IN. (50.6 x 14.0 CM.)
GIFT OF MR. AND MRS. GORDON HANES
86.5

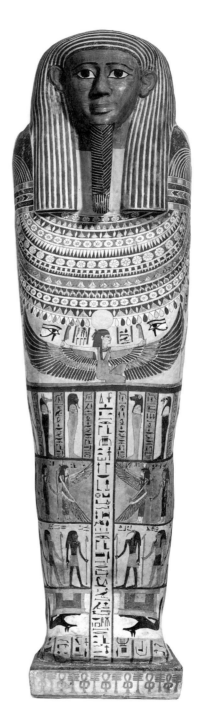

EGYPTIAN, LATE PERIOD, DYNASTY XXII–XXXII, C. 945–712 B.C.

Mummy Case of Amonred

WOOD WITH GESSO AND POLYCHROME, H. 71 IN. (180.3 CM.)
GIFT OF THE JAMES G. HANES MEMORIAL FUND
73.8.5

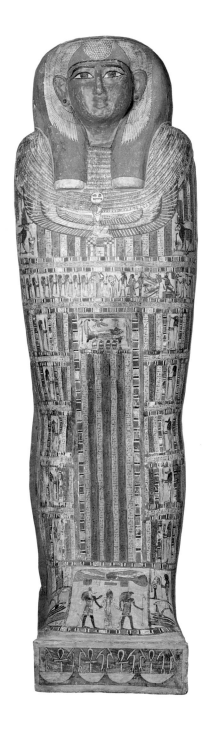

EGYPTIAN, LATE PERIOD, DYNASTY XXII-XXXIII, C. 945-712 B.C.

Mummy Case of Djed Mout

WOOD WITH GESSO AND POLYCHROME, H. 71 IN. (180.3 CM.)
GIFT OF THE JAMES G. HANES MEMORIAL FUND
73.8.4

Corner Relief with Offering Scene (front)

ASWAN GRANITE, 29 X 19½ IN. (73.7 X 49.5 CM.)
GIFT OF THE JAMES G. HANES MEMORIAL FUND
72.2.3A

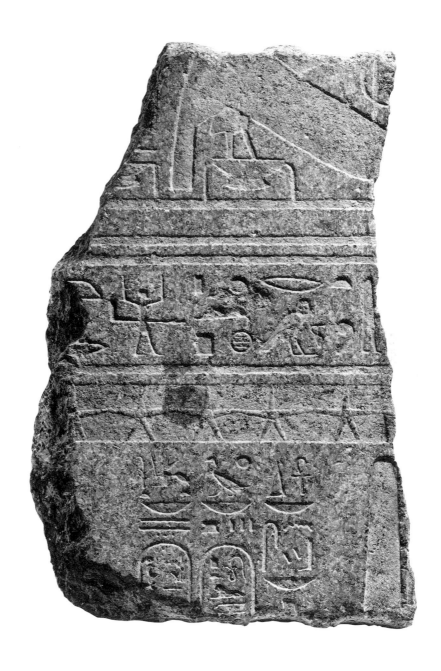

EGYPTIAN, PTOLEMAIC PERIOD, C. 285-246 B.C.

Corner Relief with Offering Scene (side)

ASWAN GRANITE, H. 29 X W. 25¼ X D. 2⅞ IN. (73.7 X 64.0 X 7.3 CM.)
GIFT OF THE JAMES G. HANES MEMORIAL FUND
72.2.3B

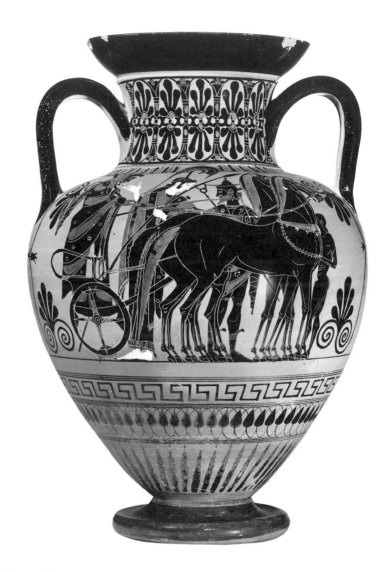

GREEK, ATTIC, ATTRIBUTED TO THE THREE LINE GROUP

Neck Amphora, C. 530-520 B.C.

BLACK-FIGURE CERAMIC WITH ADDED RED AND WHITE PAINT, H. 16⅝ IN. (42.2 CM.)
PURCHASED WITH FUNDS FROM THE NORTH CAROLINA ART SOCIETY (ROBERT F. PHIFER BEQUEST)
90.2

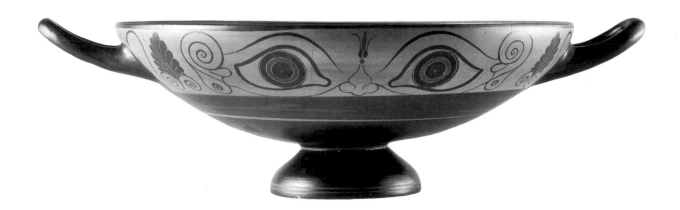

GREEK, CHALCIDIAN

Eye Cup (Kylix), C. 525-500 B.C.

CERAMIC WITH BLACK GLAZE AND ADDED RED PAINT, H. 4¼ X DIA. 15¼ IN. (10.8 X 38.8 CM.)
PURCHASED WITH FUNDS FROM THE STATE OF NORTH CAROLINA
AND THE NORTH CAROLINA MUSEUM OF ART FOUNDATION
79.1.1

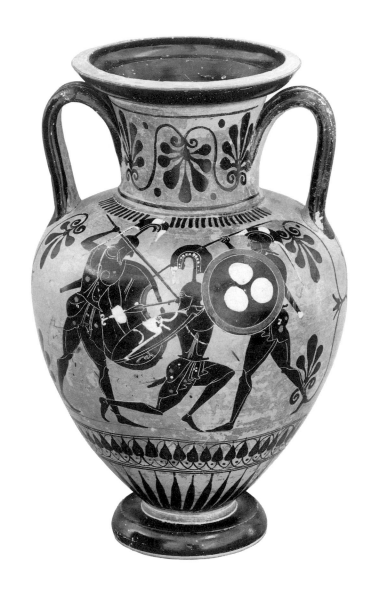

GREEK, ATTIC, LEAGROS GROUP

Neck Amphora, C. 510–500 B.C.

BLACK-FIGURE CERAMIC WITH ADDED RED AND WHITE PAINT, H. 13½ IN. (34.3 CM.)
PURCHASED WITH FUNDS FROM THE STATE OF NORTH CAROLINA
74.1.6

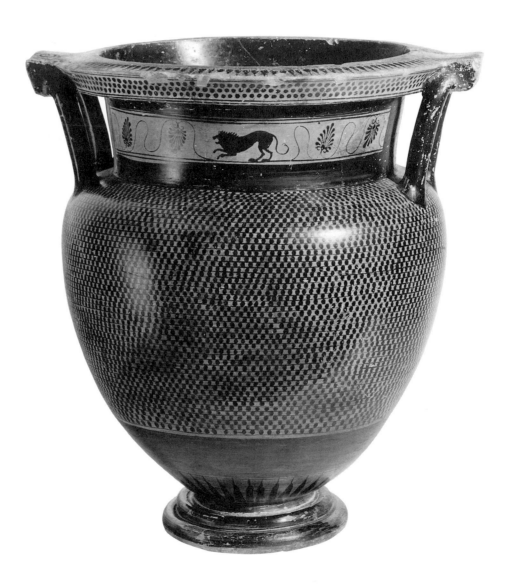

GREEK, ATTIC

Column Krater, EARLY 5TH CENTURY B.C.

CERAMIC WITH BLACK GLAZE, H. 16¼ IN. (41.3 CM.)
GIFT OF MR. AND MRS. GORDON HANES
75.8.3

Cypriot

Head of a God or Priest, c. 450-425 b.c.

Limestone, h. 15 in. (38.1 cm.)
Gift of Mr. and Mrs. Gordon Hanes
79.6.12

Greek, Attic, Painter of the Brussels Oinochoai

Oinochoe, c. 470-460 B.C.

Red-figure ceramic, h. 9⅝ in. (24.5 cm.)
Purchased with funds from the North Carolina Museum of Art Foundation (Gift of Mr. and Mrs. Gordon Hanes.)
79.II.5

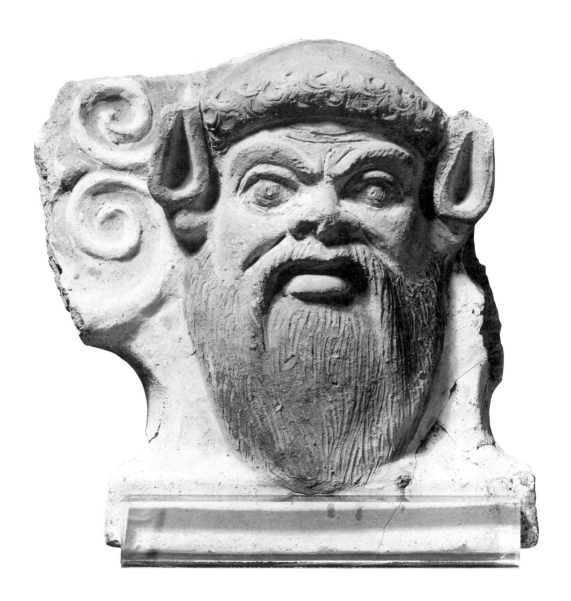

ETRUSCAN

Antefix in the Shape of a Satyr's Head, C. 450 B.C.

TERRACOTTA WITH PAINT, H. 12⅜ IN. (31.5 CM.)
PURCHASED WITH FUNDS FROM THE STATE OF NORTH CAROLINA
AND THE NORTH CAROLINA MUSEUM OF ART FOUNDATION
77.20.1

South Italian, Daunian, Attributed to a Canosan workshop

Askos, 4th-3rd century b.c.

Ceramic with black, pink, and red paint, h. 10¹/₄ in. (26.0 cm.)
Purchased with funds from the State of North Carolina
77.1.5

SOUTH ITALIAN, APULIAN, WORKSHOP OF THE PATERA PAINTER

Hydria, C. 320 B.C.

RED-FIGURE CERAMIC WITH ADDED WHITE PAINT, H. 31 IN. (78.7 CM.)
PURCHASED WITH FUNDS FROM THE STATE OF NORTH CAROLINA
74.1.2

GREEK, HADRA, ATTRIBUTED TO THE TATILLON PAINTER

Hydria, END OF 3RD CENTURY B.C.

CERAMIC WITH BLUFF SLIP AND ADDED PAINT, H. 13½ IN. (34.1 CM.)
GIFT OF MR. AND MRS. GORDON HANES
79.6.15

SICILIAN, CENTURIPE

Funerary Vase (Lebes), C. 250-225 B.C.

CERAMIC WITH PAINT AND GILDING, H. 35½ IN. (90.2 CM.)
PURCHASED WITH FUNDS FROM THE STATE OF NORTH CAROLINA
75.1.9

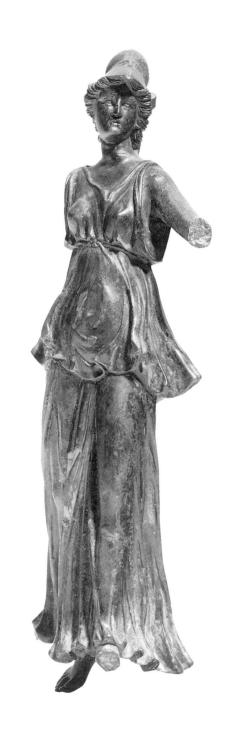

GREEK, HELLENISTIC

Athena, 2ND-1ST CENTURY B.C.

BRONZE, H. 7¾ IN. (19.7 CM.)
PURCHASED WITH NORTH CAROLINA ART SOCIETY TOUR FUNDS
79.10.1

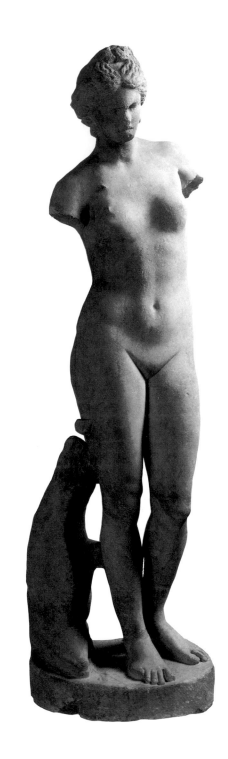

ROMAN, AFTER A HELLENISTIC ORIGINAL

Aphrodite of Cyrene, IST CENTURY

MARBLE, H. 67½ IN. (171.5 CM.)
PURCHASED WITH FUNDS FROM THE STATE OF NORTH CAROLINA
AND FROM THE NORTH CAROLINA ART SOCIETY (ROBERT F. PHIFER BEQUEST)
80.9.1

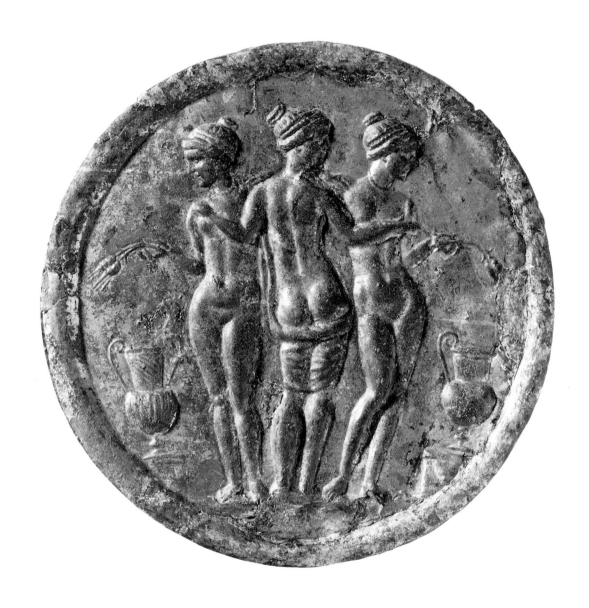

GREEK

Mirror with Representation of the Three Graces, 150-31 B.C.

SILVER AND GILT BRONZE, DIA. 5¹/8 IN. (13.0 CM.)
PURCHASED WITH FUNDS FROM THE STATE OF NORTH CAROLINA
77.1.8

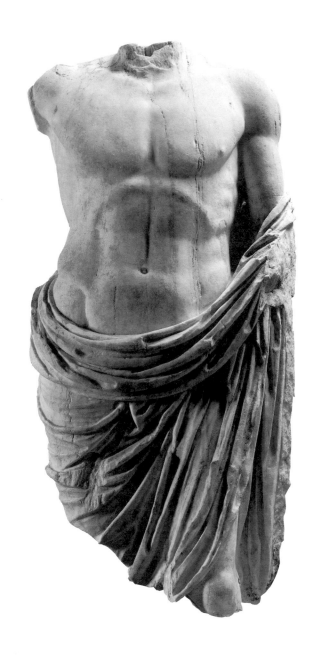

ROMAN

Torso of an Emperor in the Guise of Jupiter, 1ST CENTURY

MARBLE, H. 55¼ IN. (140.3 CM.)
GIFT OF MR. AND MRS. GORDON HANES
86.4

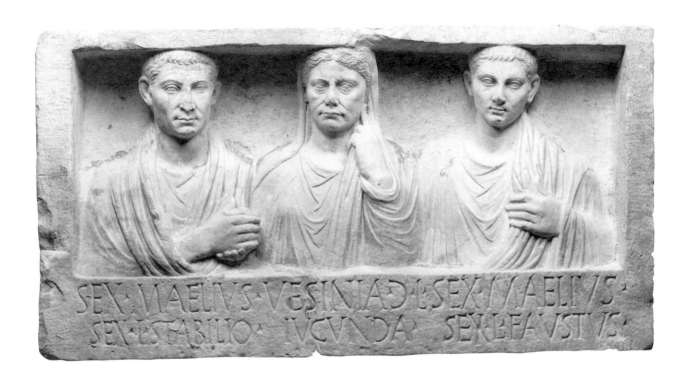

ROMAN

Funerary Monument, IST CENTURY

MARBLE, H. 27½ X W. 67 X D. 15 IN. (69.9 X 170.2 X 38.1 CM.)
PURCHASED WITH FUNDS FROM THE STATE OF NORTH CAROLINA
79.1.2

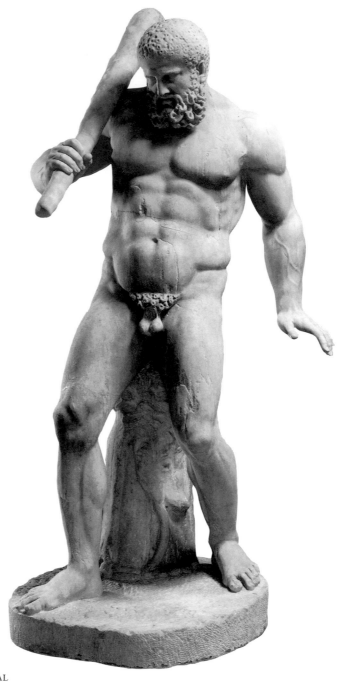

ROMAN, AFTER A HELLENISTIC ORIGINAL

Herakles, 2ND CENTURY

MARBLE, H. 65 IN. (165.1 CM.)
GIFT OF MR. AND MRS. JACK LINSKY
55.11.2

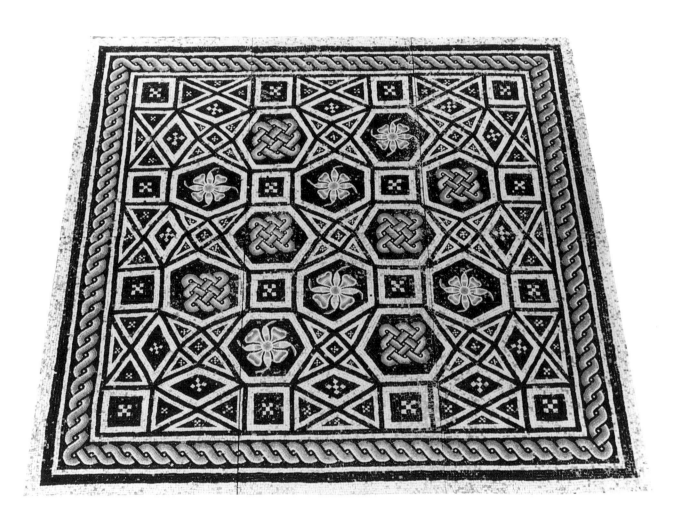

ROMAN

Mosaic, 2ND CENTURY

MARBLE AND GLASS, 98¹/₂ x 98¹/₂ IN. (250.3 x 250.3 CM.)
GIFT OF MR. AND MRS. GORDON HANES
79.6.9

ROMAN

Osteotheke, SECOND HALF OF 2ND CENTURY

MARBLE, H. 20⁷/8 X W. 37³/8 X D. 20¹/4 IN. (52.9 X 94.8 X 51.5 CM.)
GIFT OF ANNE AND CARL CARLSON IN MEMORY OF LYNN AND KARL PRICKETT
88.2

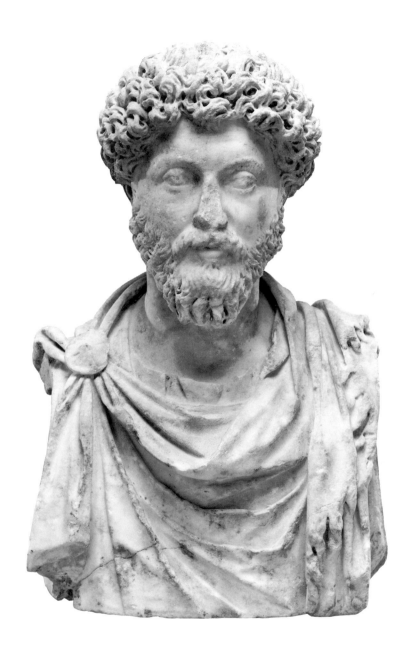

ROMAN

Portrait of the Emperor Marcus Aurelius, LATE 2ND CENTURY

MARBLE, H. 26⁵/16 IN. (69.4 CM.)
PURCHASED WITH FUNDS FROM VARIOUS DONORS, BY EXCHANGE
92.1

Roman

Emperor Caracalla in the Guise of Helios, EARLY 3RD CENTURY

MARBLE, H. 77¼ IN. (196.2 CM.)
PURCHASED WITH FUNDS FROM THE NORTH CAROLINA ART SOCIETY
(ROBERT F. PHIFER BEQUEST)
84.1

ROMAN, PHRYGIAN

Funerary Stele, LATE 3RD CENTURY

MARBLE, H. 60½ X W. 27⅜ X D. 8 IN. (153.5 X 69.5 X 20.3 CM.)
GIFT OF MR. AND MRS. GORDON HANES
79.6.13

African, New World, and Oceanic

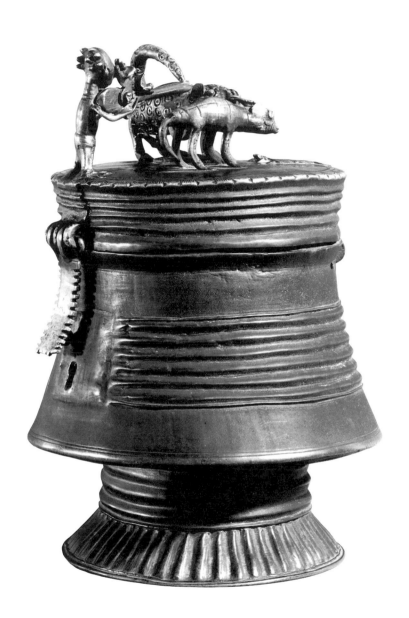

AFRICAN, GHANA, ASHANTI

Ritual Vessel (Kuduo), 19TH CENTURY

BRONZE, H. 10¼ IN. (26.1 CM.)
GIFT OF MR. AND MRS. GORDON HANES
72.19.17

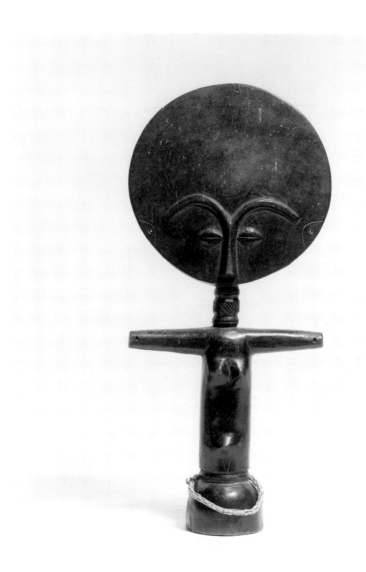

AFRICAN, GHANA, ASHANTI

Fertility Doll (Akua ba), 20TH CENTURY

WOOD AND BEADS, H. 13¹/8 IN. (33.5 CM.)
GIFT OF MR. AND MRS. GORDON HANES
72.19.42

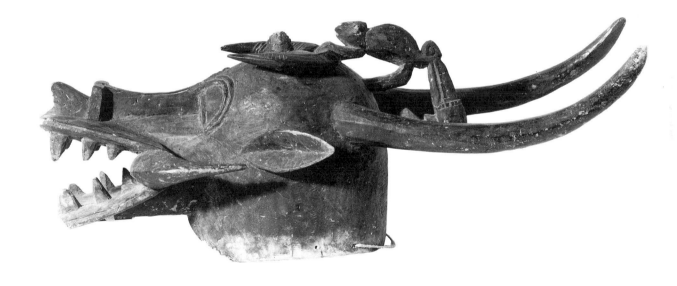

African, Ivory Coast, Senufo

Helmet Mask (Waniugo/Kponiugo), 20th century

Wood and pigment, h. 33 in. (83.8 cm.)
Gift of the Hanes Corporation
72.19.45

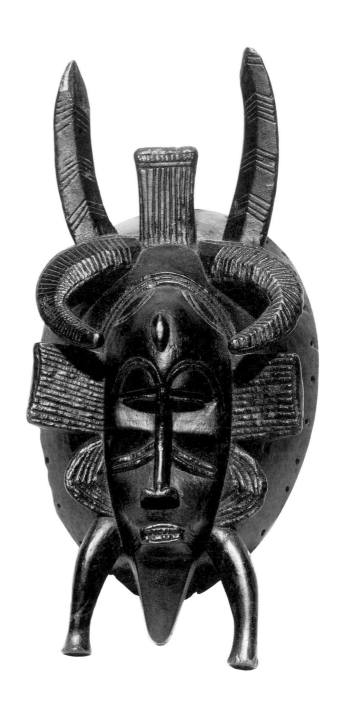

AFRICAN, IVORY COAST, SENUFO

Poro Society Mask (Kpelie), 20TH CENTURY

WOOD, H. 12½ IN. (31.7 CM.)
GIFT OF THE HANES CORPORATION
72.19.12

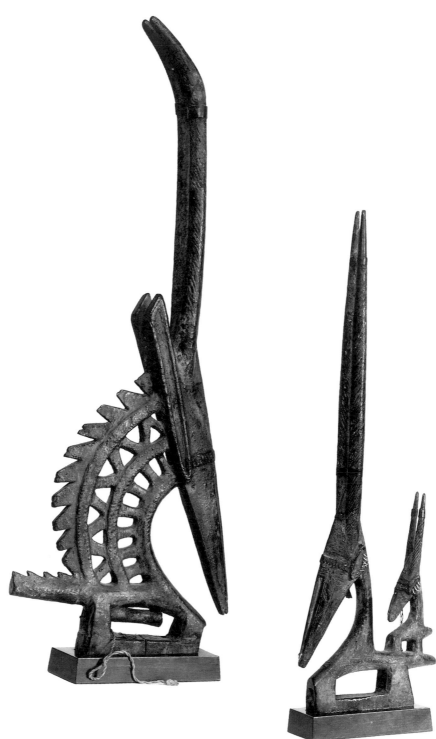

AFRICAN, MALI, BAMANA

Antelope Headpieces (Tji Wara), 20TH CENTURY

WOOD, TWINE, AND METAL, H. 33¼ IN. (84.5 CM.) MALE FIGURE, H. 26⅞ IN. (68.3 CM.) FEMALE FIGURE
PURCHASED WITH FUNDS FROM THE NORTH CAROLINA ART SOCIETY (ROBERT F. PHIFER BEQUEST)
86.1/1-2

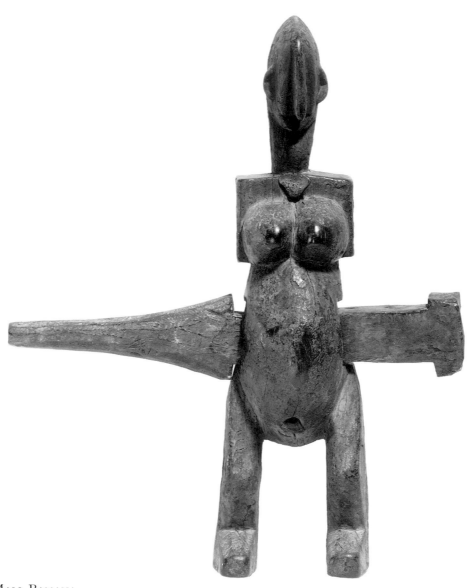

AFRICAN, MALI, BAMANA

Door Lock (Konbalabala), 20TH CENTURY

WOOD AND METAL, H. 18¾ IN. (47.6 CM.)
GIFT OF LEWIS W. PATE
73.15.18 A–B

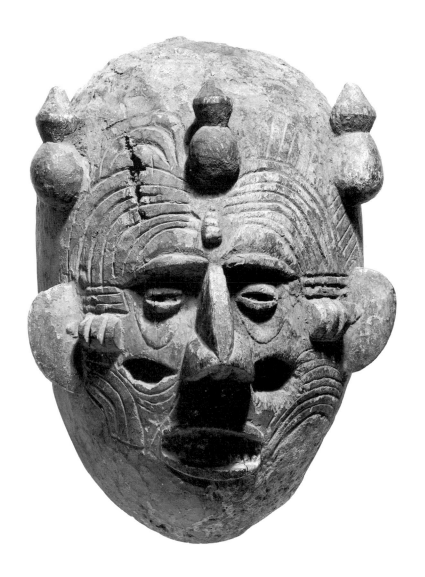

AFRICAN, NIGERIA, IBO

Mmwa Cult Face Mask, 20TH CENTURY

WOOD, H. 15 IN. (38.1 CM.)
GIFT OF FRED JAMNER
75.38.3

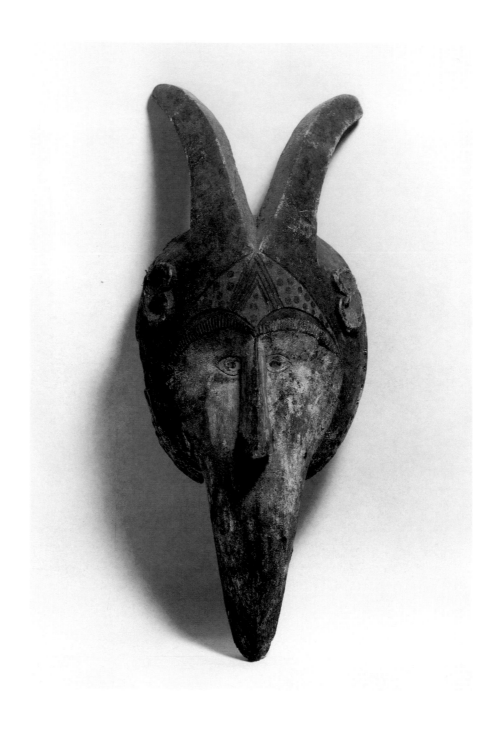

AFRICAN, NIGERIA, IBO

Animal Spirit Headdress (Mkpe), 20TH CENTURY

WOOD AND PAINT, H. 15⅝ IN. (39.7 CM.)
GIFT OF THE HANES CORPORATION
72.19.31

AFRICAN, NIGERIA, IBO

Egbukele Society Headdress Mask, 20TH CENTURY

WOOD, MIRRORS, AND PAINT, H. 27¼ X W. 19⅞ X L. 89⅜ IN. (69.3 X 50.6 X 227.0 CM.)
PURCHASED WITH FUNDS FROM VARIOUS DONORS, BY EXCHANGE
85.1

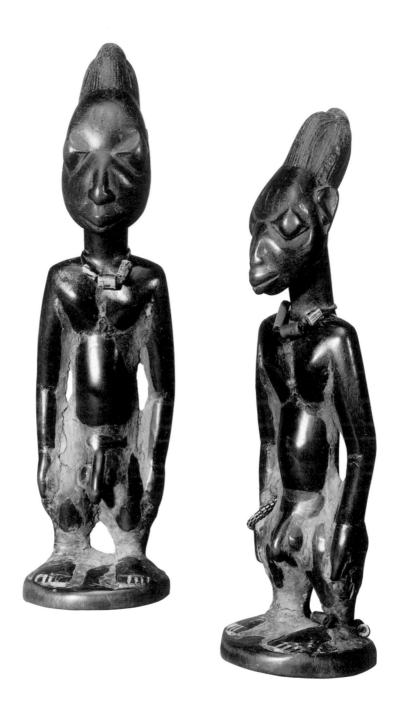

African, Nigeria, Yoruba, Igbomina

Twin Figures (Ibeji), late 19th-early 20th century

Wood, beads, and camwood powder, h. 10¼ x w. 2⅞ x d. 2⅞ in. (26.1 x 7.4 x 7.4 cm.)
Purchased with funds from various donors, by exchange
85.2/1-2

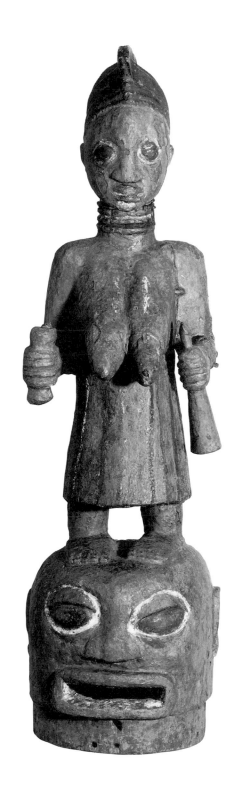

African, Nigeria, Yoruba, Igbomina

Epa Society Mask, late 19th–early 20th century

Wood, paint, and metal, h. 37½ in. (95.3 cm.)
Gift of Bob Bronson
76.20.3

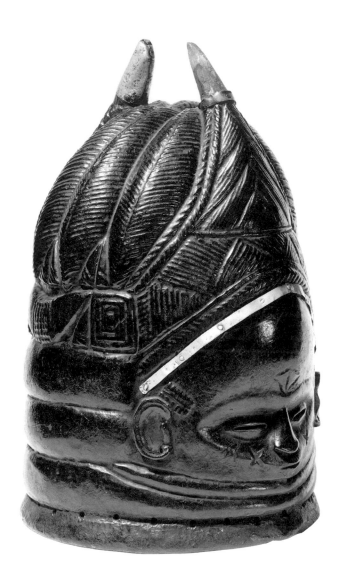

African, Sierra Leone, Mende

Sande Society Mask (Bondo), 20TH CENTURY

WOOD AND METAL, H. 14 IN. (35.6 CM.)
GIFT OF THE JAMES G. HANES MEMORIAL FUND
73.8.25

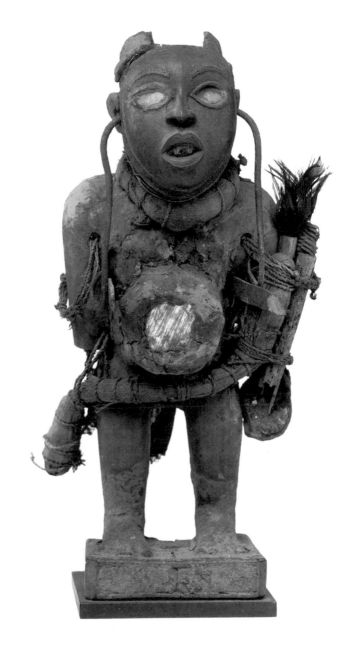

African, Zaire, Kongo, Yombe Subgroup

Oath-Taking and Healing Image (Nkondi)

Wood, metal, and quills, h. 14¾ in. (37.5 cm.)
Gift of Mr. and Mrs. Gordon Hanes
91.7

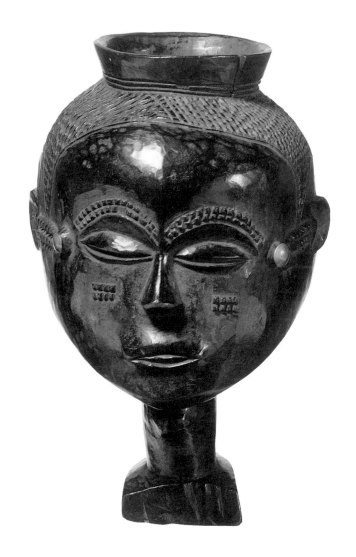

AFRICAN, ZAIRE, KUBA

Cup, 20TH CENTURY

WOOD AND METAL, H. 7¼ IN. (18.4 CM.)
GIFT OF BOB BRONSON
78.30.1

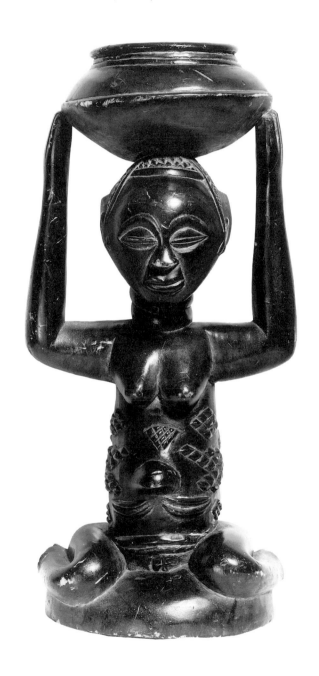

AFRICAN, ZAIRE, LUBA

Bowl Bearer (Mboko), 20TH CENTURY

WOOD, H. 17⅞ IN. (45.5 CM.)
GIFT OF MR. AND MRS. GORDON HANES
72.19.38

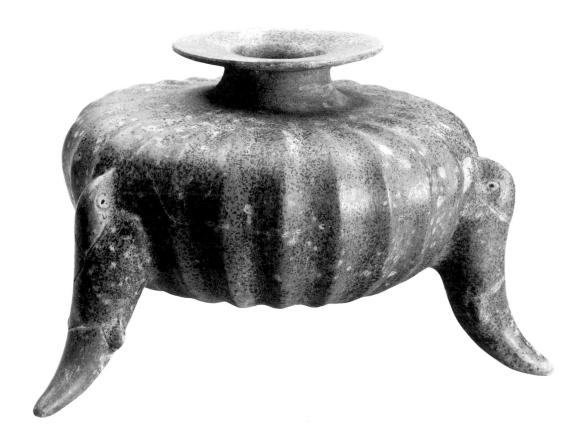

New World, Mexico, Colima, early Classic Period

Tripod Vessel, c. 300-600

Terracotta, h. 9¾ x d. 15½ in. (24.6 x 39.4 cm.)
Gift of the James G. Hanes Memorial Fund
74.2.13

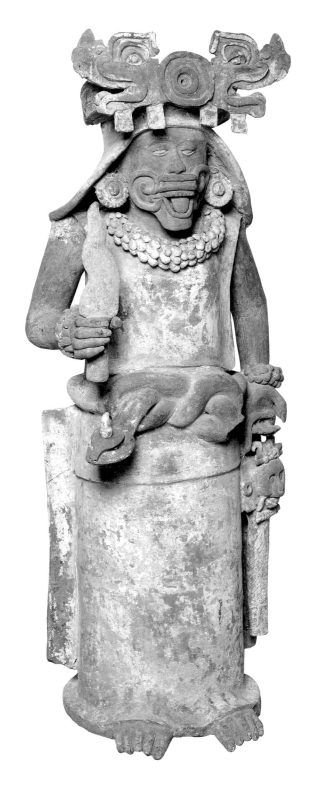

New World, Mexico, Vera Cruz, Classic Period

Priestess, c. 500-900

Terracotta and paint, 57¼ x 22⅜ in. (145.4 x 56.8 cm.)
Gift of Mr. and Mrs. Gordon Hanes
86.8

New World, West Mexico, Colima, Classic Period

Vessel, c. 500-1000

Terracotta, h. 4³⁄₈ x dia. 10³⁄₈ in. (11.1 x 26.4 cm.)
Gift of Mr. and Mrs. Joseph M. Goldenberg
74.20.4

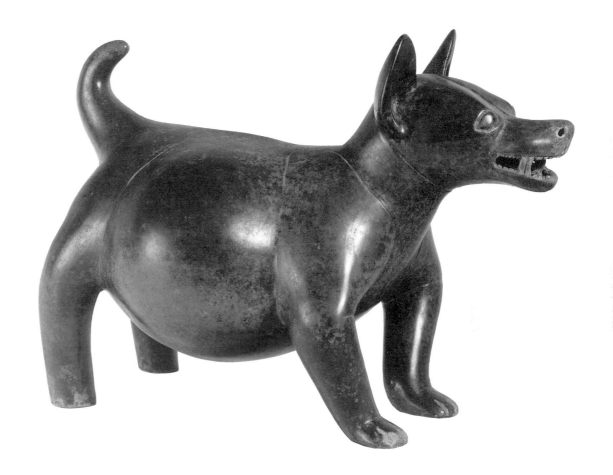

New World, West Mexico, Colima, Classic Period

Dog, c. 500-1000

Terracotta, h. 11 in. (27.9 cm.)
Gift of Mr. and Mrs. Mace Neufeld
73.20.3

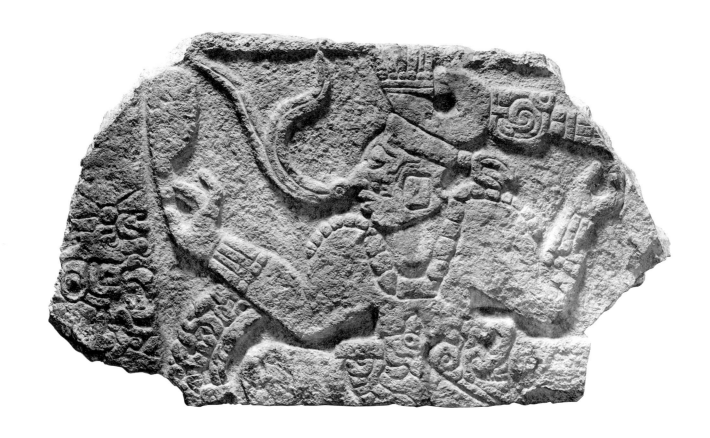

New World, Mexico, Yucatan, Maya, late Classic Period

Relief, c. 550-800

Limestone, 20⅞ x 35⅝ in. (53.1 x 91.6 cm.)
Gift of Mr. and Mrs. Cedric H. Marks
70.1.1

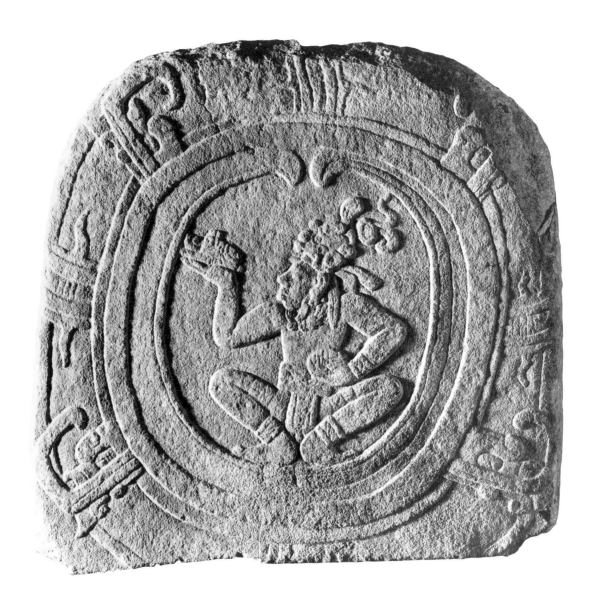

New World, Mexico, Maya, late Classic Period

Ball Court Marker, c. 600-900

Stone, 23⅛ x 24 in. (58.8 x 61.0 cm.)
Gift of Mr. and Mrs. Gordon Hanes
82.14

New World, West Mexico, Nayarit, Classic Period

Standing Figure of a Warrior, c. 500–1000

Terracotta, paint, h. 21 in. (53.3 cm.)
Gift of Mr. and Mrs. S. J. Levin
58.8.1

New World, West Mexico, Nayarit, Classic Period

Female Figure, c. 500–1000

Terracotta, paint, h. 21 in. (53.3 cm.)
Gift of Mr. and Mrs. S. J. Levin
58.8.2

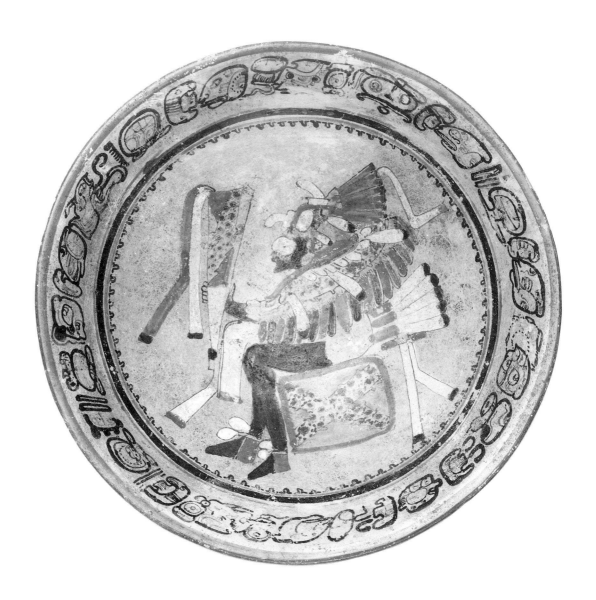

New World, Mexico, Maya, Peten, Late Classic Period

Tripod Plate with Priest Holding a Ritual Object, c. 600-700

Terracotta, h. 3¼ x dia. 13⅝ in. (8.3 x 34.6 cm.)
Gift of Mr. John B. Fulling
76.2.4

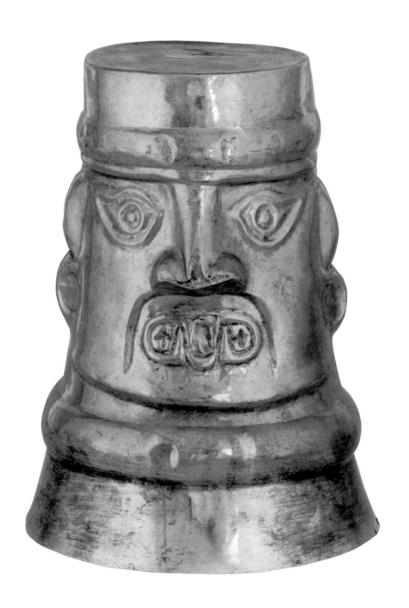

New World, Peru, Sicán

Beaker Depicting Face of a Deity, c. 850-1050

Gold alloy, h. 10 in. (25.4 cm.)
Purchased with funds from the State of North Carolina
74.1.3

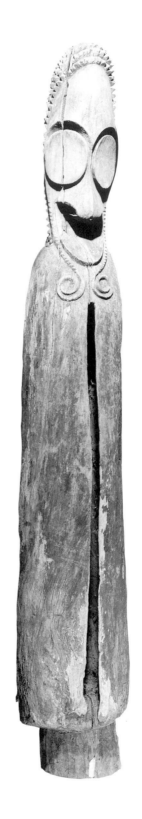

Oceanic, New Hebrides, Ambrym Island

Slit Gong, 20th century

Wood, h. 118 x circum. 58⅝ x dia. 19¾ in. (299.8 x 148.9 x 50.2 cm.)
Gift of Mr. and Mrs. Gordon Hanes
86.14

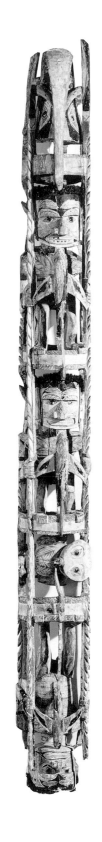

OCEANIC, NEW IRELAND

Memorial Carving (Malanggan), EARLY 20TH CENTURY

WOOD, GRASS, SHELL, AND PAINT, H. 92¹/₂ X DIA. 10¹/₄ IN. (235.0 X 26.0 CM.)
PURCHASED WITH FUNDS FROM THE STATE OF NORTH CAROLINA
78.1.2

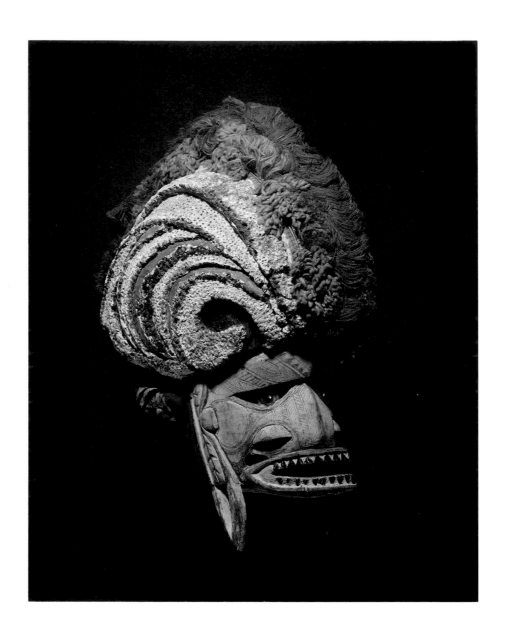

Oceanic, New Ireland

Helmet Mask, 20th century

Wood, fiber, and paint, 17 x 8¹/8 in. (43.2 x 20.6 cm.)
Gift of Mr. and Mrs. Gordon Hanes
86.9

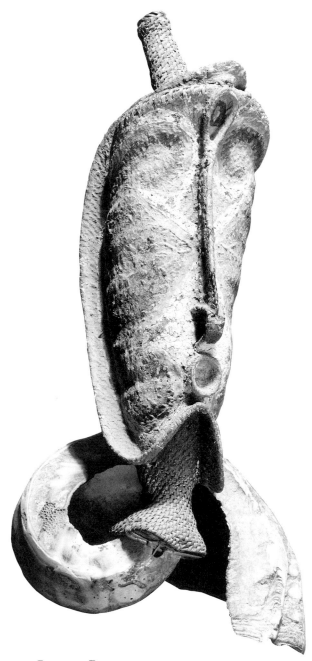

Oceanic, Papua, New Guinea, Prince Alexander Region, Boiken

Bride Wealth Mask, 20TH CENTURY

FIBER, PAINT, SHELL, AND RATTAN, H. 13⅝ IN. (34.7 CM.)
GIFT OF MR. AND MRS. GORDON HANES
77.2.6

Judaica

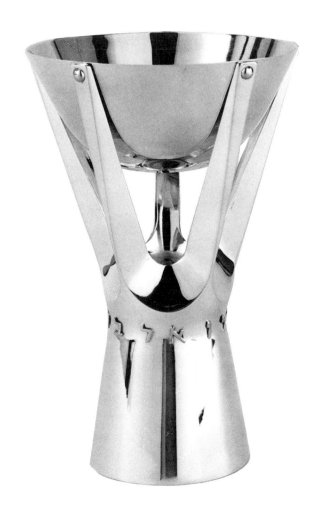

Moshe Zabari *American,* born Israel 1935

Cup for the Prophet Elijah, 1965

Silver, gilt, h. 5³⁄₄ in. (14.6 cm.)
Gift of Hampton Industries, Inc., in memory of its first Chairman of the Board, Sam Fuchs
77.3.2

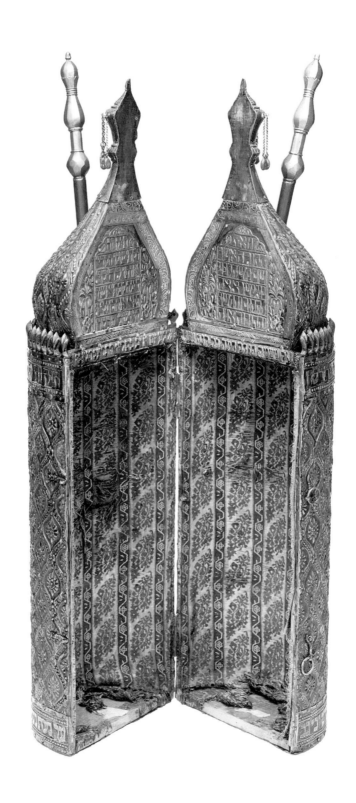

Possibly Iraqi

Torah Case, LATE 19TH-EARLY 20TH CENTURY

SILVER GILT OVER WOOD, H. 36⅞ IN. (93.6 CM.)
JUDAICA ART FUND AND MUSEUM PURCHASE FUND
80.3.5

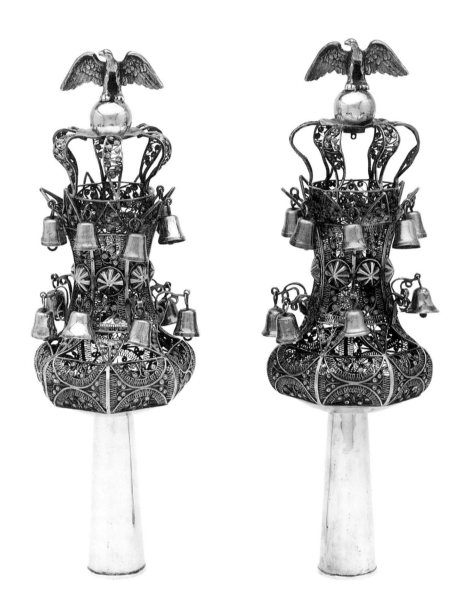

DUTCH

Pair of Torah Finials, c. 1800

SILVER, H. 13½ IN. (34.3 CM.)
GIFT OF DAVID FALK
76.4.1 A-B

European

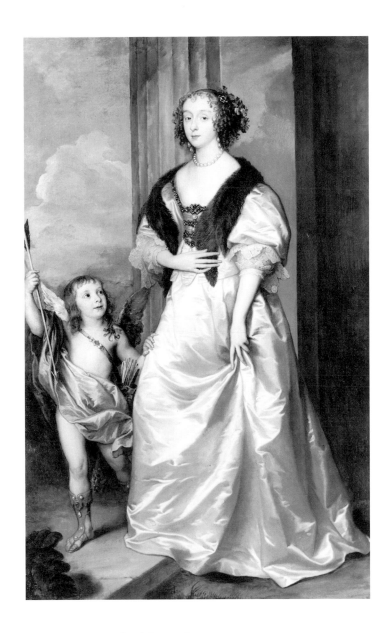

SIR ANTHONY VAN DYCK *Flemish,* 1599-1641, active in England from 1632

Lady Mary Villiers, later Duchess of Richmond and Lennox (1622-1685)
with Charles Hamilton, Lord Arran (d. 1640), C. 1636

OIL ON CANVAS, 83⅜ x 52⁹/₁₆ IN. (211.8 x 133.5 CM.)
GIFT OF MRS. THEODORE WEBB
52.17.1

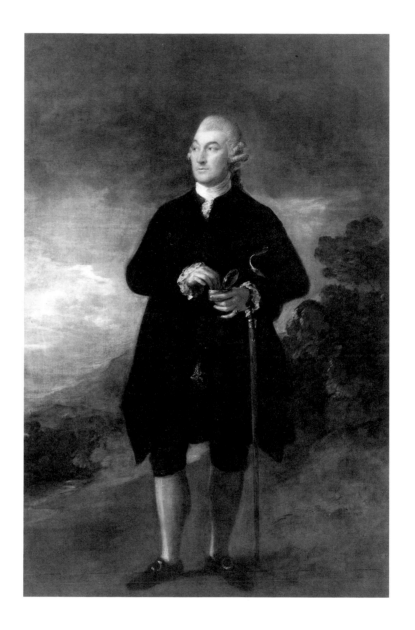

Thomas Gainsborough *British, 1727-1788*

Ralph Bell (1720-1801), 1772-74

Oil on canvas, 92¼ x 61⅛ in. (234.3 x 155.3 cm.)
Purchased with funds from the State of North Carolina
and the North Carolina Art Society (Robert F. Phifer Bequest)
52.9.70

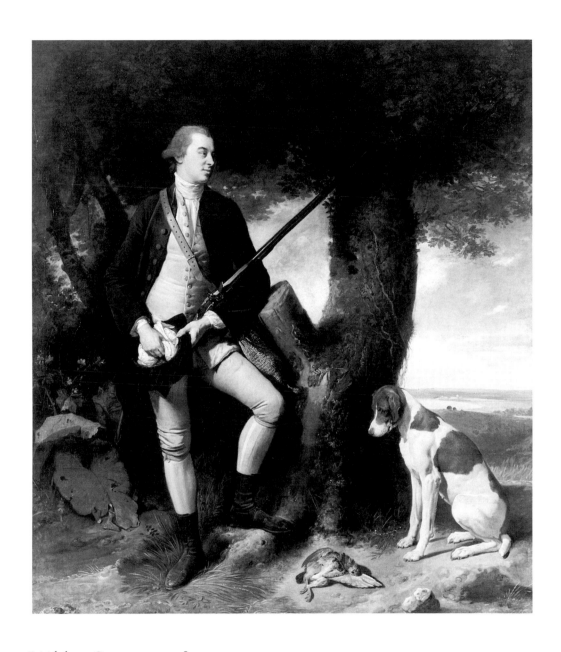

JOHANN ZOFFANY *British,* born Germany, 1733-1810

Oldfield Bowles (1740-1810), C. 1775-80

OIL ON CANVAS, 91 X 79 IN. (231.1 X 200.7 CM.)
PURCHASED WITH FUNDS FROM THE STATE OF NORTH CAROLINA
52.9.87

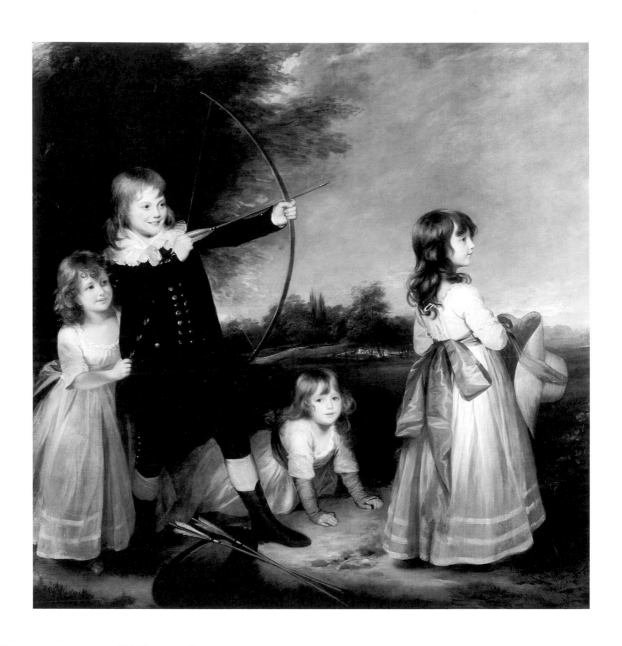

Sir William Beechey *British, 1753-1839*

The Oddie Children, 1789

Oil on canvas, 72 x 71⅞ in. (183.0 x 182.6 cm.)
Purchased with funds from the State of North Carolina
52.9.65

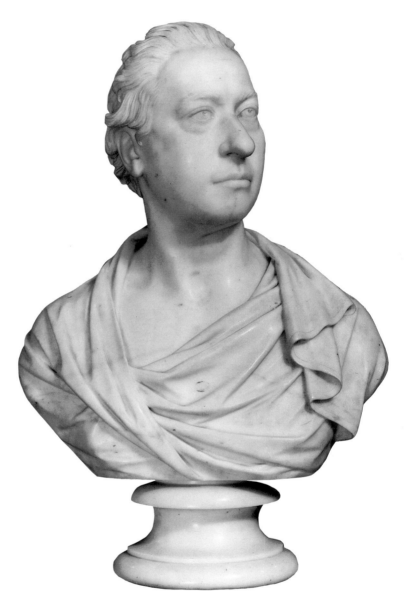

JOSEPH NOLLEKENS *British, 1737-1823*

William, 5th Duke of Devonshire (1749-1811), C. 1812

MARBLE, H. 26½ IN. (67.3 CM.)
GIFT OF MR. AND MRS. RALPH W. GARDNER
58.11.1

Sir Henry Raeburn *British, 1756-1823*

Thomas Robert Hay, 11th Earl of Kinnoull (1785-1866), 1815

Oil on canvas, 93½ x 59 in. (237.5 x 149.9 cm.)
Purchased with funds from the State of North Carolina
64.19.1

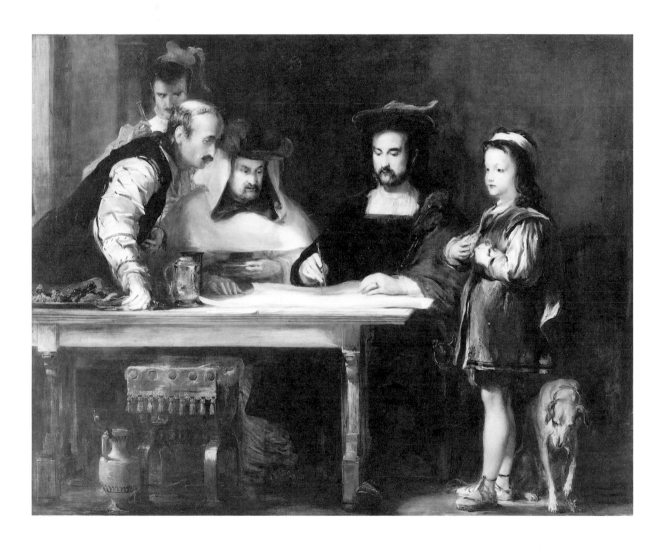

SIR DAVID WILKIE *British,* 1785-1841

Christopher Columbus in the Convent of La Rábida
Explaining His Intended Voyage, 1834

OIL ON CANVAS, 58½ x 74¼ IN. (148.6 x 188.6 CM.)
GIFT OF HIRSCHL & ADLER GALLERIES
57.17.1

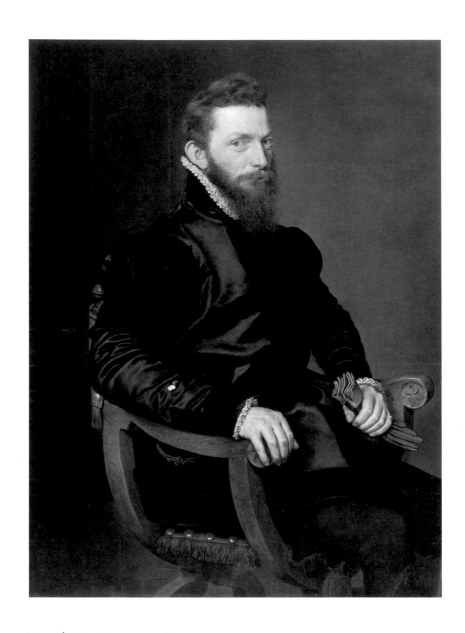

ANTONIS MOR (ANTONIO MORO) *Dutch, 1519-1576/77*

Portrait of a Gentleman, C. 1570

OIL ON PANEL, 48 X 35¼ IN. (122.0 X 89.5 CM.)
GIFT OF MR. AND MRS. RALPH C. PRICE
55.4.1

Esaias van de Velde *Dutch,* 1587-1630

Winter Scene, 1614

Oil on panel, 5 x 12⁵/₈ in. (12.7 x 31.9 cm.) (original dimensions; later enlarged)
Purchased with funds from the State of North Carolina
52.9.61

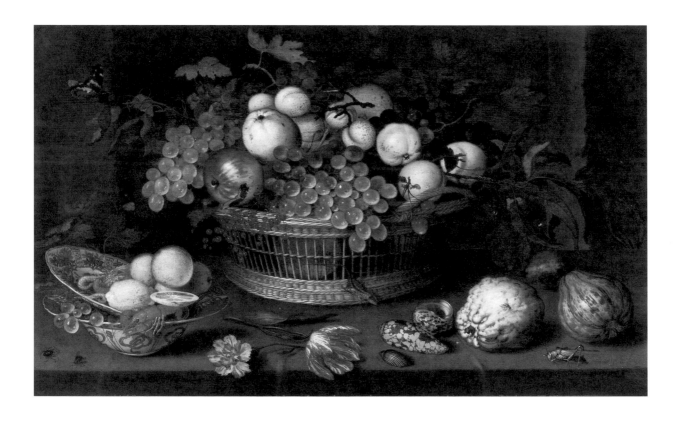

Balthasar van der Ast *Dutch,* 1593/94-1657

Still Life with a Basket of Fruit, 1622

OIL ON PANEL, 19½ x 32 IN. (49.5 x 81.3 CM.)
PURCHASED WITH FUNDS FROM THE STATE OF NORTH CAROLINA
52.9.197

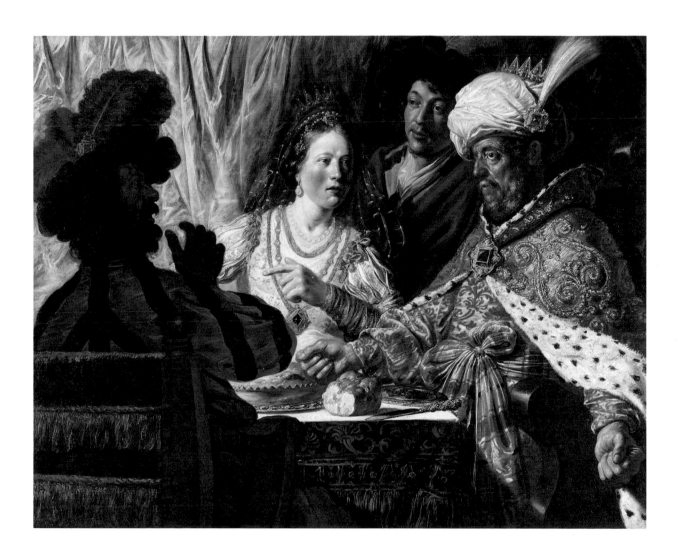

JAN LIEVENS *Dutch, 1607-1674*

The Feast of Esther, C. 1625-26

OIL ON CANVAS, 53 X 65 IN. (134.6 X 165.1 CM.)
PURCHASED WITH FUNDS FROM THE STATE OF NORTH CAROLINA
52.9.55

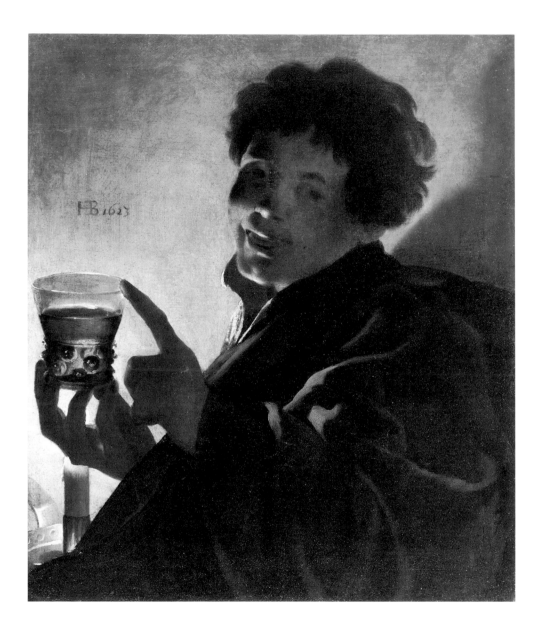

HENDRICK TER BRUGGHEN *Dutch, c. 1588-1629*

Boy with a Wineglass, 1623

OIL ON CANVAS, 26½ x 22¼ IN. (67.3 x 56.5 CM.)
GIFT OF DAVID M. KOETSER, IN HONOR OF W. R. VALENTINER
55.5.1

HENDRICK TER BRUGGHEN *Dutch*, c. 1588-1629

David Praised by the Israelite Women, 1623

OIL ON CANVAS, 32³/₁₆ x 41¹/₂ IN. (81.8 x 105.4 CM.)
GIFT OF THE SAMUEL H. KRESS FOUNDATION
60.17.66

Jan Jansz. den Uyl *Dutch, 1595/96-1639/40*

Vanitas Banquet Piece, c. 1635

Oil on panel, 31³/8 x 37 in. (79.7 x 94.0 cm.)
Purchased with funds from the State of North Carolina
52.9.43

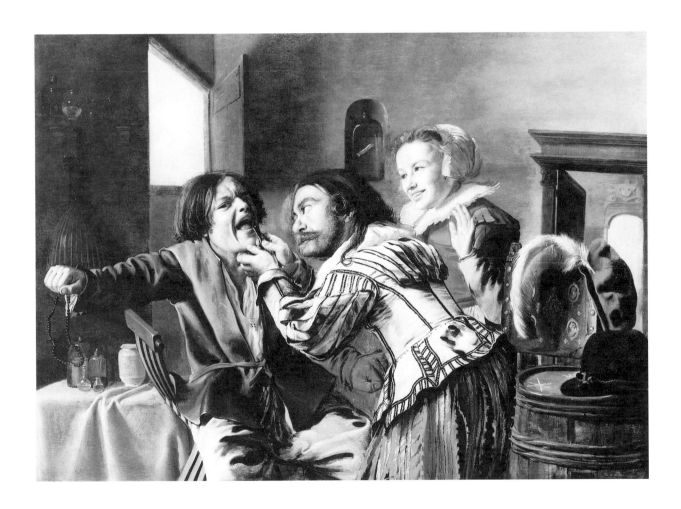

JAN MIENSE MOLENAER *Dutch, c. 1610-1668*

The Dentist, 1629

OIL ON PANEL, 23⅛ X 31⁹⁄₁₆ IN. (58.8 X 80.2 CM.)
PURCHASED WITH FUNDS FROM THE STATE OF NORTH CAROLINA
52.9.50

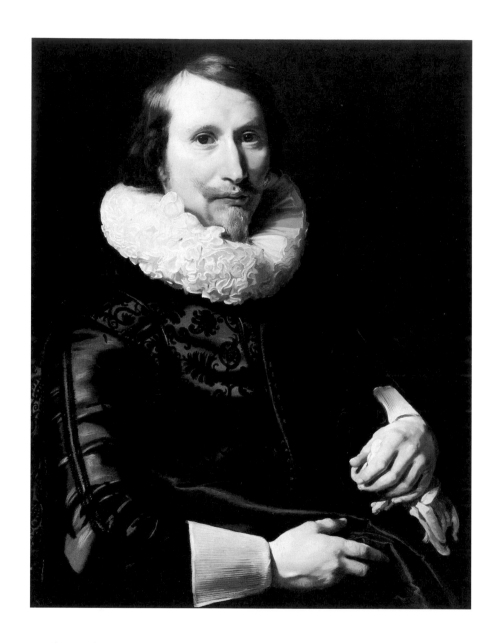

Thomas de Keyser *Dutch, 1596/7-1667*

Portrait of a Gentleman, c. 1626

Oil on panel, 28¼ x 21⅞ in. (71.8 x 55.6 cm.)
Anonymous gift
63.18.1

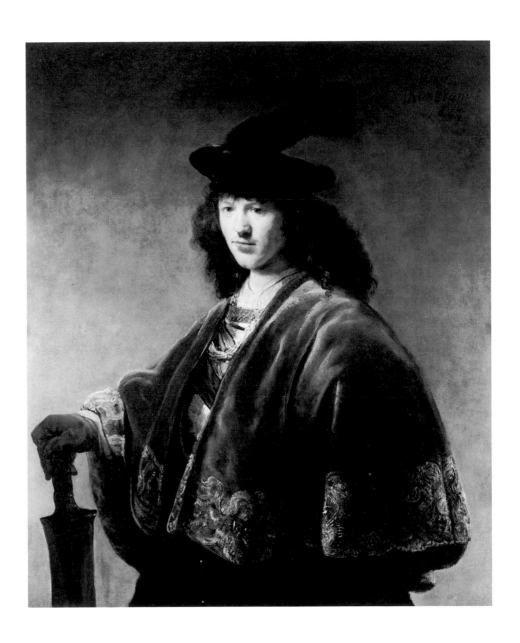

GOVERT FLINCK, attributed to *Dutch,* 1615-1660

Portrait of a Young Man with a Sword, c. 1635-40

OIL ON CANVAS, 46⁹/₁₆ x 38¹/₁₆ IN. (118.4 x 96.7 CM.)
GIFT OF THE SAMUEL H. KRESS FOUNDATION
60.17.68

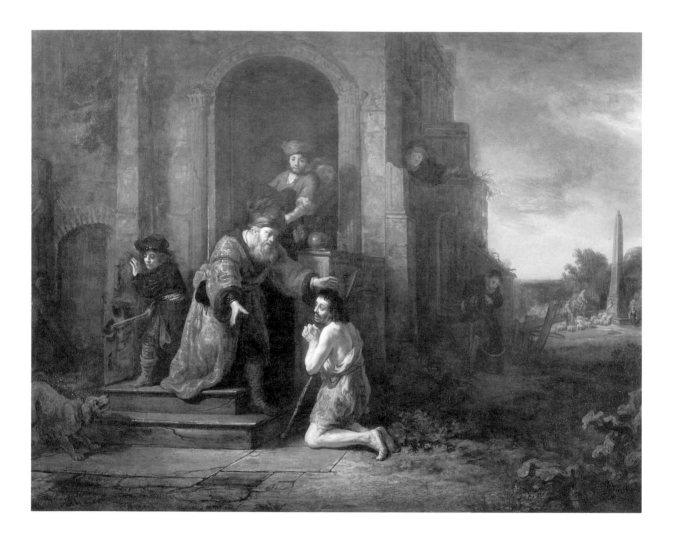

GOVERT FLINCK *Dutch,* 1615-1660

The Return of the Prodigal Son, C. 1640

OIL ON CANVAS, 52½ X 67 IN. (133.4 X 170.2 CM.)
PURCHASED WITH FUNDS FROM THE STATE OF NORTH CAROLINA
52.9.41

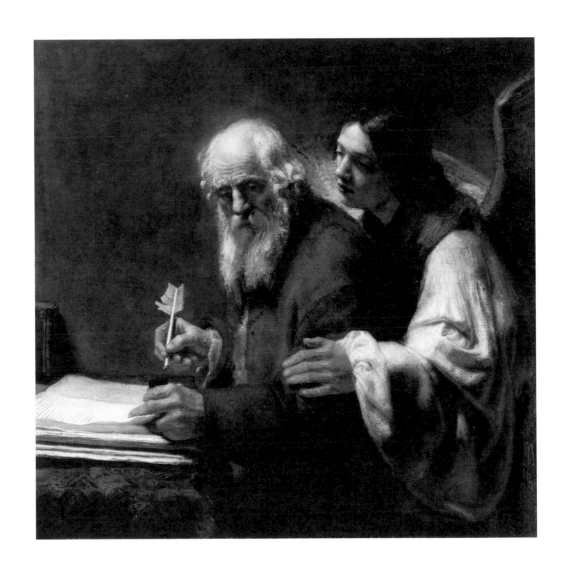

WILLEM DROST *Dutch,* active by 1652-AFTER 1680

St. Matthew and the Angel, C. 1650-60

OIL ON CANVAS, 42 X 42¹/₂ IN. (106.7 X 108.0 CM.)
PURCHASED WITH FUNDS FROM THE STATE OF NORTH CAROLINA AND PUBLIC SUBSCRIPTION
59.35.1

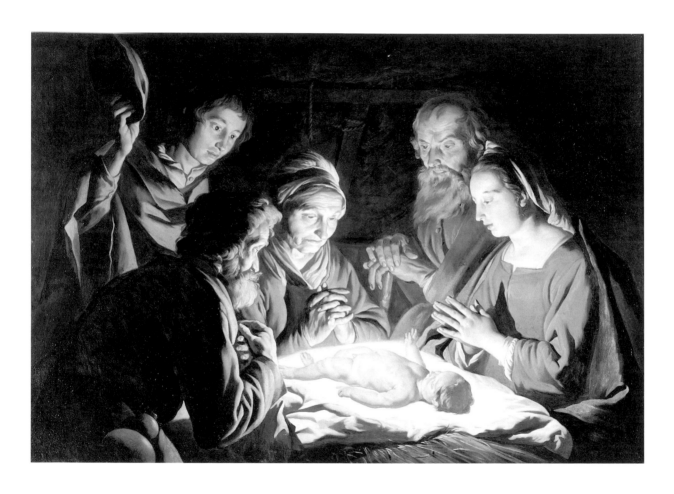

MATTHIAS STOMER (STOM) *Dutch,* c. 1600-after 1649, active in Italy from c. 1630

The Adoration of the Shepherds, c. 1640

OIL ON CANVAS, 44 X 63 IN. (111.8 X 160.0 CM.)
PURCHASED WITH FUNDS FROM THE STATE OF NORTH CAROLINA
52.9.59

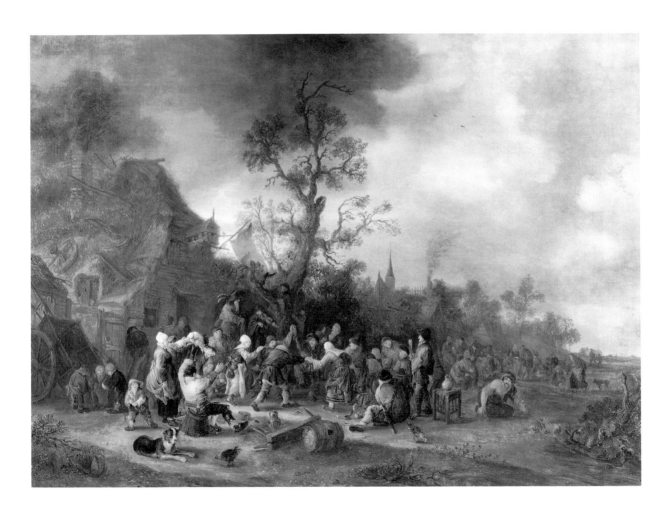

ISACK VAN OSTADE *Dutch*, 1621-1649

Peasants Gathered outside an Inn, C. 1642

OIL ON CANVAS, 42⁵/₁₆ X 58⁵/₈ IN. (107.5 X 149.0 CM.)
PURCHASED WITH FUNDS FROM THE STATE OF NORTH CAROLINA
52.9.53

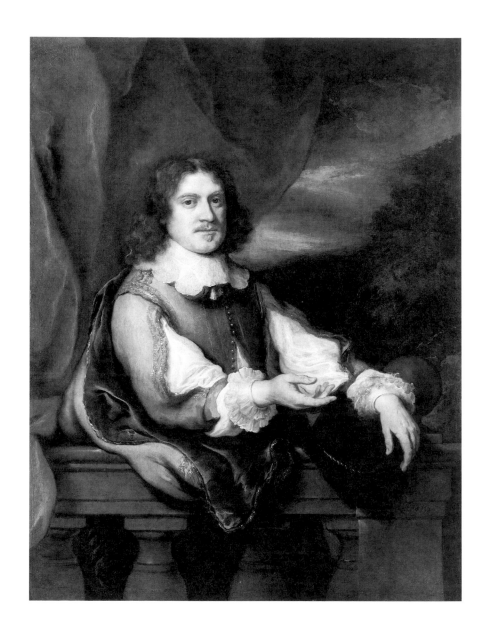

GOVERT FLINCK *Dutch, 1615-1660*

Portrait of a Gentleman, 1646

OIL ON CANVAS, 49 X 37 IN. (124.5 X 94.0 CM.)
PURCHASED WITH FUNDS FROM THE STATE OF NORTH CAROLINA
58.4.2

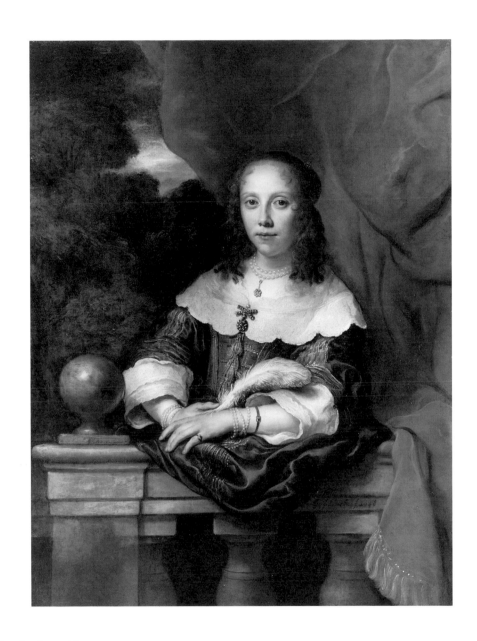

GOVERT FLINCK *Dutch, 1615-1660*

Portrait of a Lady, 1646

OIL ON CANVAS, 49 X 37 IN. (124.5 X 94.0 CM.)
PURCHASED WITH FUNDS FROM THE STATE OF NORTH CAROLINA
58.4.3

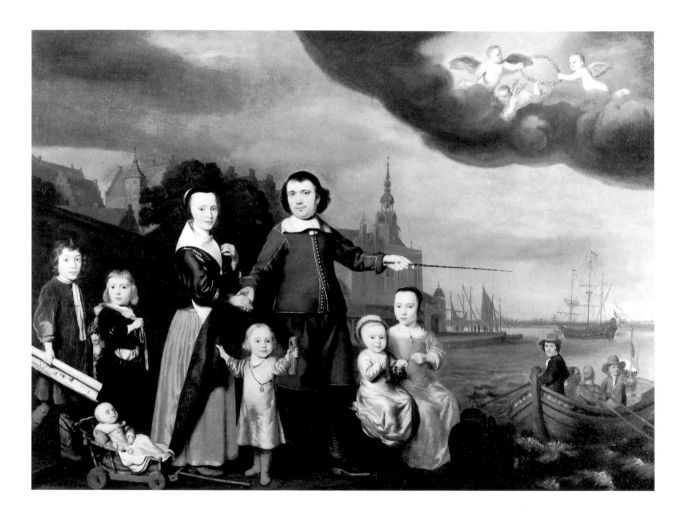

NICOLAES MAES *Dutch, 1634-1693*

Captain Job Jansse Cuyter and His Family, 1659

OIL ON CANVAS, 43½ X 60 IN. (110.5 X 152.4 CM.)
PURCHASED WITH FUNDS FROM THE STATE OF NORTH CAROLINA
52.9.47

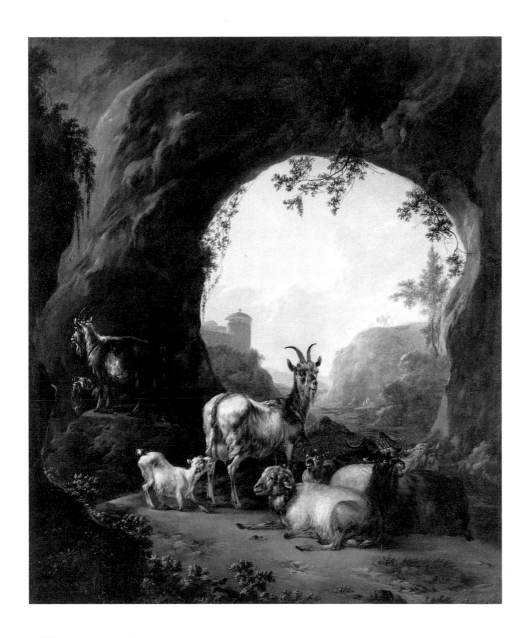

WILLEM BUYTEWECH THE YOUNGER *Dutch, 1625-1670*

Goats and Sheep in a Grotto, C. 1660-70

OIL ON CANVAS, 30¹/₁₆ X 25¹/₈ IN. (76.4 X 63.9 CM.)
PURCHASED WITH FUNDS FROM THE NORTH CAROLINA ART SOCIETY
(ROBERT F. PHIFER BEQUEST) AND THE LONDON MEMORIAL FUND,
IN HONOR OF THE LATE MAMIE ELLIOT LONDON (MRS. HENRY M. LONDON)
87.8

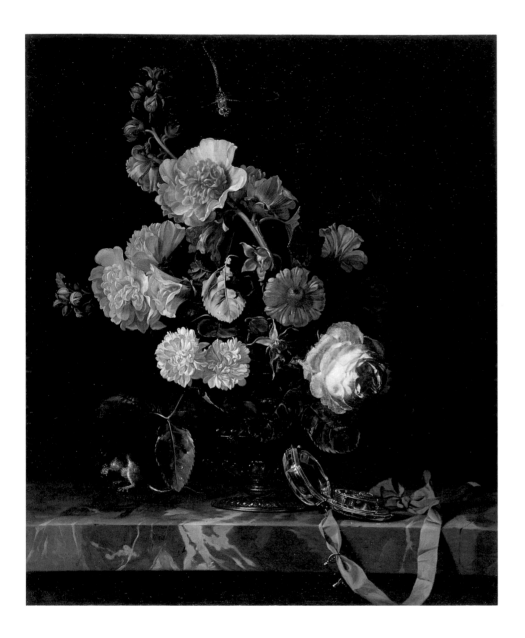

WILLEM VAN AELST *Dutch, 1625/26-after 1682*

Vanitas Flower Still Life, C. 1656

OIL ON CANVAS, 22 X 18¹/4 IN. (55.9 X 46.4 CM.)
PURCHASED WITH FUNDS FROM THE STATE OF NORTH CAROLINA
52.9.57

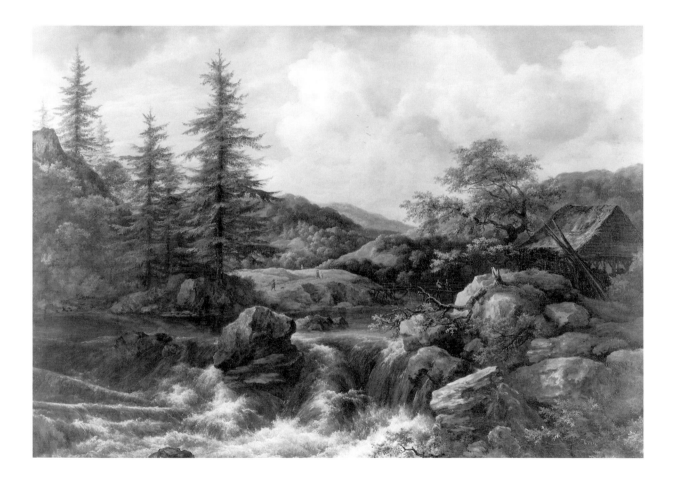
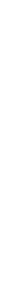

Jacob van Ruisdael *Dutch*, 1628/29-1682

Spruce Trees at a Waterfall, c. 1670

Oil on canvas, 41 x 56½ in. (104.1 x 143.5 cm.)
Purchased with funds from the State of North Carolina
52.9.56

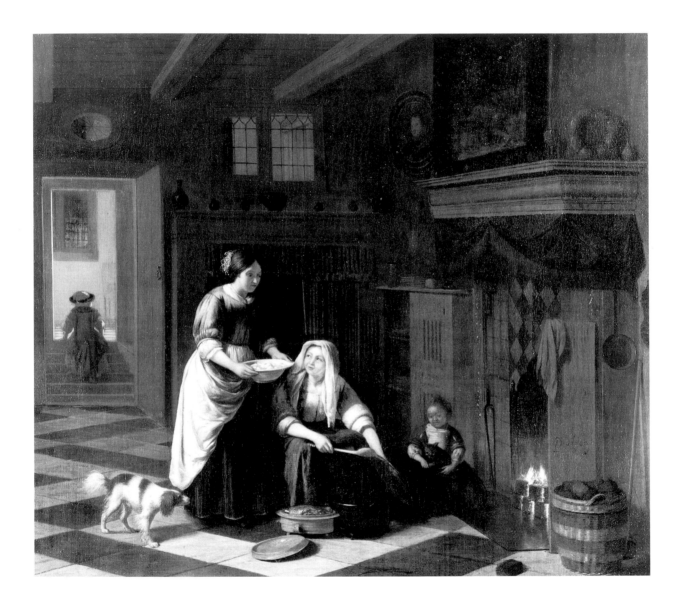

PIETER DE HOOCH *Dutch,* 1629-1684

The Fireside, C. 1670-75

OIL ON CANVAS, 25½ X 30¼ IN. (64.8 X 77.0 CM.)
PURCHASED WITH FUNDS FROM THE STATE OF NORTH CAROLINA
52.9.45

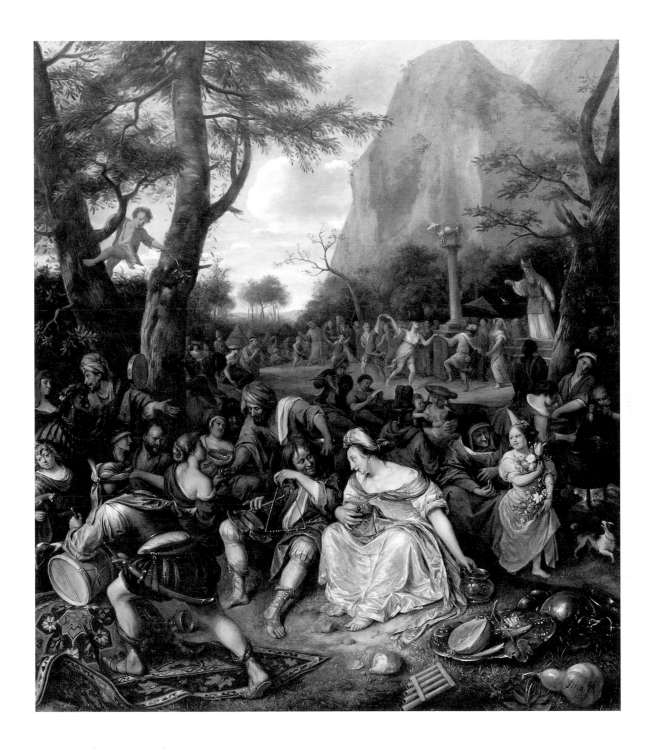

JAN STEEN *Dutch, 1625/26-1679*

The Worship of the Golden Calf, C. 1671-72

OIL ON CANVAS, 70¼ X 61¼ IN. (178.4 X 155.6 CM.)
PURCHASED WITH FUNDS FROM THE STATE OF NORTH CAROLINA
52.9.64

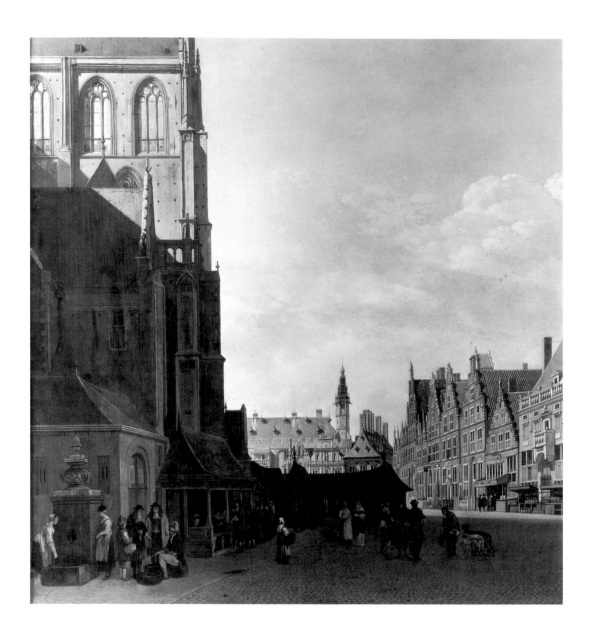

GERRIT BERCKHEYDE *Dutch,* 1638-1698

Fish Market, Haarlem, C. 1675-80

OIL ON PANEL, 17¾ X 16¾ IN. (45.1 X 42.6 CM.)
GIFT OF THE SAMUEL H. KRESS FOUNDATION
60.17.69

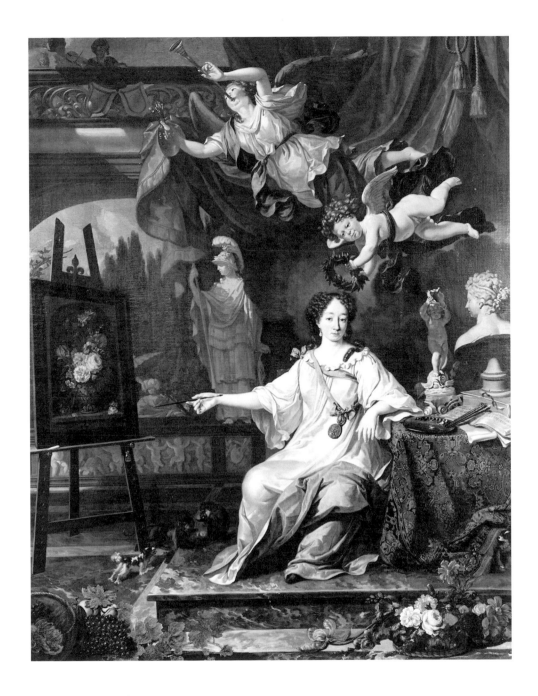

MICHIEL VAN MUSSCHER *Dutch,* 1645-1705

Allegorical Portrait of an Artist in Her Studio, C. 1680-85

OIL ON CANVAS, 44¹⁵/₁₆ X 35⁷/₈ IN. (114.2 X 91.0 CM.)
GIFT OF ARMAND AND VICTOR HAMMER
57.10.1

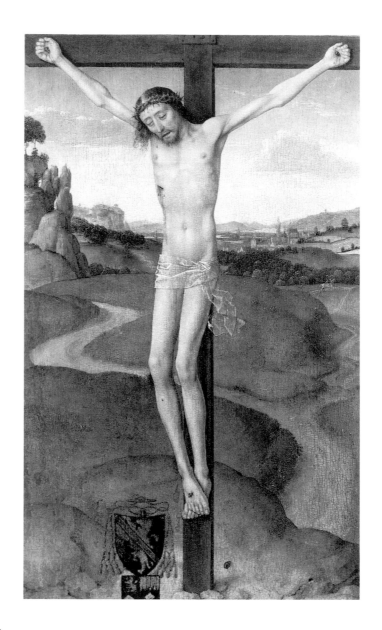

Hans Memling, attributed to *Flemish,* c. 1433-1494

Christus on the Cross, c. 1480

Oil on panel, 17¾ x 11 in. (45.0 x 28.0 cm.)
Purchased with funds from the State of North Carolina
52.9.102

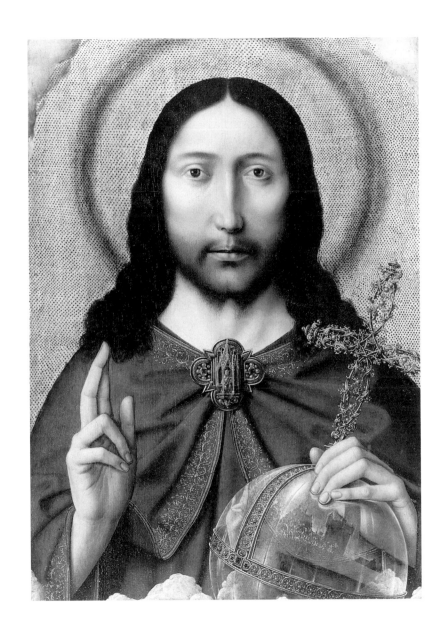

QUENTIN MASSYS AND STUDIO *Flemish,* 1465-1530

Salvator Mundi, C. 1500-1510

OIL ON PANEL, 21 X 14½ IN. (53.3 X 36.8 CM.)
GIFT OF THE SAMUEL H. KRESS FOUNDATION
60.17.62

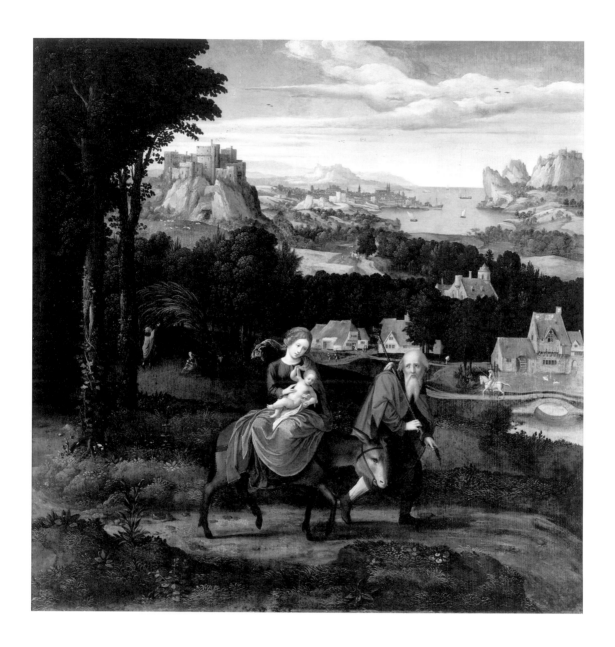

MASTER OF THE FEMALE HALF-LENGTHS *Flemish,* active c. 1525-50

The Flight into Egypt, c. 1530-35

OIL ON PANEL, 25³⁄₄ x 24⁷⁄₈ IN. (65.4 x 63.2 CM.)
PURCHASED WITH FUNDS FROM THE NORTH CAROLINA ART SOCIETY (ROBERT F. PHIFER BEQUEST)
52.9.105

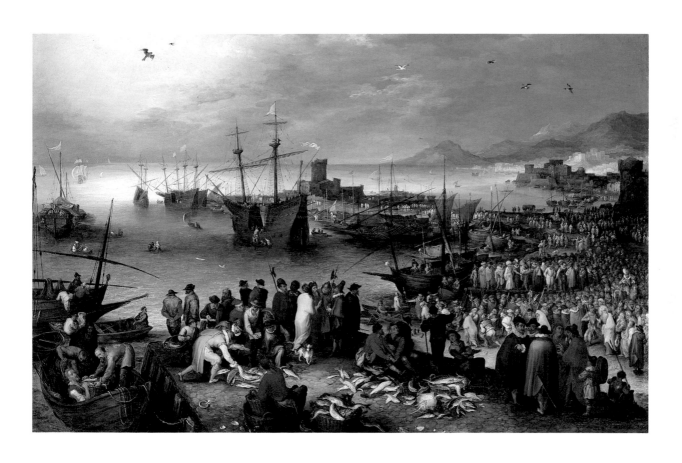

Jan Brueghel the Elder *Flemish, 1568-1625*

Harbor Scene with St. Paul's Departure from Caesarea, 1596

Oil on copper, 14¼ x 21½ in. (36.2 x 54.6 cm.)
Purchased with funds from the State of North Carolina
52.9.92

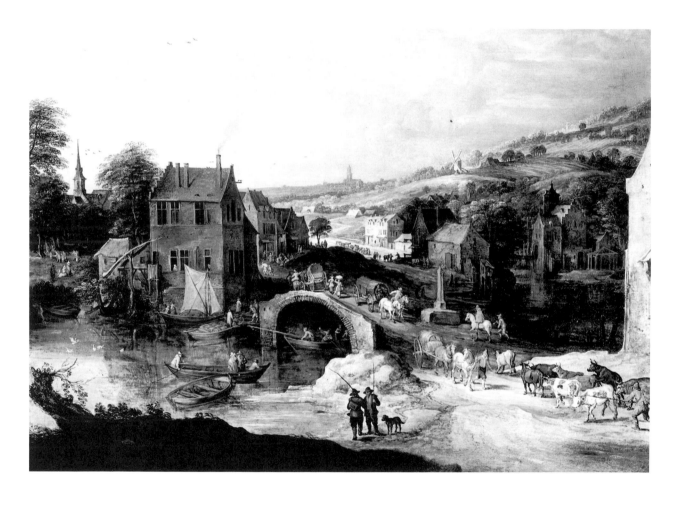

Joos de Momper *Flemish, 1564-1635*

Landscape with a Bridge, c. 1600

Oil on canvas, 52½ x 74 in. (133.4 x 188.0 cm.)
Purchased with funds from the State of North Carolina
52.9.103

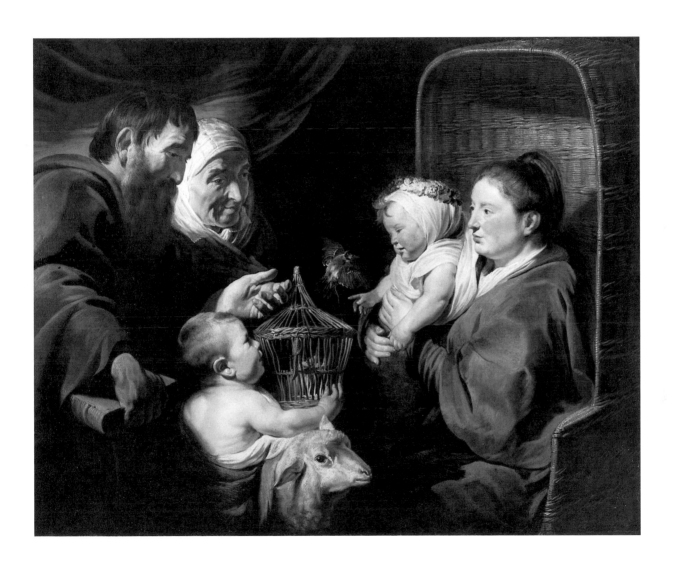

JACOB JORDAENS *Flemish, 1593-1678*

The Holy Family, C. 1615

OIL ON CANVAS, 46 x 56⅞ IN. (116.8 x 144.5 CM.)
PURCHASED WITH FUNDS FROM THE STATE OF NORTH CAROLINA
52.9.101

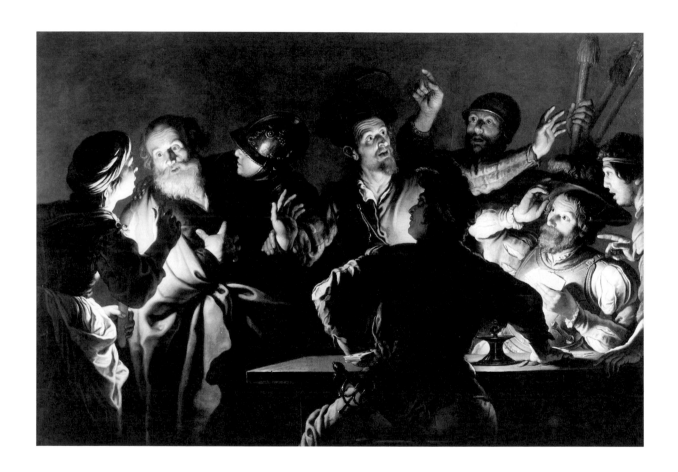

Gerard Seghers *Flemish*, 1591-1651

The Denial of St. Peter, c. 1620-25

Oil on canvas, 62 x 89⅝ in. (157.5 x 227.7 cm.)
Purchased with funds from the State of North Carolina
52.9.112

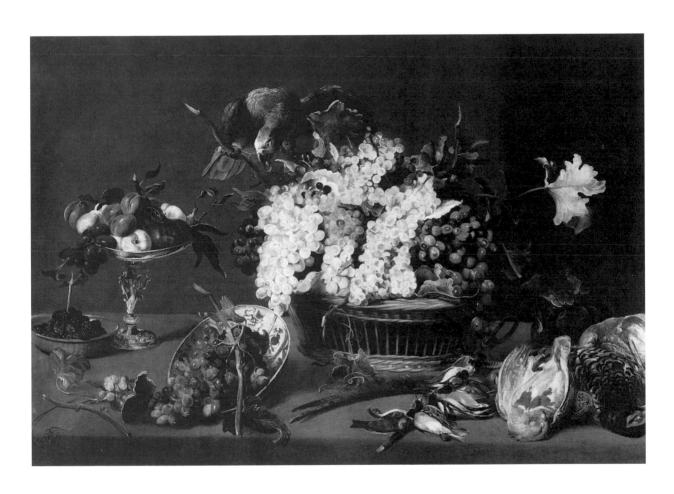

FRANS SNYDERS *Flemish, 1579-1657*

Still Life with a Gray Parrot, c. 1625-35

OIL ON CANVAS, 36⅝ x 53¹/₁₆ IN. (93.0 x 134.7 CM.)
PURCHASED WITH FUNDS FROM THE STATE OF NORTH CAROLINA
52.9.201

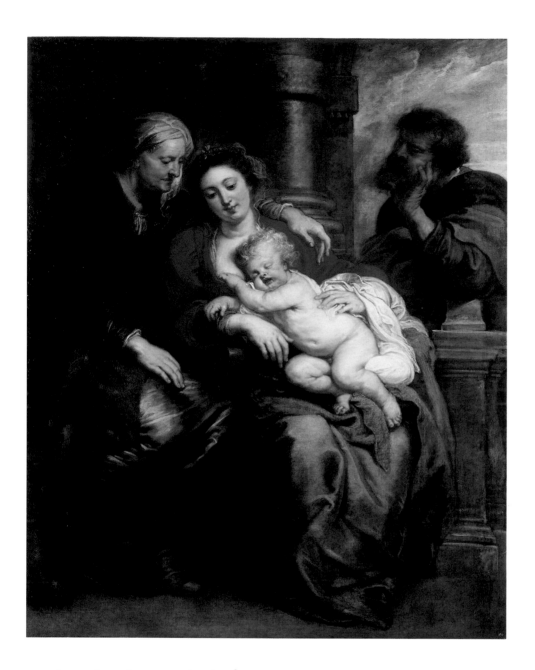

PETER PAUL RUBENS *Flemish, 1577-1640*

The Holy Family, C. 1633-35

OIL ON CANVAS, 68¾ X 56 IN. (174.6 X 142.2 CM.)
PURCHASED WITH FUNDS FROM THE STATE OF NORTH CAROLINA
52.9.107

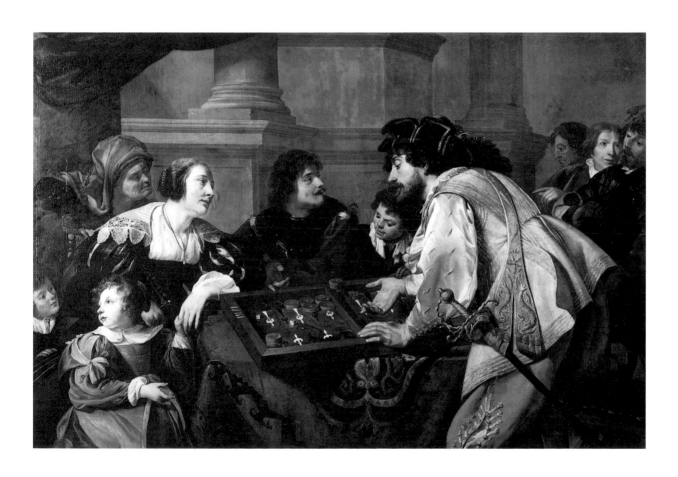

THEODOR ROMBOUTS *Flemish, 1597–1637*

The Backgammon Players, 1634

OIL ON CANVAS, 63¼ x 92⁷⁄₁₆ IN. (160.7 x 234.8 CM.)
GIFT OF E. GRAHAM FLANAGAN, CHARLES R. FLANAGAN,
AND MRS. ROSEMOND FLANAGAN WAGNER, IN MEMORY OF THEIR FATHER, E. G. FLANAGAN
52.2.1

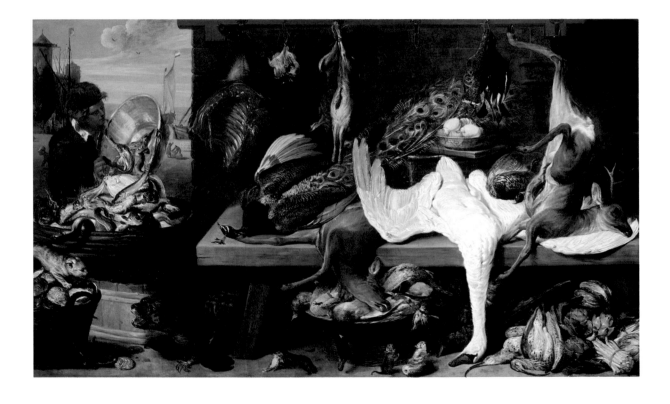

FRANS SNYDERS *Flemish*, 1579-1657

Market Scene on a Quay, C. 1635

OIL ON CANVAS, 79³/8 X 136 IN. (201.6 X 345.4 CM.)
PURCHASED WITH FUNDS FROM THE STATE OF NORTH CAROLINA
52.9.113

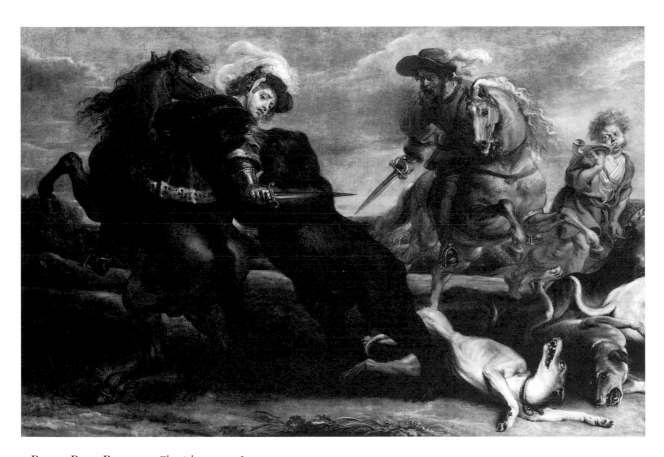

PETER PAUL RUBENS *Flemish, 1577-1640*
FRANS SNYDERS *Flemish, 1579-1657*

The Bear Hunt, 1639-40

OIL ON CANVAS, 51 X 77 IN. (129.5 X 195.5 CM.)
PURCHASED WITH FUNDS FROM THE STATE OF NORTH CAROLINA
52.9.108

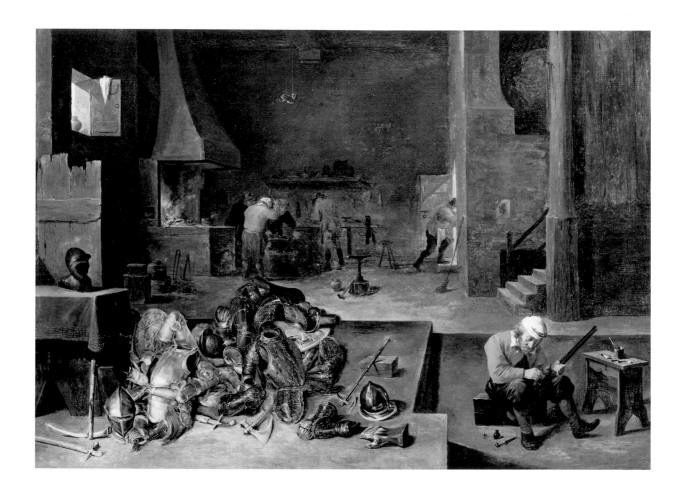

DAVID TENIERS II *Flemish, 1610-1690*

The Armorer's Shop, C. 1643

OIL ON PANEL, 22½ X 31⅞ IN. (57.1 X 80.9 CM.)
PURCHASED WITH FUNDS FROM THE STATE OF NORTH CAROLINA
52.9.116

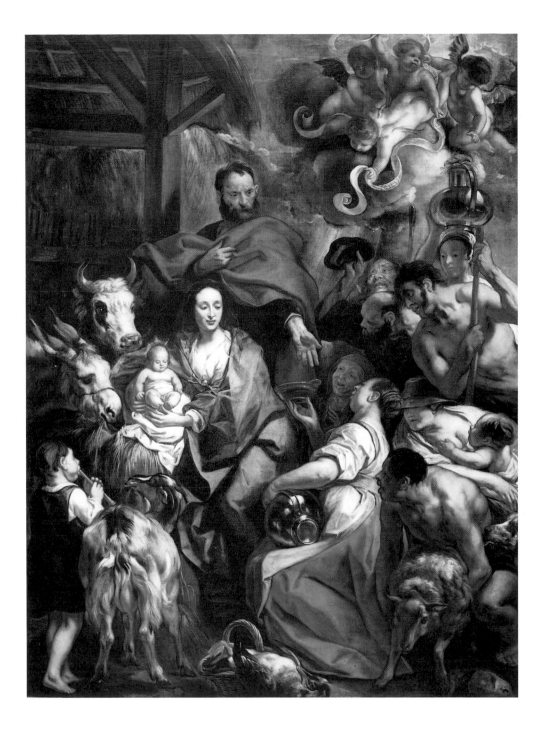

JACOB JORDAENS *Flemish, 1593-1678*

The Adoration of the Shepherds, 1657

OIL ON CANVAS, 106¼ X 81 IN. (270.0 X 205.7 CM.)
GIFT OF JOHN MOTLEY MOREHEAD
55.7.1

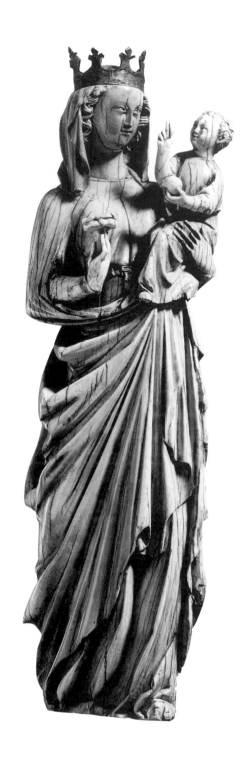

FRENCH, PARIS, LATE 13TH CENTURY

Madonna and Child, C. 1260-90

IVORY, METAL, H. 11¾ IN. (29.9 CM.)
GIFT OF MRS. EDSEL FORD, IN MEMORY OF W. R. VALENTINER
59.6.1

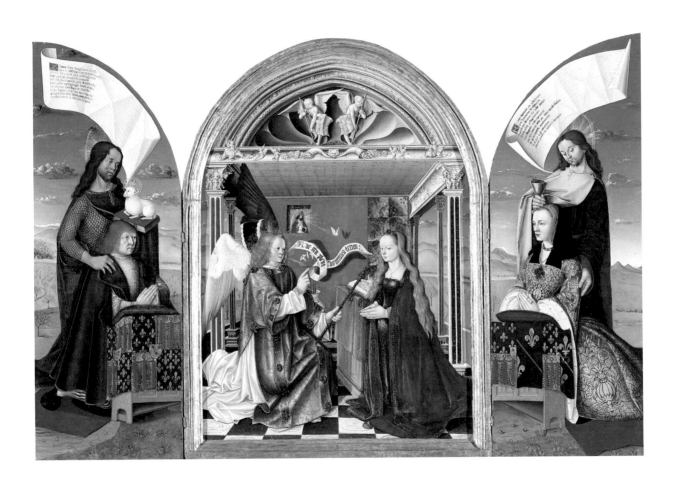

MASTER OF THE LATOUR D'AUVERGNE TRIPTYCH *French*, active c. 1490–1500

The Annunciation with Saints and Donors, called *The Latour d'Auvergne Triptych,* c. 1497

OIL ON PANEL, CENTER 28³/₄ X 19⁷/₁₆ IN. (73 X 49.4 CM.), WINGS (EACH) 26¹/₂ X 9³/₈ IN. (67.3 X 23.6 CM.)
GIFT OF THE SAMUEL H. KRESS FOUNDATION
60.17.61

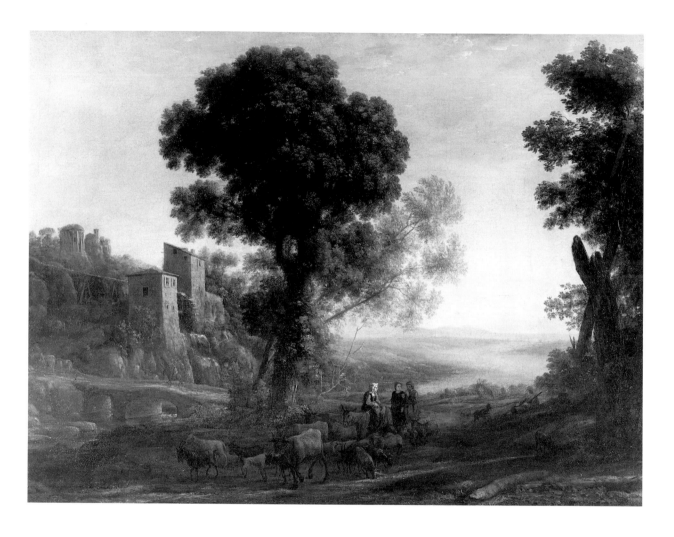

CLAUDE LORRAIN (CLAUDE GELLÉE) *French,* 1600-1682, active in Italy

Landscape with Peasants Returning with Their Herds, C. 1637

OIL ON CANVAS, 29¼ X 39 IN. (74.3 X 99.1 CM.)
PURCHASED WITH FUNDS FROM THE STATE OF NORTH CAROLINA
52.9.125

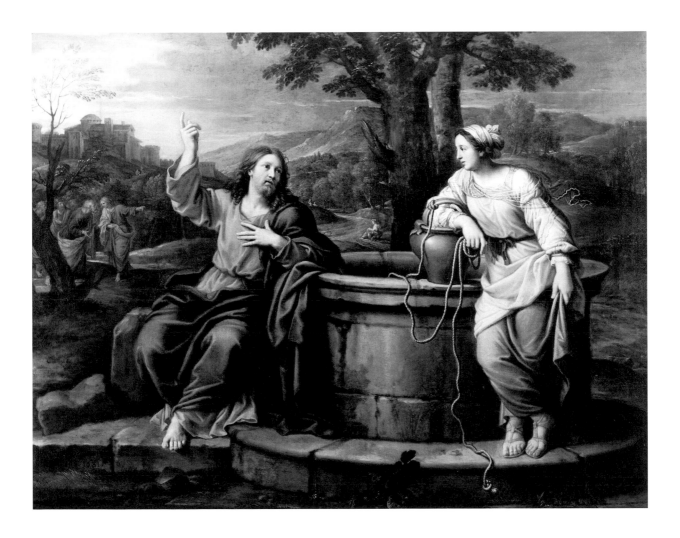

PIERRE MIGNARD *French,* 1612-1695, active in Rome 1635-57

Christ and the Woman of Samaria, 1681

OIL ON CANVAS, 48 X 63 IN. (121.9 X 160.0 CM.)
PURCHASED WITH FUNDS FROM THE STATE OF NORTH CAROLINA
52.9.127

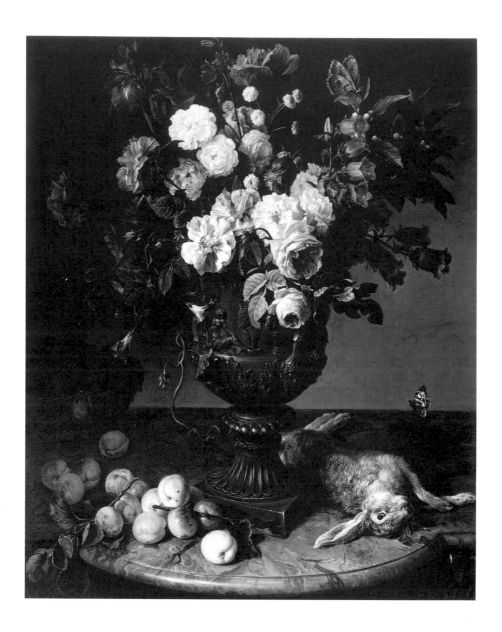

François Desportes *French, 1661-1743*

Urn of Flowers with a Rabbit, 1715

Oil on canvas, 40 x 32 in. (101.6 x 81.3 cm.)
Purchased with funds from the State of North Carolina
52.9.123

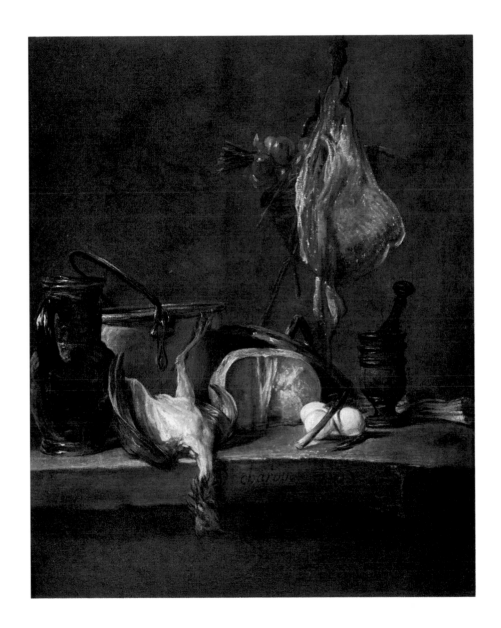

Jean Siméon Chardin *French, 1699-1779*

Still Life with Ray Fish and a Basket of Onions, 1731

Oil on canvas, 16 x 12⁵/8 in. (40.6 x 32.0 cm.)
Purchased with funds from the State of North Carolina
63.29.1

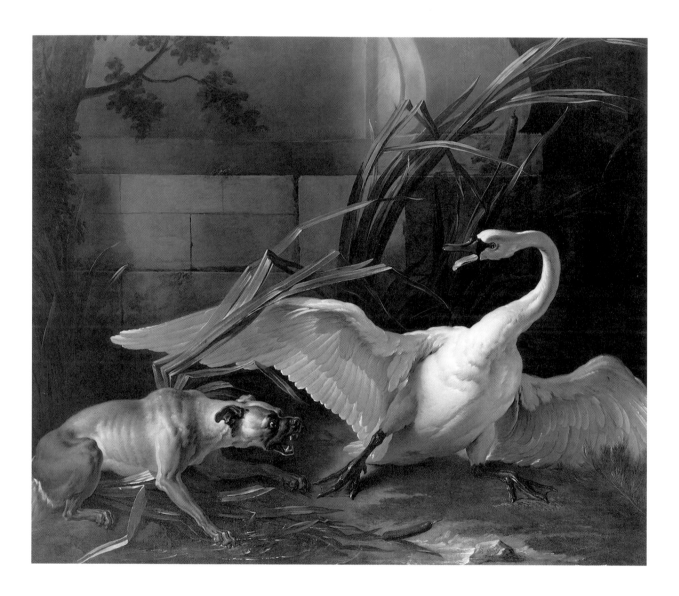

Jean-Baptiste Oudry *French*, 1686-1755

Swan Frightened by a Dog, 1745

Oil on canvas, 70 x 82 in. (177.8 x 208.3 cm.)
Purchased with funds from the North Carolina Art Society
(Robert F. Phifer Bequest)
52.9.131

see cover

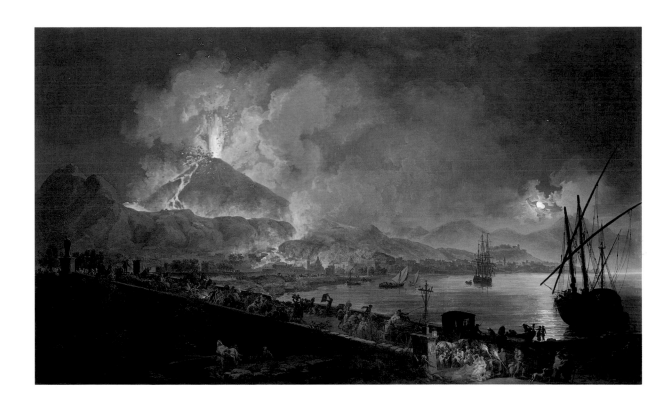

PIERRE-JACQUES VOLAIRE *French,* 1729-before 1802

The Eruption of Mt. Vesuvius, 1777

OIL ON CANVAS, 53¹/₈ X 89 IN. (135.0 X 226.0 CM.)
PURCHASED WITH FUNDS FROM THE ALCY C. KENDRICK BEQUEST
AND FROM THE STATE OF NORTH CAROLINA, BY EXCHANGE
82.1

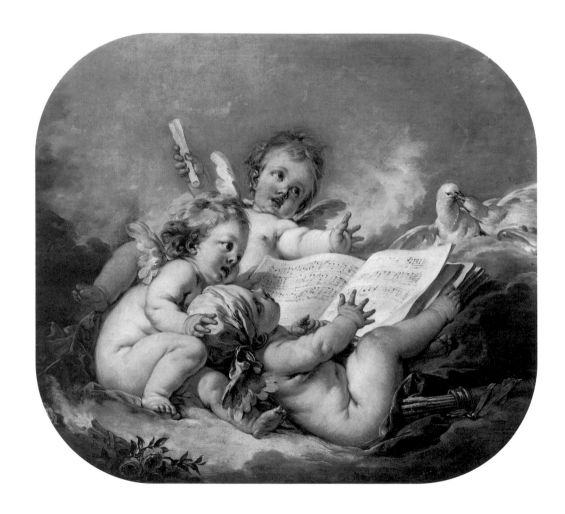

François Boucher *French, 1703-1770*

Allegory of Music, 1752

Oil on canvas, 26½ x 30 in. (67.3 x 76.2 cm.)
Purchased with funds from the State of North Carolina
52.9.118

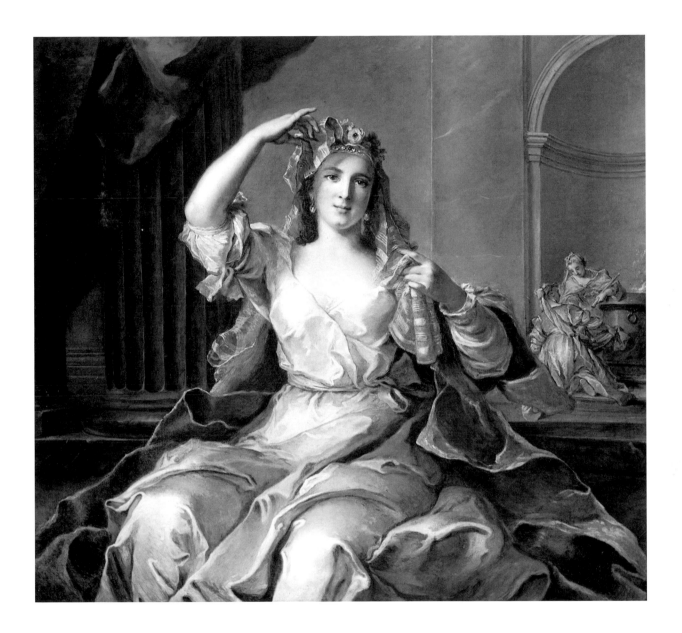

JEAN-MARC NATTIER *French, 1685-1766*

Portrait of a Lady as a Vestal Virgin, 1759

OIL ON CANVAS, 45½ x 53½ IN. (115.6 x 135.9 CM.)
PURCHASED WITH FUNDS FROM THE STATE OF NORTH CAROLINA
52.9.130

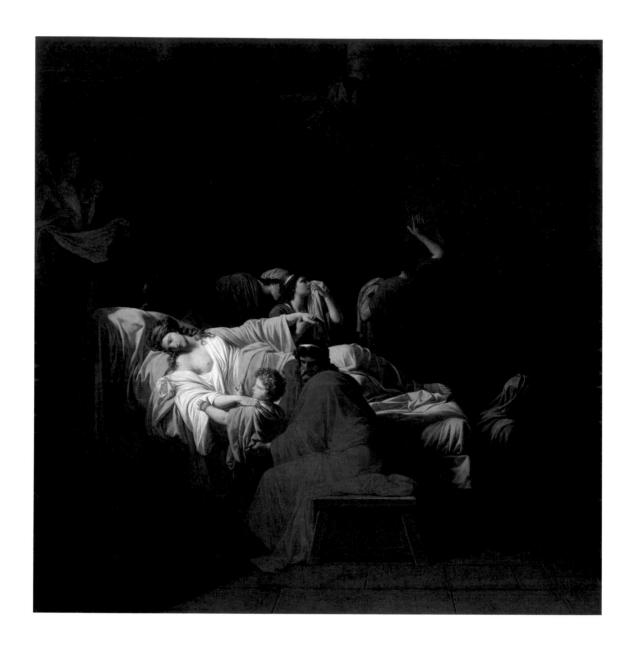

PIERRE PEYRON *French, 1744-1814*

The Death of Alcestis, 1794

OIL ON CANVAS, 38 X 38¼ IN. (96.5 X 97.0 CM.)
PURCHASED WITH FUNDS FROM VARIOUS DONORS, BY EXCHANGE
91.1

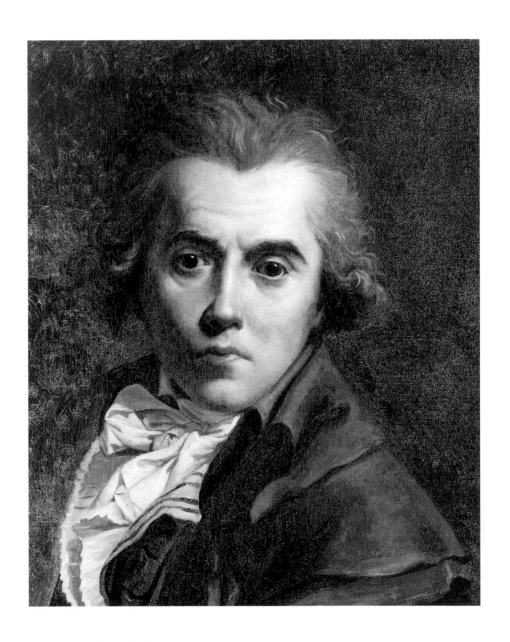

JACQUES-LOUIS DAVID, STUDIO OF *French,* 1748-1825

Copy after David's *Self-Portrait,* C. 1790-1800

OIL ON CANVAS, 19 X 15 IN. (48.3 X 38.1 CM.)
PURCHASED WITH FUNDS FROM THE STATE OF NORTH CAROLINA
52.9.122

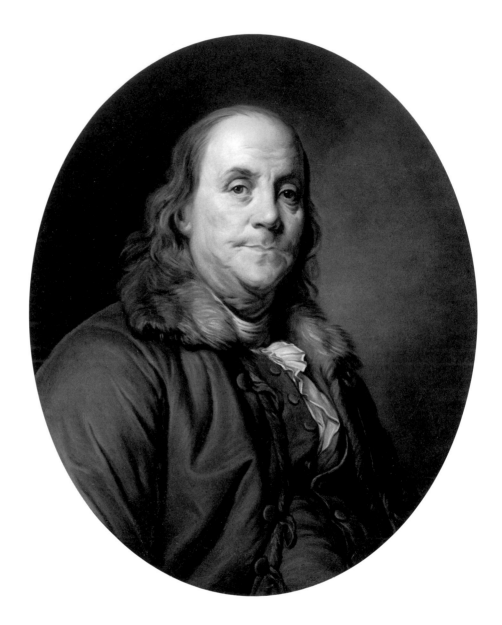

JOSEPH-SIFFRED DUPLESSIS *French,* 1725-1802

Benjamin Franklin (1706-1790), C. 1779

OIL ON CANVAS, 28⅝ X 23 IN. (72.7 X 58.4 CM.)
GIFT OF THE NORTH CAROLINA CITIZENS ASSOCIATION
75.26.1

ELISABETH LOUISE VIGÉE-LEBRUN *French, 1755-1842*

Count Ivan Ivanovitch Chouvaloff (1717-1797), C. 1795-97

OIL ON CANVAS, 33 X 24 IN. (83.8 X 61.0 CM.)
PURCHASED WITH FUNDS FROM THE STATE OF NORTH CAROLINA
52.9.224

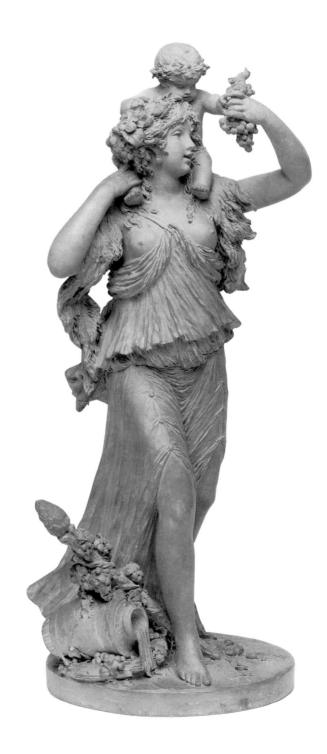

JOSEPH-CHARLES MARIN *French, 1759-1834*

Bacchante Carrying a Child on Her Shoulder, C. 1780-96

TERRACOTTA, H. 27⅝ IN. (70.0 CM.)
PURCHASED WITH FUNDS FROM THE STATE OF NORTH CAROLINA
85.3

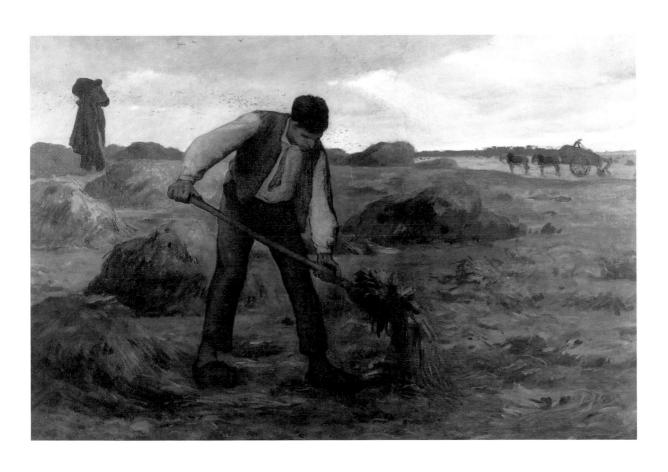

Jean-François Millet *French, 1814-1875*

Peasant Spreading Manure, 1854-55

Oil on canvas, 32 x 44 in. (81.3 x 111.8 cm.)
Purchased with funds from the North Carolina Art Society (Robert F. Phifer Bequest)
52.9.128

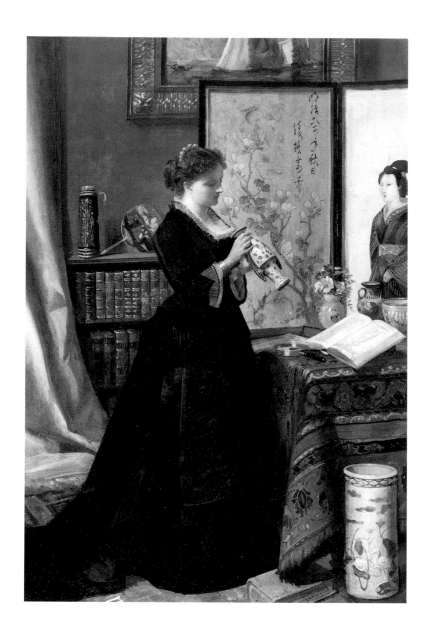

ALFRED STEVENS *Belgian,* 1823-1906, active in France from 1852

The Porcelain Collector, 1868

OIL ON CANVAS, 26⅞ x 18 IN. (68.3 x 45.7 CM.)
GIFT OF DR. AND MRS. HENRY C. LANDON III
81.11.1

Albert-Ernest Carrier-Belleuse *French,* 1824-1887

Printemps-La Rose (Margaret de Longée), c. 1870-75

Terracotta, h. 24½ in. (62.2 cm.)
Purchased with funds from the Lady Marcia Cunliffe-Owen Bequest
and the State of North Carolina
81.1.1

EUGÈNE BOUDIN *French, 1824-1898*

Trouville, The Jetties, High Tide, 1876

OIL ON CANVAS, 12¼ X 17¾ IN. (31.1 X 45.1 CM.)
GIFT OF THE NORTH CAROLINA NATIONAL BANK
67.12.1

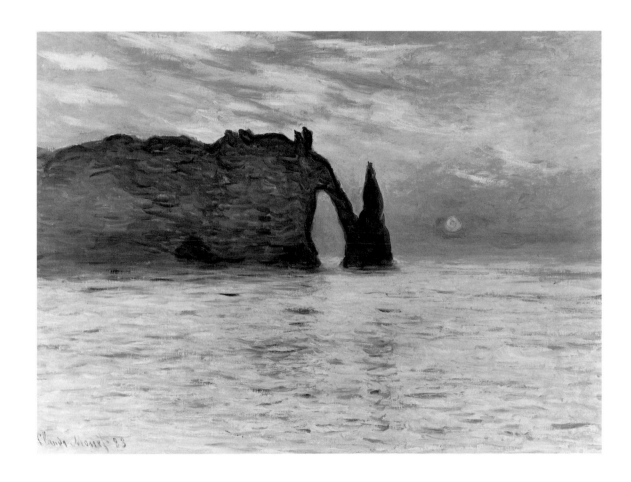

CLAUDE MONET *French, 1840-1926*

The Cliff, Etretat, Sunset, 1883

OIL ON CANVAS, 21³/₄ X 31³/₄ IN. (55.3 X 80.7 CM.)
PURCHASED WITH FUNDS FROM THE STATE OF NORTH CAROLINA
67.24.1

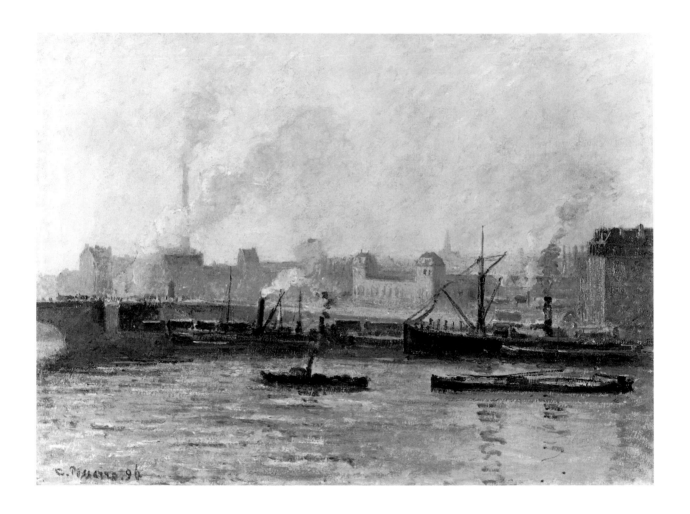

CAMILLE PISSARRO *French, 1831-1903*

The St. Sever Bridge from Rouen, Fog, 1896

OIL ON CANVAS, 23³/₄ X 34¹/₄ IN. (60.0 X 87.0 CM.)
GIFT OF WACHOVIA BANK AND TRUST COMPANY
67.26.1

CAROLUS-DURAN (CHARLES-EMILE-AUGUSTE DURAND) *French, 1838-1917*

Madame Carolus-Duran, 1885

OIL ON CANVAS, 39¹/₂ X 27³/₄ IN. (100.0 X 70.5 CM.)
PURCHASED WITH FUNDS FROM THE NORTH CAROLINA ART SOCIETY
(ROBERT F. PHIFER BEQUEST), IN HONOR OF ZOË STRAWN WEBSTER
83.6

CLAUDE MONET *French,* 1840-1926

The Seine at Giverny, Morning Mists, 1897

OIL ON CANVAS, 35 X 36 IN. (89.0 X 91.4 CM.)
PURCHASED WITH FUNDS FROM THE NORTH CAROLINA ART SOCIETY
(ROBERT F. PHIFER BEQUEST) AND THE SARAH GRAHAM KENAN FOUNDATION
75.24.1

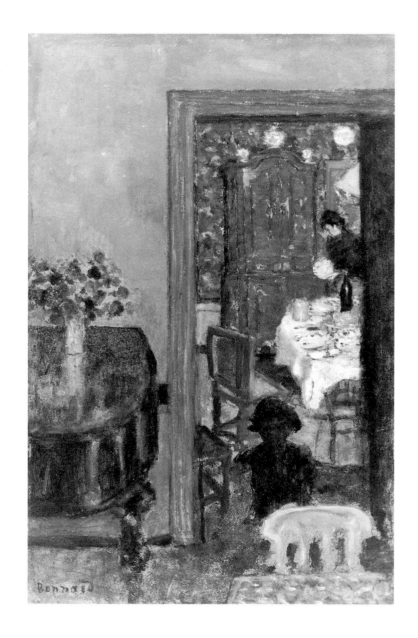

PIERRE BONNARD *French,* 1867-1947

The Lessons, 1898

OIL ON BOARD, 20¼ X 13¼ IN. (52.4 X 33.7 CM.)
PURCHASED WITH FUNDS FROM THE STATE OF NORTH CAROLINA
72.1.3

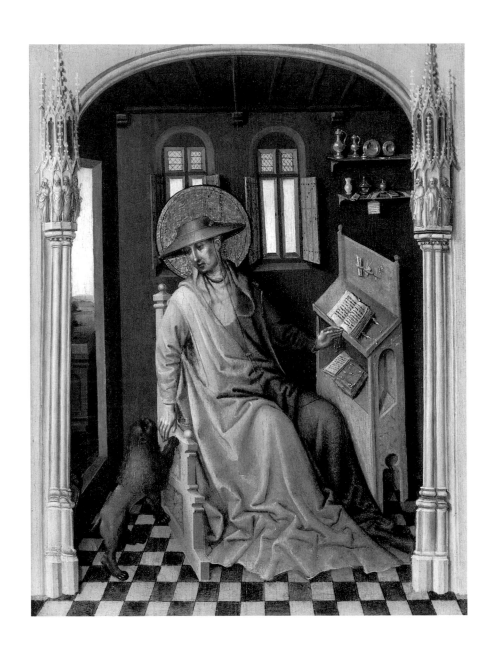

STEFAN LOCHNER, attributed to *German,* active c. 1400-1451

St. Jerome in His Study, c. 1440

OIL ON PANEL, 15½ x 12 IN. (39.4 x 30.5 CM.)
PURCHASED WITH FUNDS FROM THE NORTH CAROLINA ART SOCIETY
(ROBERT F. PHIFER BEQUEST)
52.9.139

LUCAS CRANACH THE ELDER *German, 1472-1553*

Madonna and Child in a Landscape, C. 1518

OIL ON PANEL, 16½ X 10¼ IN. (41.9 X 26.0 CM.)
GIFT OF MRS. GEORGE KHUNER
64.35.1

PETER KOELLIN, attributed to *German*, active c. 1450-75

Madonna and Child Sheltering Supplicants under Her Cloak, c. 1470

LINDEN WOOD WITH GESSO AND POLYCHROME, H. 57 IN. (144.8 CM.)
GIFT OF R. J. REYNOLDS INDUSTRIES, INC.
61.13.1

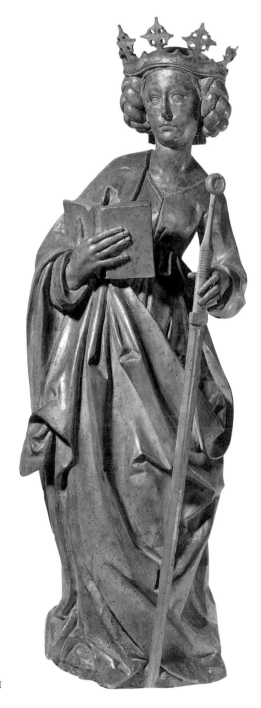

TILMANN RIEMENSCHNEIDER *German, c. 1460-1531*

Female Saint, c. 1505-10

LINDEN WOOD WITH TRACES OF PIGMENT (SWORD ADDED LATER), H. 38 IN. (96.5 CM.)
PURCHASED WITH FUNDS FROM THE STATE OF NORTH CAROLINA
68.33.1

PETER GAERTNER *German,* active 1524-37

Portrait of a Man, 1524

OIL ON PANEL, 19 X 13 IN. (48.3 X 33.0 CM.)
PURCHASED WITH FUNDS FROM THE STATE OF NORTH CAROLINA
52.9.138

HANS MIELICH *German, 1516-1573*

Portrait of a Man, 1543

OIL ON PANEL, 25½ x 19 IN. (64.8 x 48.3 CM.)
PURCHASED WITH FUNDS FROM THE STATE OF NORTH CAROLINA
52.9.140

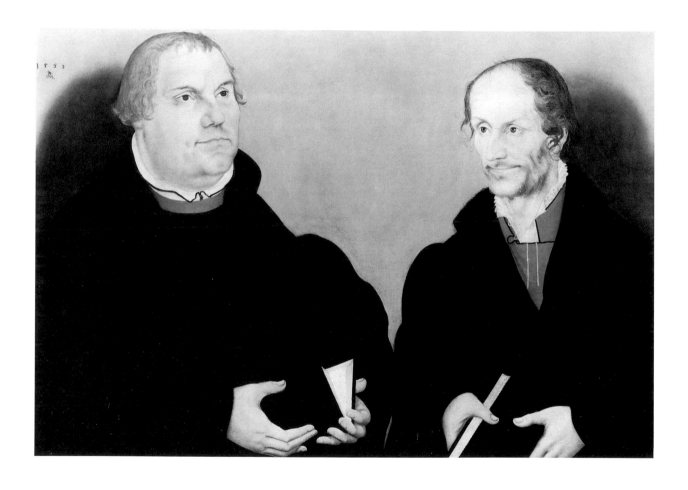

LUCAS CRANACH THE YOUNGER *German, 1515-1586*

Martin Luther (1483-1546) and Philipp Melanchthon (1497-1560), 1558

OIL ON PEAR WOOD, 24¹⁄₈ X 34⁷⁄₈ IN. (61.2 X 88.5 CM.)
GIFT OF THE SAMUEL H. KRESS FOUNDATION
60.17.65

GERMAN, BAVARIAN

Adoring Angel, C. 1735-60

WOOD, POLYCHROME, AND GOLD LEAF, 41¼ x 31 IN. (104.8 x 78.7 CM.)
GIFT OF THE MARY DUKE BIDDLE FOUNDATION
62.18.1

BERLINGHIERO, SCHOOL OF *Italian,* active c. 1215–before 1243

Madonna and Child, c. 1220–40

TEMPERA AND GOLD LEAF ON PANEL, 28¼ x 19¼ IN. (71.8 x 48.9 CM.)
GIFT OF WACHOVIA BANK AND TRUST COMPANY
57.16.1

Tino da Camaino *Italian, c. 1285-1337*

Madonna and Child, c. 1317-20

Marble, 18 x 19½ in. (45.7 x 49.5 cm.)
Gift of the Samuel H. Kress Foundation
60.17.4

Segna di Bonaventura *Italian*, active by 1298–before 1331

Madonna and Child, c. 1320-30

Tempera and gold leaf on panel, 35³/8 x 22¹/4 in. (89.9 x 56.5 cm.)
Gift of the Samuel H. Kress Foundation
60.17.1

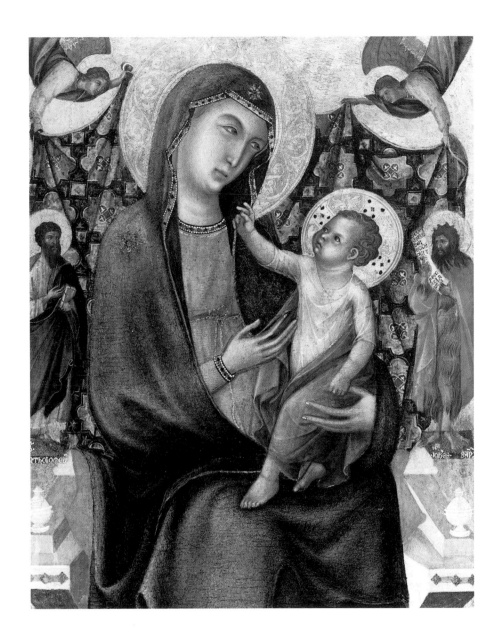

MASTER OF SAN TORPÈ, attributed to *Italian,* active C. 1290–C. 1320

Madonna and Child with St. Bartholomew and St. John the Baptist, C. 1320

TEMPERA AND GOLD LEAF ON PANEL, TRANSFERRED TO CANVAS, 19¹¹/₁₆ X 15¹/₂ IN. (50.0 X 39.4 CM.)
GIFT OF THE SAMUEL H. KRESS FOUNDATION
60.17.3

GIOTTO DI BONDONE AND ASSISTANTS *Italian, c. 1266-1336*

The "Peruzzi Altarpiece," C. 1322

TEMPERA AND GOLD LEAF ON PANEL, 41½ x 98½ IN. (105.4 x 250.2 CM.)
GIFT OF THE SAMUEL H. KRESS FOUNDATION
60.17.7

GIOTTO DI BONDONE AND ASSISTANTS *Italian,* c. 1266-1336

St. Francis, from the *"Peruzzi Altarpiece,"* c. 1322

TEMPERA AND GOLD LEAF ON PANEL, 24½ x 16½ IN. (62.3 x 42.0 CM.)
GIFT OF THE SAMUEL H. KRESS FOUNDATION
60.17.7

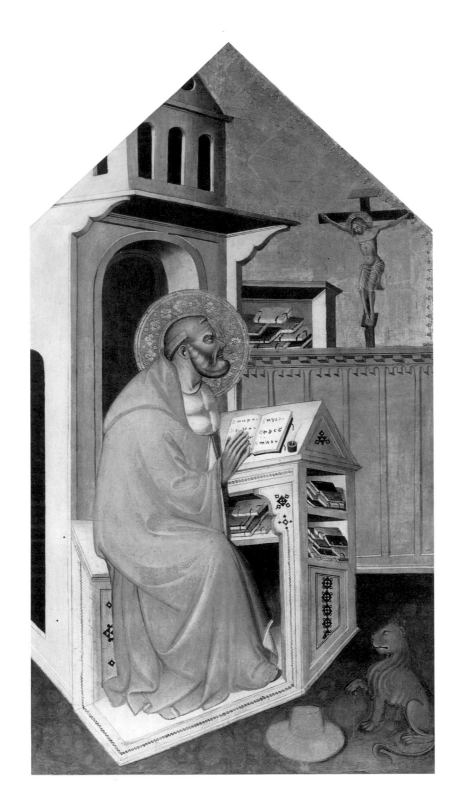

CECCO DI PIETRO *Italian,* active c. 1370–1402

St. Jerome in His Study, c. 1370

TEMPERA AND GOLD LEAF ON PANEL, 35⅛ x 20⅛ IN. (89.2 x 51.1 CM.)
GIFT OF THE SAMUEL H. KRESS FOUNDATION
60.17.16

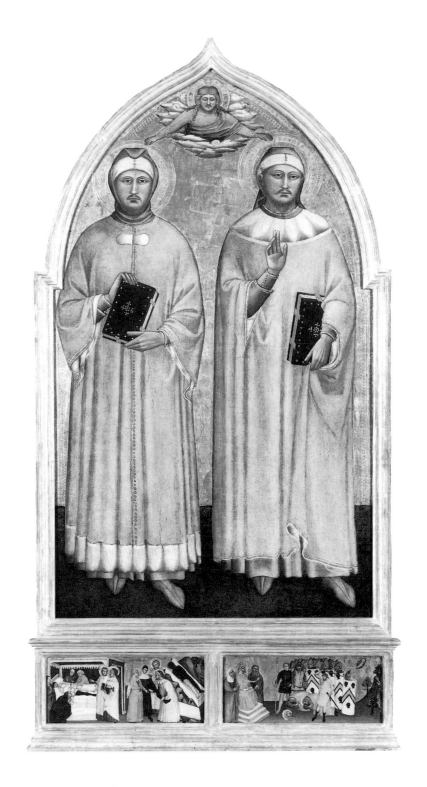

MASTER OF THE RINUCCINI CHAPEL (MATTEO DI PACINO?) *Italian, active c. 1350-75*

St. Cosmas and St. Damian, c. 1370-75

TEMPERA AND GOLD LEAF ON PANEL, 52¾ X 30⅝ IN. (134.0 X 77.8 CM.)
GIFT OF THE SAMUEL H. KRESS FOUNDATION
60.17.9

FRANCESCUCCIO GHISSI, attributed to *Italian,* active C. 1359-C. 1395

Acteus and Eugenius Imploring St. John the Evangelist to Restore Their Wealth, C. 1375

TEMPERA AND GOLD LEAF ON PANEL, 13¾ X 15 IN. (34.9 X 38.1 CM.)
GIFT OF THE SAMUEL H. KRESS FOUNDATION
60.17.19

Jacopino di Francesco, attributed to *Italian,* active c. 1360–83

The Nativity and the Adoration of the Magi, c. 1360–70

Tempera and gold leaf on panel, 20¾ x 31⅝ in. (52.7 x 80.3 cm.)
Gift of the Samuel H. Kress Foundation
60.17.11

Mariotto di Nardo, attributed to *Italian,* active 1393-1424

Crucifixion with St. John the Baptist, the Virgin, St. John the Evangelist, and St. Nicholas, c. 1380-85

Tempera and gold leaf on panel, 13 x 9⅞ in. (33.0 x 25.1 cm.)
Gift of the Samuel H. Kress Foundation
60.17.10

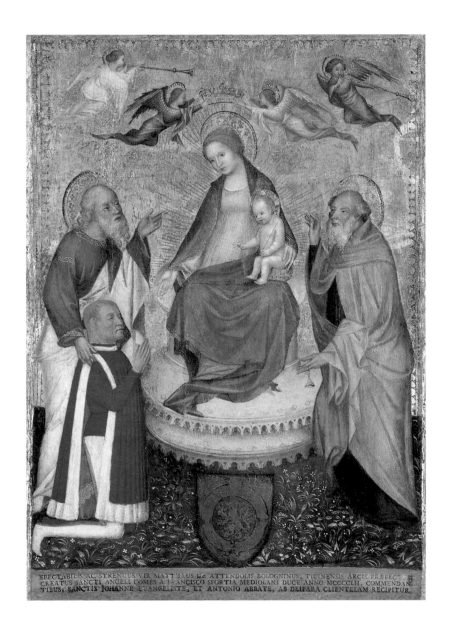

SCHOOL OF PAVIA *Italian, c. 1400-1450*

Madonna and Child with St. John the Evangelist, a Donor, and St. Anthony Abbot, c. 1420-50

OIL, TEMPERA, AND GOLD LEAF ON PANEL, 13³⁄8 X 9¹⁄2 IN. (34.0 X 24.1 CM.)
GIFT OF THE SAMUEL H. KRESS FOUNDATION
60.17.21

Neroccio de' Landi and workshop *Italian, 1447-1500*

The Visit of Cleopatra to Antony, c. 1480-95 (top)

Tempera and gold and silver leaf on panel, 14¼ x 44½ in. (36.2 x 113.0 cm.)
Gift of the Samuel H. Kress Foundation
60.17.29

Neroccio de' Landi and workshop *Italian, 1447-1500*

The Battle of Actium, c. 1480-95 (bottom)

Tempera and gold leaf on panel, 14³/₈ x 44¹/₈ in. (36.5 x 112.1 cm.)
Gift of the Samuel H. Kress Foundation
60.17.30

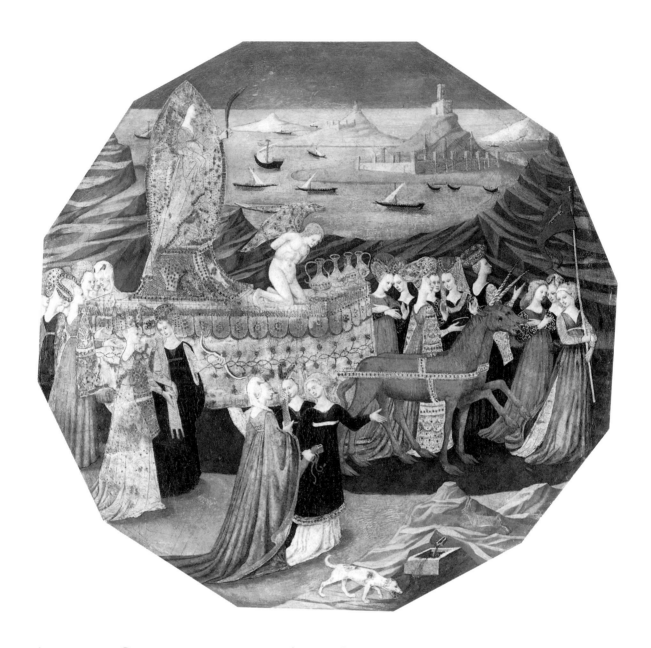

APOLLONIO DI GIOVANNI, WORKSHOP OF *Italian, 1415/17-1465*

The Triumph of Chastity, C. 1450-60

TEMPERA AND GOLD LEAF ON PANEL, 23 X 23¼ IN. (58.4 X 59.1 CM.)
GIFT OF THE SAMUEL H. KRESS FOUNDATION
60.17.23

BOTTICELLI (ALESSANDRO DI MARIANO FILIPEPI) AND ASSISTANTS *Italian, 1444/45-1510*

The Adoration of the Child, C. 1490

TEMPERA ON PANEL, DIA. 49½ IN. (125.7 CM.)
GIFT OF THE SAMUEL H. KRESS FOUNDATION
60.17.26

Francesco Francia (Francesco Raibolini) *Italian, c. 1450–1517/18*

Madonna and Child with Two Angels, c. 1495–1500

Oil on panel, 34¾ x 22¼ in. (88.3 x 56.5 cm.)
Gift of the Samuel H. Kress Foundation
60.17.39

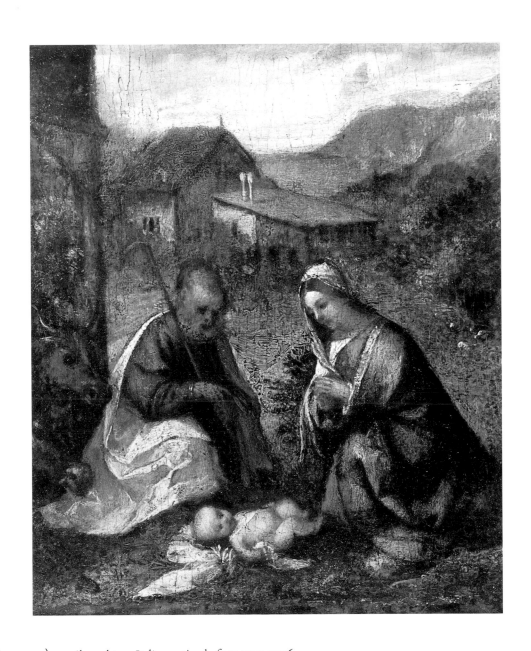

TITIAN (TIZIANO VECELLIO), attributed to *Italian,* active before 1511-1576

The Adoration of the Child, c. 1507-1508

OIL ON PANEL, 7½ X 6⅜ IN. (19.0 X 16.2 CM.)
GIFT OF THE SAMUEL H. KRESS FOUNDATION
60.17.41

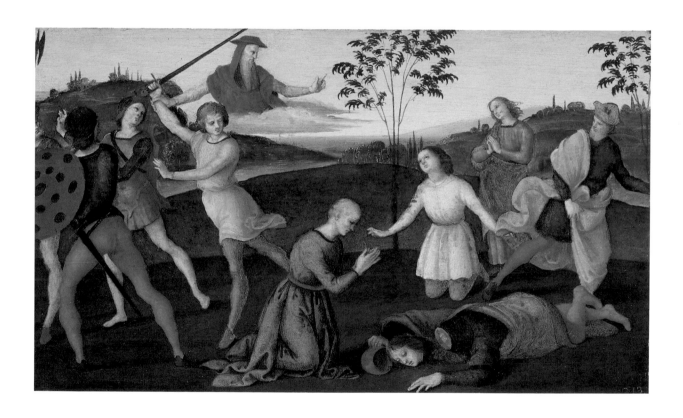

Raphael (Raffaello Sanzio) *Italian, 1483-1520*

St. Jerome Punishing the Heretic Sabinian, c. 1502-1503

Oil on panel, 10⅛ x 16½ in. (25.7 x 41.9 cm.)
Purchased with funds from Mrs. Nancy Susan Reynolds, the Sarah Graham Kenan Foundation,
Julius H. Weitzner, and the State of North Carolina
65.21.1

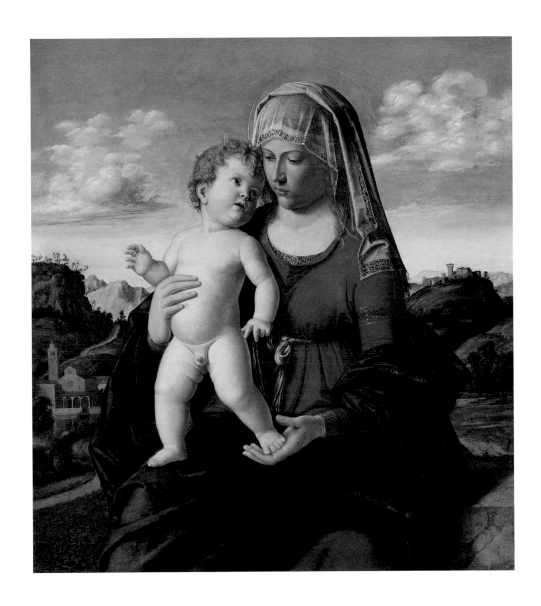

Giovanni Battista Cima da Conegliano *Italian, 1459/60-1517/18*

Madonna and Child in a Landscape, c. 1496-99

Oil on panel, transferred to canvas, 28 x 24¾ in. (71.1 x 62.9 cm.)
Purchased with funds from the State of North Carolina
52.9.152

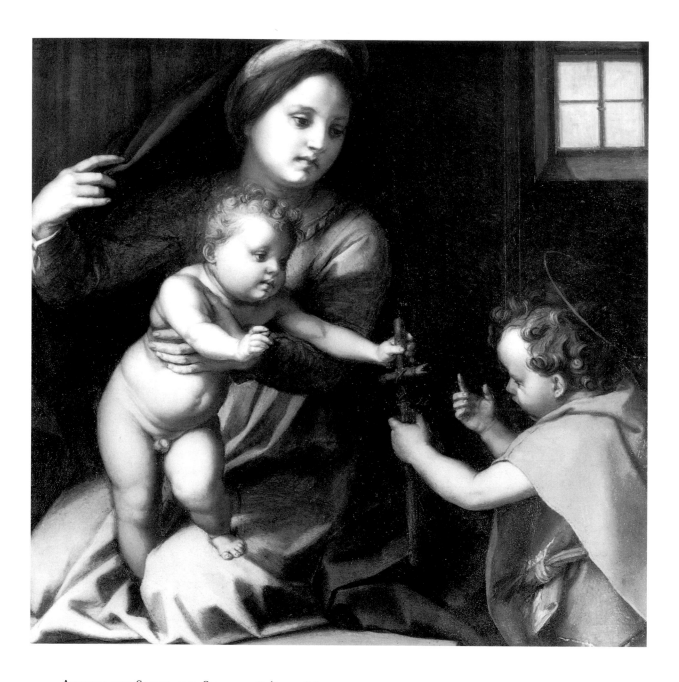

Andrea del Sarto and Studio *Italian, 1486-1530*

Madonna and Child with St. John the Baptist, c. 1528

Oil on panel, 23 x 24½ in. (58.4 x 62.2 cm.)
Purchased with funds from the State of North Carolina
52.9.167

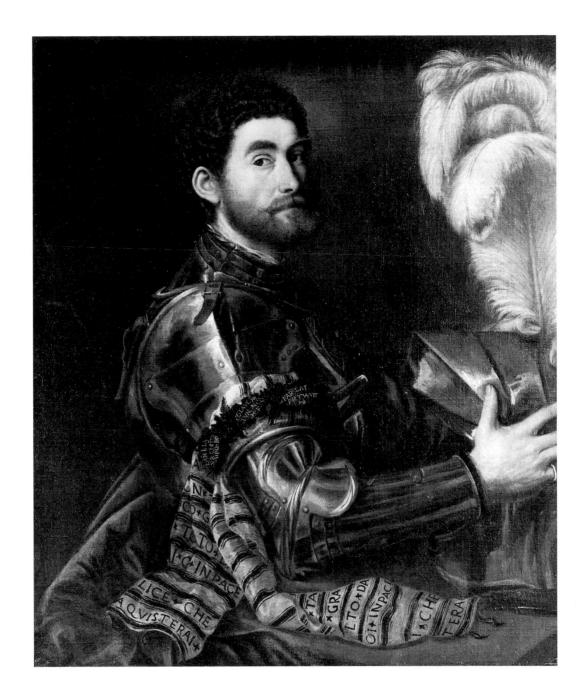

PARIS BORDON *Italian, 1500-1571*

Portrait of a Man in Armor, C. 1535-40

OIL ON CANVAS, 36 X 30 IN. (91.4 X 76.2 CM.)
PURCHASED WITH FUNDS FROM THE STATE OF NORTH CAROLINA
52.9.148

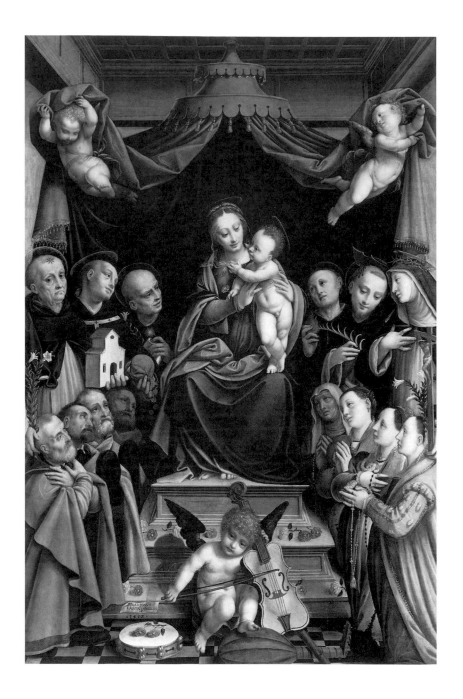

Bernardino Lanino *Italian, c. 1512-1583*

Madonna Enthroned with Saints and Donors, 1552

Oil on panel, 92³⁄8 x 60¹⁄2 in. (234.7 x 153.7 cm.)
Gift of the Samuel H. Kress Foundation
60.17.45

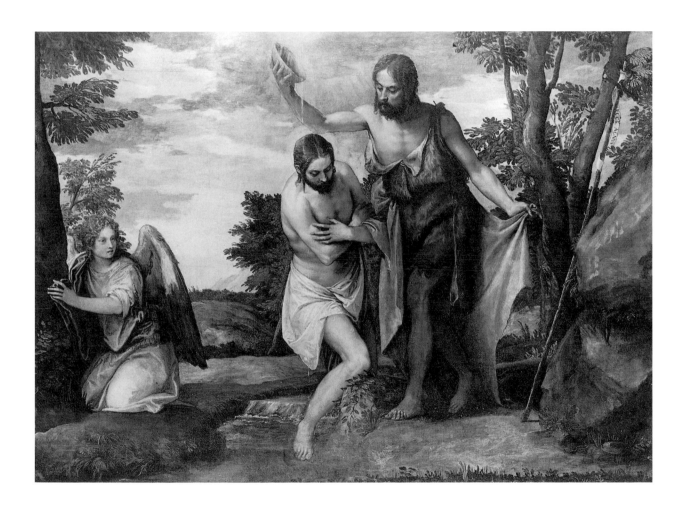

Paolo Veronese (Paolo Caliari) *Italian, 1528-1588*

The Baptism of Christ, c. 1550-58

Oil on canvas, 33³⁄8 x 45¹⁄2 in. (85.7 x 116.8 cm.)
Gift of the Samuel H. Kress Foundation
60.17.47

BENVENUTO CELLINI, attributed to *Italian, 1500-1571*

Neptune, C. 1560

BRONZE, H. 9½ IN. (24.1 CM.)
GIFT OF MR. AND MRS. ARTHUR W. LEVY, JR.
57.11.2

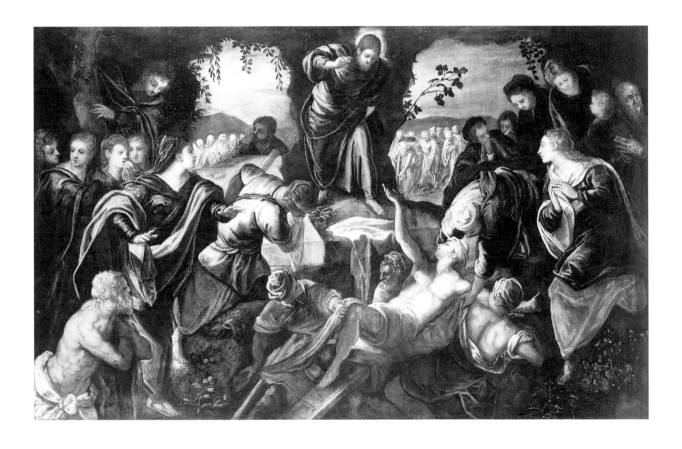

Domenico Tintoretto *Italian, c. 1560-1635*

The Raising of Lazarus, c. 1580-90

Oil on canvas, 47⅞ x 77¼ in. (121.6 x 196.2 cm.)
Gift of the Samuel H. Kress Foundation
60.17.49

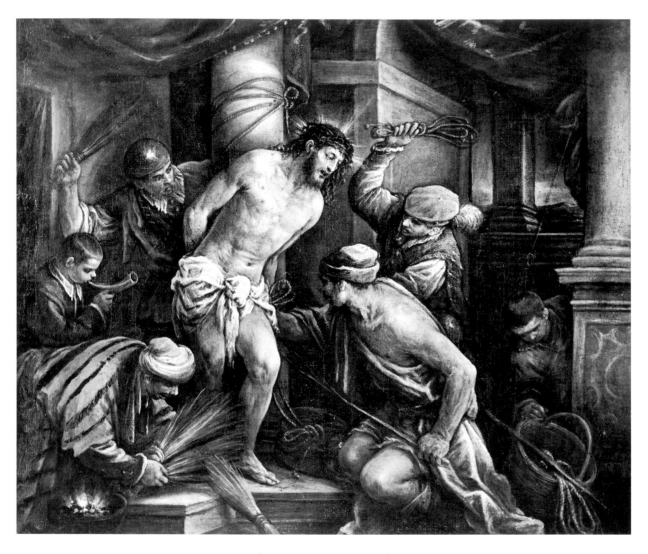

FRANCESCO BASSANO THE YOUNGER (FRANCESCO DA PONTE) *Italian, 1549-1592*
JACOPO BASSANO (JACOPO DA PONTE) *Italian, c. 1510-1592*

The Scourging of Christ, C. 1580-85

OIL ON CANVAS, 46¼ X 37½ IN. (117.5 X 95.2 CM.)
GIFT OF THE SAMUEL H. KRESS FOUNDATION
60.17.50

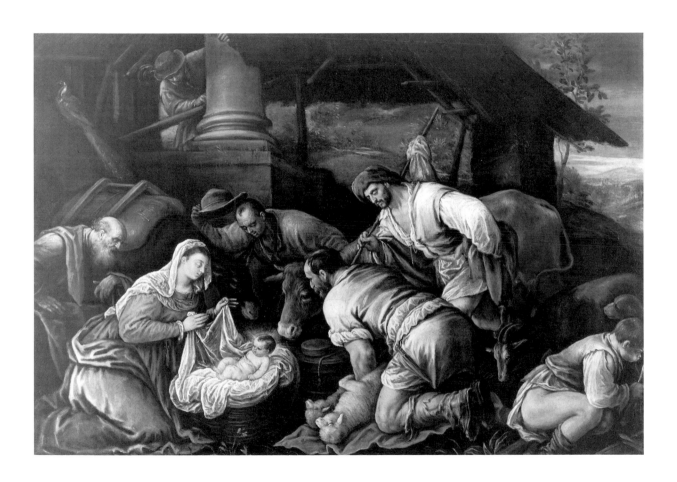

FRANCESCO BASSANO THE YOUNGER (FRANCESCO DA PONTE) *Italian, 1549-1592*

Adoration of the Shepherds, C. 1585-90

OIL ON CANVAS, 46 X 66 IN. (116.8 X 167.6 CM.)
PURCHASED WITH FUNDS FROM THE STATE OF NORTH CAROLINA AND
THE NORTH CAROLINA ART SOCIETY (ROBERT F. PHIFER BEQUEST)
52.9.144

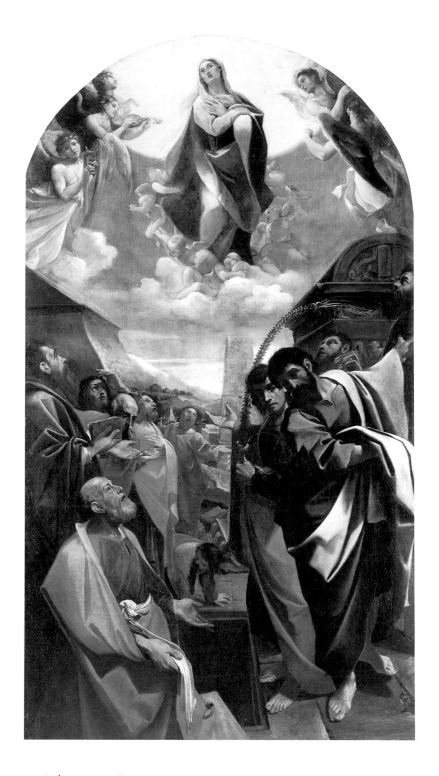

LODOVICO CARRACCI *Italian, 1555-1619*

The Assumption of the Virgin, c. 1586-87

OIL ON CANVAS, 96½ x 53 IN. (245.0 x 134.6 CM.)
GIFT OF MRS. J. L. DORMINY, IN MEMORY OF HER HUSBAND
57.21.1

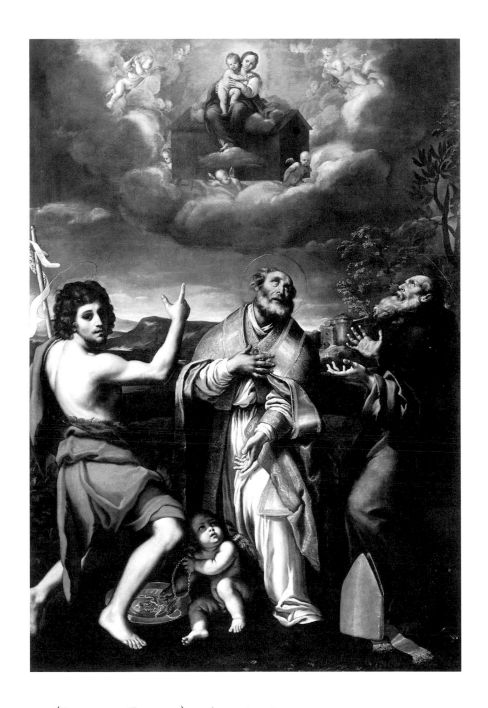

Domenichino (Domenico Zampieri) *Italian, 1581-1641*

The Madonna of Loreto Appearing to St. John the Baptist, St. Paterniano, and St. Anthony Abbot, 1618-19

Oil on canvas, 94⅞ x 67⅛ in. (241.0 x 170.5 cm.)
Gift of the Samuel H. Kress Foundation
60.17.51

Bernardo Strozzi *Italian, 1581-1644*

Portrait of a Gentleman, c. 1629

Oil on canvas, 46½ x 35½ in. (118.0 x 90.2 cm.)
Gift of R. J. and G. C. Maxwell, in honor of their sister, Rachel Maxwell Moore
59.36.1

BERNARDO STROZZI *Italian, 1581-1644*

St. Lawrence Distributing the Goods of the Church, C. 1625

OIL ON CANVAS, 46¹/₂ X 62 IN. (118.0 X 157.5 CM.)
PURCHASED WITH FUNDS FROM THE STATE OF NORTH CAROLINA
52.9.168

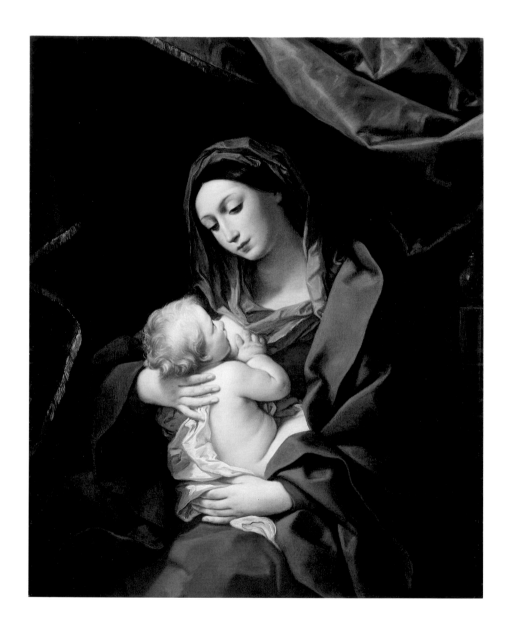

Guido Reni *Italian, 1575-1642*

Madonna and Child, c. 1628-30

Oil on canvas, 45 x 36 in. (114.3 x 91.4 cm.)
Gift of Mr. and Mrs. Robert Lee Humber, in memory of their daughter, Eileen Genevieve
55.12.1

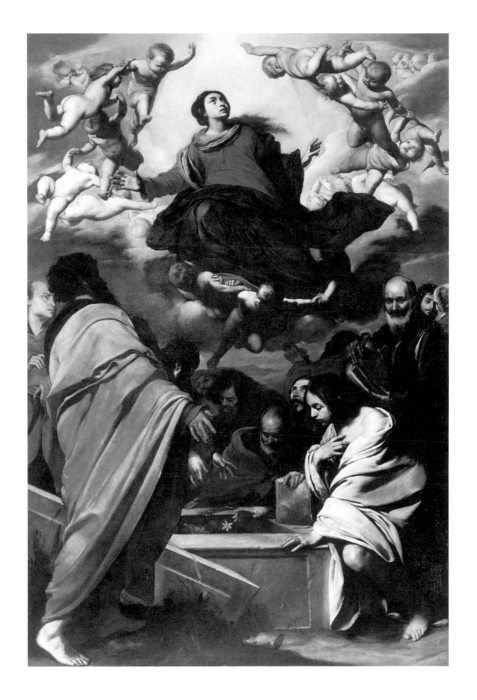

MASSIMO STANZIONE *Italian, 1585-1656*

The Assumption of the Virgin, C. 1630-35

OIL ON CANVAS, 108¹/₂ X 74⁵/₈ IN. (275.6 X 189.0 CM.)
GIFT OF THE SAMUEL H. KRESS FOUNDATION
60.17.52

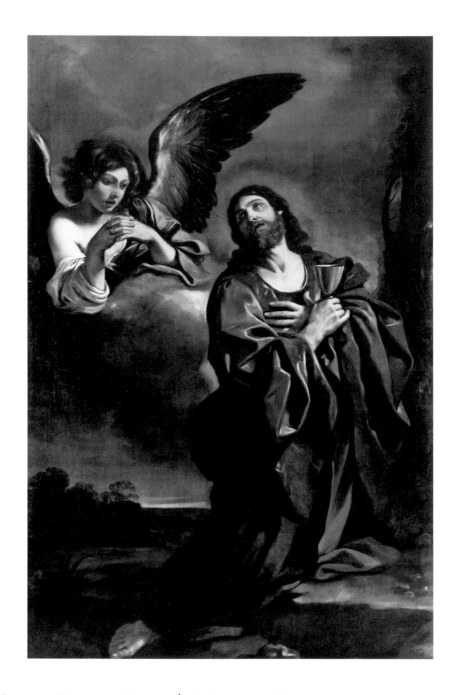

GUERCINO (GIOVANNI FRANCESCO BARBIERI) *Italian, 1591-1666*

Christic in the Garden of Gethsemane, C. 1632

OIL ON CANVAS, 85¾ x 55⅝ IN. (217.9 x 140.5 CM.)
PURCHASED WITH FUNDS FROM THE STATE OF NORTH CAROLINA
84.4

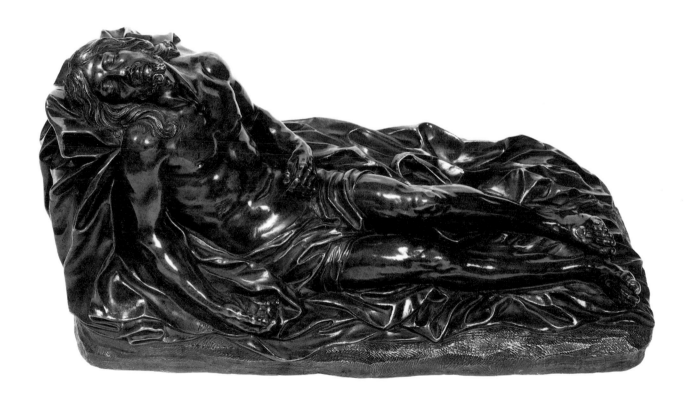

GIUSEPPE MAZZUOLI, attributed to *Italian,* 1644-1725

Deposed Christ, C. 1670-80

BRONZE, 10¹/8 X 22 X 11 IN. (25.7 X 55.7 X 27.9 CM.)
PURCHASED WITH FUNDS FROM THE STATE OF NORTH CAROLINA AND VARIOUS DONORS, BY EXCHANGE
85.5

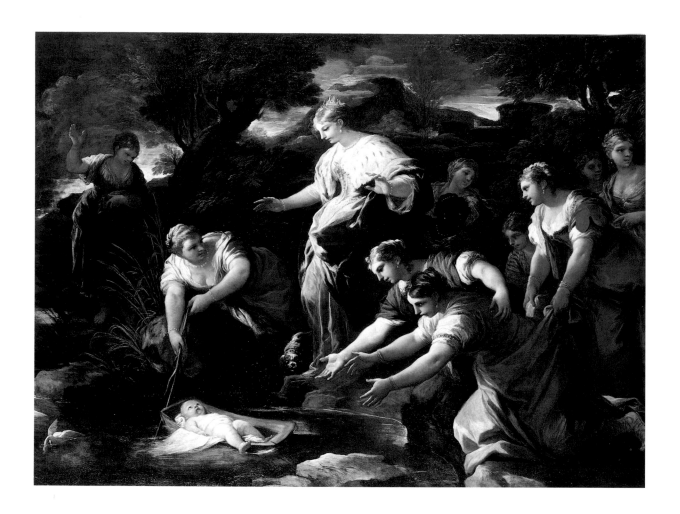

LUCA GIORDANO *Italian,* 1634-1705

The Finding of Moses, c. 1685-90

OIL ON CANVAS, 60⅜ x 82⅜ IN. (153.4 x 209.3 CM.)
PURCHASED WITH FUNDS FROM THE STATE OF NORTH CAROLINA
52.9.158

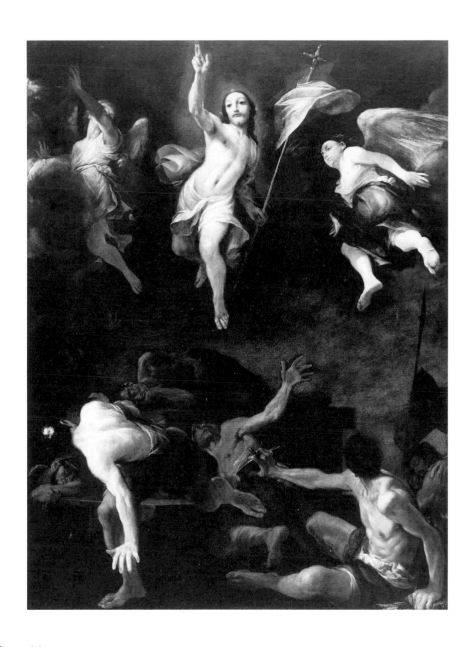

GIUSEPPE MARIA CRESPI *Italian, 1665-1747*

The Resurrection of Christ, C. 1690

OIL ON CANVAS, 56½ X 40 IN. (143.5 X 101.6 CM.)
PURCHASED WITH FUNDS FROM THE STATE OF NORTH CAROLINA
52.9.153

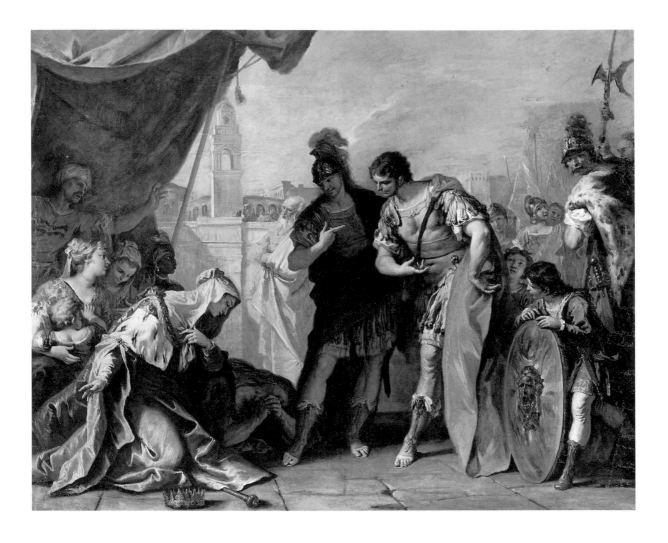

Sebastiano Ricci *Italian, 1659-1734*

Alexander and the Family of Darius, c. 1708-10

Oil on canvas, 76 x 96 in. (193.0 x 243.8 cm.)
Purchased with funds from the State of North Carolina
52.9.165

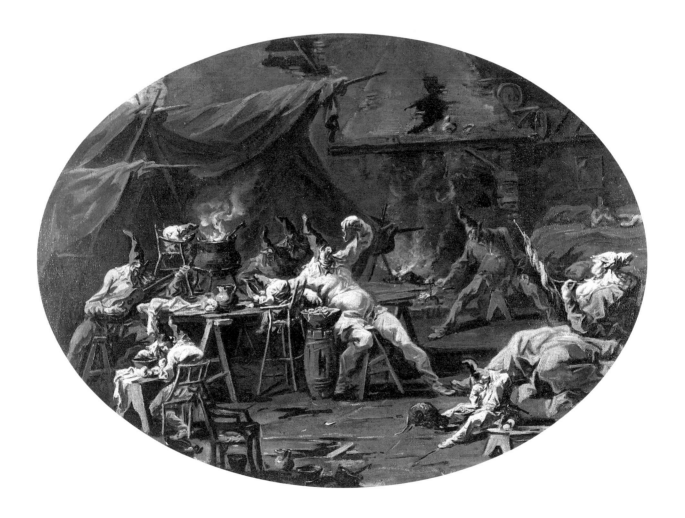

Alessandro Magnasco *Italian*, 1667-1749

The Supper of Pulcinella and Colombina, c. 1710-20

Oil on canvas, 30¾ x 41⅜ in. (78.1 x 105.1 cm.)
Gift of the Samuel H. Kress Foundation
60.17.56

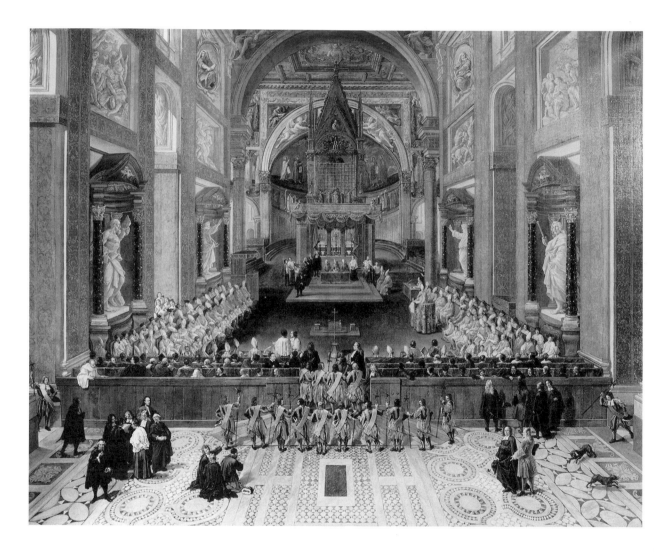

PIER LEONE GHEZZI *Italian,* 1674-1755

The Lateran Convention of 1725, C. 1725

OIL ON CANVAS, 95⅞ X 122½ IN. (243.5 X 311.2 CM.)
PURCHASED WITH FUNDS FROM THE STATE OF NORTH CAROLINA
52.9.157

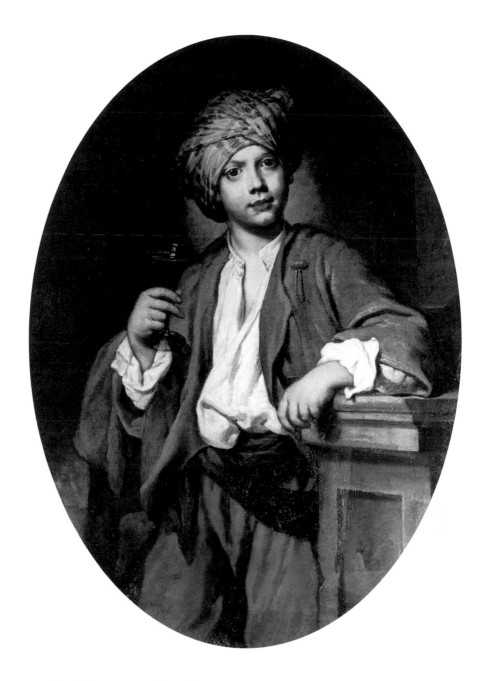

GIUSEPPE GHISLANDI, CALLED FRA GALGARIO *Italian, 1655-1743*

Portrait of a Pupil with a Turban, C. 1720-30

OIL ON CANVAS, 55 x 39¾ IN. (139.7 x 101.0 CM.)
GIFT OF THE SAMUEL H. KRESS FOUNDATION
60.17.54

Francesco Solimena *Italian,* 1657-1747

Christ Appearing in a Dream to St. Martin, c. 1733

Oil on canvas, 39½ x 49½ in. (100.3 x 125.7 cm.)
Gift of Mrs. Florence G. Montgomery
59.2.1

Alessandro Magnasco Italian, 1667-1749

Bay with Shipwreck, c. 1735-45

Oil on canvas, 45¼ x 68⅛ in. (114.9 x 173.0 cm.)
Gift of the Samuel H. Kress Foundation
60.17.57

Pompeo Girolamo Batoni *Italian, 1708-1787*

The Triumph of Venice, 1737

Oil on canvas, 68⅝ x 112⅝ in. (174.3 x 286.1 cm.)
Gift of the Samuel H. Kress Foundation
60.17.60

MICHELE MARIESCHI *Italian, 1710-1743*

The Grand Canal at the Palazzo Foscari, c. 1740-43

OIL ON CANVAS, 24¼ x 37⅞ IN. (61.1 x 96.2 CM.)
GIFT OF THE SAMUEL H. KRESS FOUNDATION
60.17.59

BERNARDO BELLOTTO *Italian, 1720-1780*

View of Dresden with the Frauenkirche at Left, 1747

OIL ON CANVAS, 59 X 93 IN. (149.9 X 236.2 CM.)
PURCHASED WITH FUNDS FROM THE STATE OF NORTH CAROLINA
52.9.145

Bernardo Bellotto *Italian, 1720-1780*

View of Dresden with the Hofkirche at Right, 1748

Oil on canvas, 59 x 93 in. (149.9 x 236.2 cm.)
Purchased with funds from the State of North Carolina
52.9.146

Giacomo Antonio Ceruti *Italian, 1698-1767*

The Card Game, c. 1740-50

Oil on canvas, 28½ x 40¾ in. (72.4 x 103.5 cm.)
Gift of the Samuel H. Kress Foundation
60.17.55

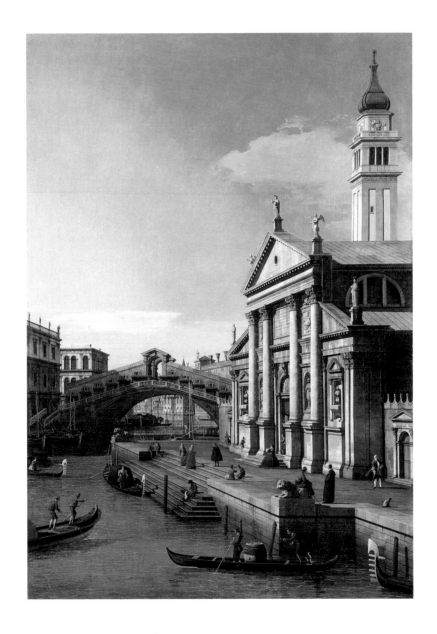

CANALETTO (GIOVANNI ANTONIO CANALE) *Italian, 1697-1768*

Capriccio: The Rialto Bridge and the Church of S. Giorgio Maggiore, c. 1760

OIL ON CANVAS, 66 X 45 IN. (167.6 X 114.3 CM.)
PURCHASED WITH FUNDS FROM THE STATE OF NORTH CAROLINA
52.9.149

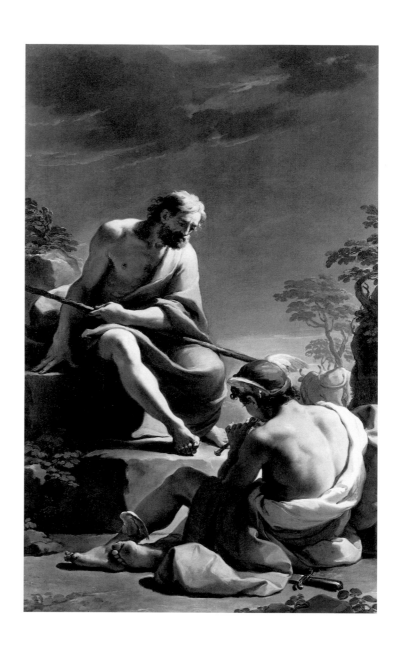

Ubaldo Gandolfi *Italian, 1728–1781*

Mercury Lulling Argus to Sleep, c. 1770

Oil on canvas, 86 x 53⅜ in. (218.4 x 135.6 cm.)
Purchased with funds from the North Carolina Art Society (Robert F. Phifer Bequest),
in memory of Robert Lee Humber
83.1

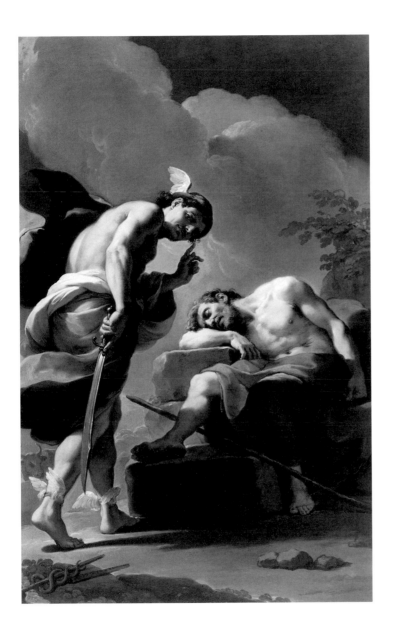

UBALDO GANDOLFI *Italian*, 1728-1781

Mercury about to Behead Argus, C. 1770

OIL ON CANVAS, 86¹/₈ X 53⁷/₈ IN. (218.7 X 136.9 CM.)
PURCHASED WITH FUNDS FROM THE NORTH CAROLINA ART SOCIETY
(ROBERT F. PHIFER BEQUEST), IN MEMORY OF ROBERT LEE HUMBER
83.2

Anton von Maron *Austrian,* 1733-1808, active in Rome from 1755

Cardinal Muzio Gallo (1721-1801), 1785

Oil on canvas, 82¼ x 46½ in. (209.0 x 118.0 cm.)
Purchased with funds from the George and Lucy Finch Trust,
the North Carolina Art Society, and the State of North Carolina
82.2

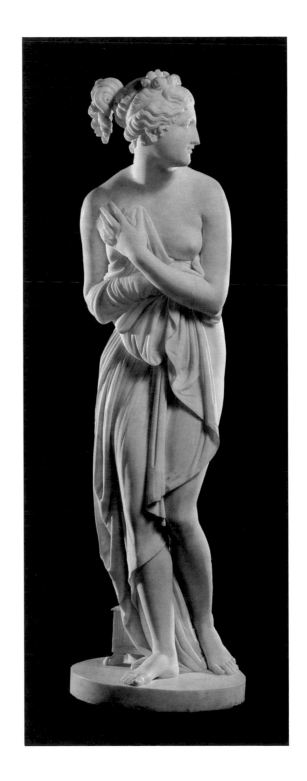

ANTONIO CANOVA, studio of *Italian, 1756-1822*

Venus Italica, C. 1815-22

MARBLE, H. 67¾ IN. (172.1 CM.)
PURCHASED WITH FUNDS FROM THE NORTH CAROLINA ART SOCIETY (ROBERT F. PHIFER BEQUEST)
92.2

JUSEPE DE RIBERA *Spanish,* 1591-1652, active in Naples from 1616

St. John the Baptist, c. 1637-40

OIL ON CANVAS, 70⅝ x 50⅞ IN. (179.3 x 129.2 CM.)
PURCHASED WITH FUNDS FROM THE STATE OF NORTH CAROLINA
52.9.183

Florece en Santidad Gil, Y el noueno Visitale fray Gil el pecho lleno Teme entrar Y alfin entra del claustro pleno, Q admirando Al Pontifice aquedado,
Gregorio por hablarle Va aperosa, Defertuor Y obediencia Afectuosa Siendo suamor Y se tan milagrosa, En extasis Diuino arrebatado,

BARTOLOMÉ ESTEBAN MURILLO *Spanish, 1617-1682*

The Blessed Giles before Pope Gregory IX, 1645-46

OIL ON CANVAS, 65½ X 73¼ IN. (166.3 X 186.0 CM.)
PURCHASED WITH FUNDS FROM THE STATE OF NORTH CAROLINA
52.9.178

ESTEBAN MÁRQUEZ DE VELASCO *Spanish,* died 1696

The Marriage of the Virgin, C. 1693

OIL ON CANVAS, 96 X 60 IN. (243.8 X 152.4 CM.)
PURCHASED WITH FUNDS FROM THE STATE OF NORTH CAROLINA
52.9.180

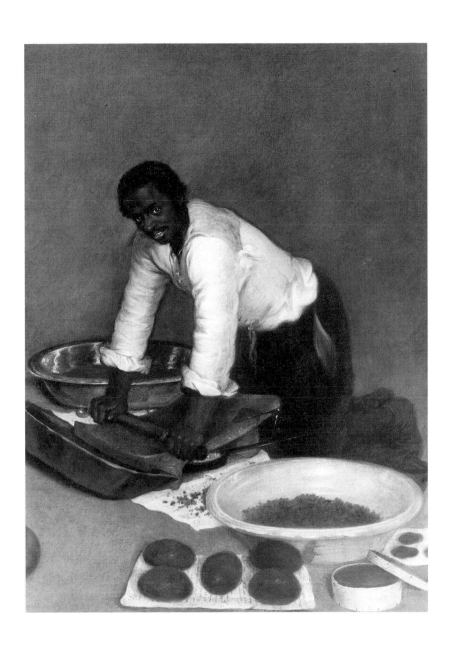

SPANISH

A Man Scraping Chocolate, C. 1680-1780

OIL ON CANVAS, 41 X 28 IN. (104.1 X 71.1 CM.)
GIFT OF MR. AND MRS. BENJAMIN CONE
69.20.1

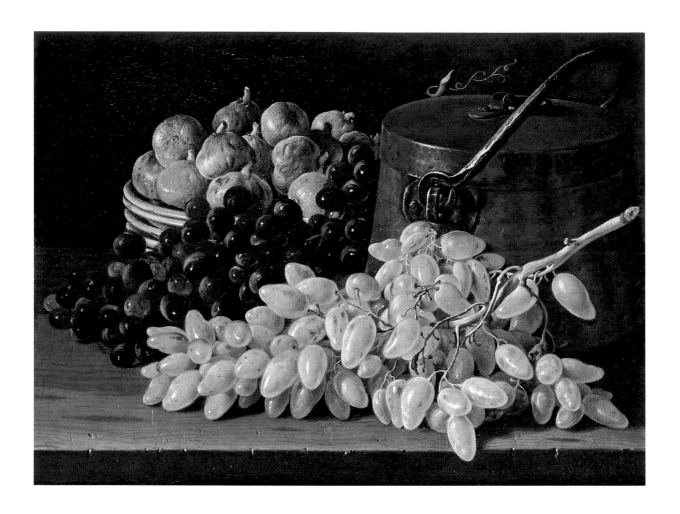

Luis Egidio Meléndez *Spanish, 1716-1780*

Still Life with Grapes, Figs, and a Copper Kettle, c. 1770-80

Oil on canvas, 14⁹/₁₆ x 19³/₈ in. (37.0 x 49.2 cm.)
Purchased with funds from the North Carolina Art Society (Robert F. Phifer Bequest)
52.9.176

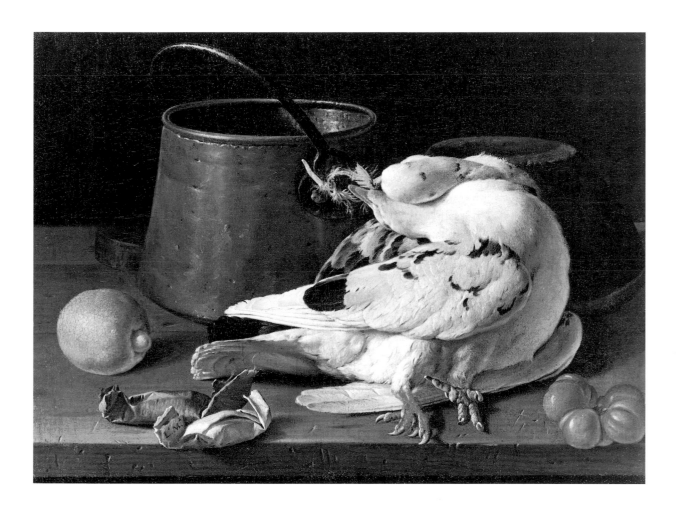

Luis Egidio Meléndez *Spanish,* 1716-1780

Still Life with Game, c. 1770-80

Oil on canvas, 14⁹/₁₆ x 19³/₈ in. (37.0 x 49.2 cm.)
Purchased with funds from the North Carolina Art Society (Robert F. Phifer Bequest)
52.9.177

American

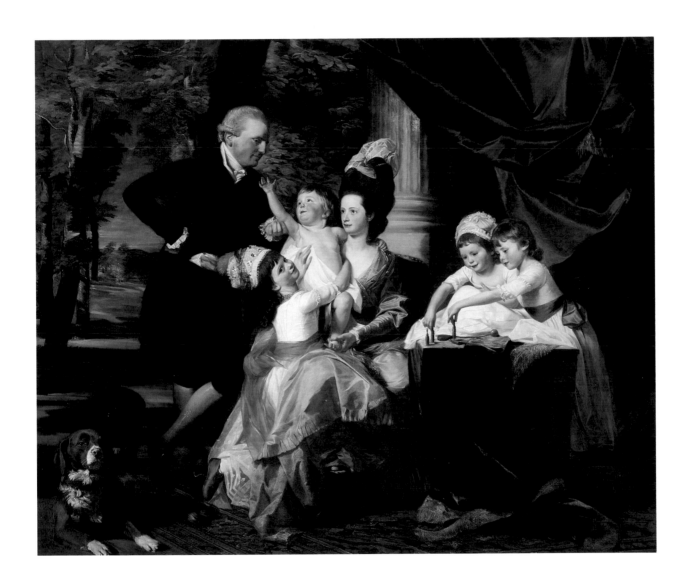

John Singleton Copley *American,* 1738-1815, active in Great Britain from 1774

Sir William Pepperrell (1746-1816) and His Family, 1778

Oil on canvas, 90 x 108 in. (228.6 x 274.3 cm.)
Purchased with funds from the State of North Carolina
52.9.8

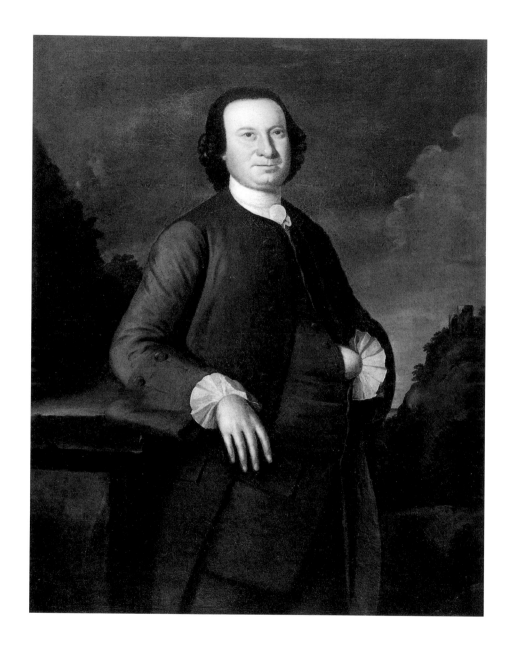

JOHN HESSELIUS *American, 1728-1778*

Thomas Sprigg (1715-1781), 1764

OIL ON CANVAS, 49⅜ X 37⅞ (125.7 X 96.5 CM.)
GIFT OF MR. AND MRS. CHARLES V. CHENEY
63.33.1

Rembrandt Peale *American, 1778-1860*

George Washington (1732-1799), c. 1855

Oil on canvas, 36 x 29 in. (91.4 x 73.7 cm.)
Gift of Mrs. Charles Lee Smith, Sr., William Oliver Smith, Charles Lee Smith, Jr.,
and Mrs. Joseph H. Hardison, in memory of Dr. Charles Lee Smith
56.4.1

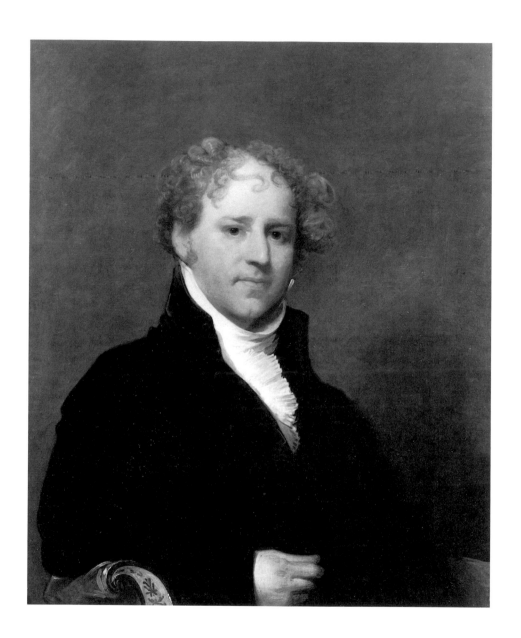

GILBERT STUART *American, 1755-1828*

Mr. Charles Davis (1777-1821), c. 1808-9

OIL ON PANEL, 32¾ x 26⅜ IN. (83.2 x 66.9 CM.)
PURCHASED WITH FUNDS FROM THE STATE OF NORTH CAROLINA
52.9.31

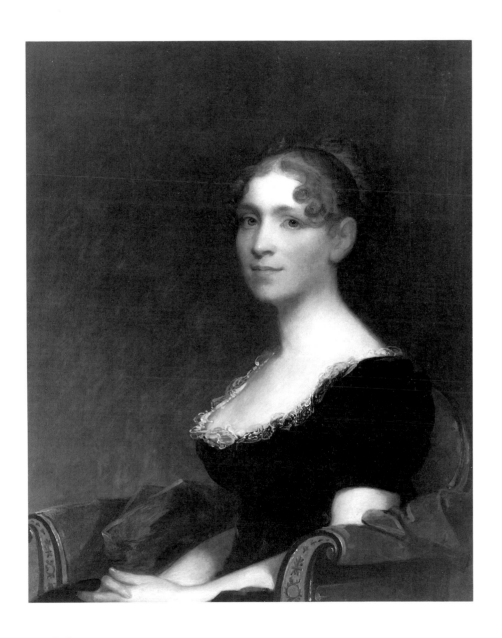

GILBERT STUART *American, 1755-1828*

Mrs. Charles Davis (Eliza Bussey) (1783-1841), C. 1808-9

OIL ON PANEL, 33 X 26½ IN. (83.2 X 67.4 CM.)
PURCHASED WITH FUNDS FROM THE STATE OF NORTH CAROLINA
52.9.32

THOMAS COLE *American,* born Great Britain, 1801-1848

Romantic Landscape, C. 1826

OIL ON PANEL, 16¹/16 X 21¹⁵/16 IN. (40.7 X 55.8 CM.)
PURCHASED WITH FUNDS FROM THE STATE OF NORTH CAROLINA
52.9.7

JASPER FRANCIS CROPSEY *American, 1823-1900*

Eagle Cliff, Franconia Notch, New Hampshire, 1858

OIL ON CANVAS, 23¹⁵/₁₆ x 39 IN. (60.8 x 99.0 CM.)
PURCHASED WITH FUNDS FROM THE STATE OF NORTH CAROLINA
52.9.9

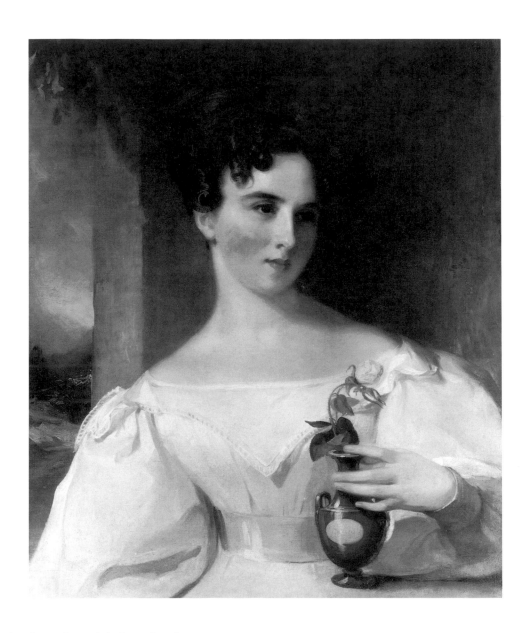

Thomas Sully *American,* born Great Britain, 1783-1872

Udney Maria Blakeley (1815-1842), 1830

Oil on canvas, 30 x 25 in. (76.2 x 63.5 cm.)
Gift of the James G. Hanes Memorial Fund, in memory of Lucy Hanes Chatham;
and Dr. Edgar D. Baker and Dr. G. Fred Hale
68.18.1

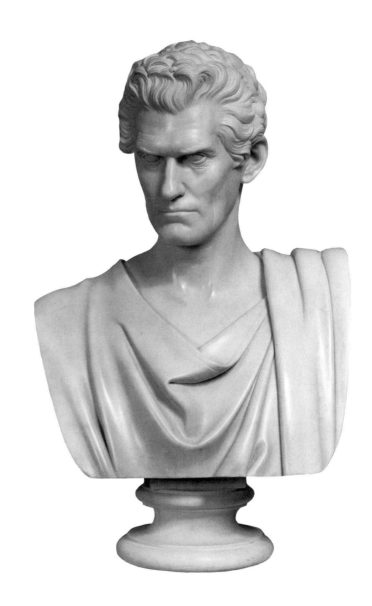

Hiram Powers *American, 1805-1873, active in Italy from 1837*

John C. Calhoun (1782-1850), modeled 1837, carved 1858-59

Marble, h. 29½ in. (75.1 cm.)
Gift of the North Carolina Museum of History
56.3.1

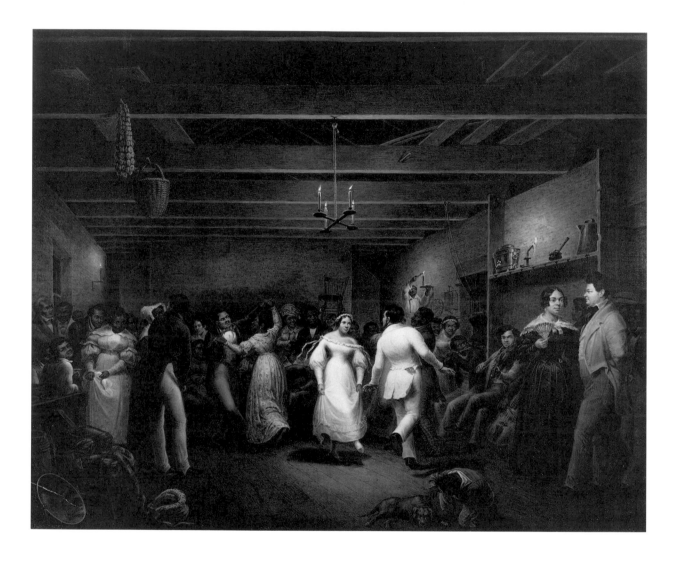

CHRISTIAN MAYR *American,* born Germany, c. 1805-1851

Kitchen Ball at White Sulphur Springs, Virginia, 1838

OIL ON CANVAS, 24 X 29½ IN. (61.0 X 75.0 CM.)
PURCHASED WITH FUNDS FROM THE STATE OF NORTH CAROLINA
52.9.23

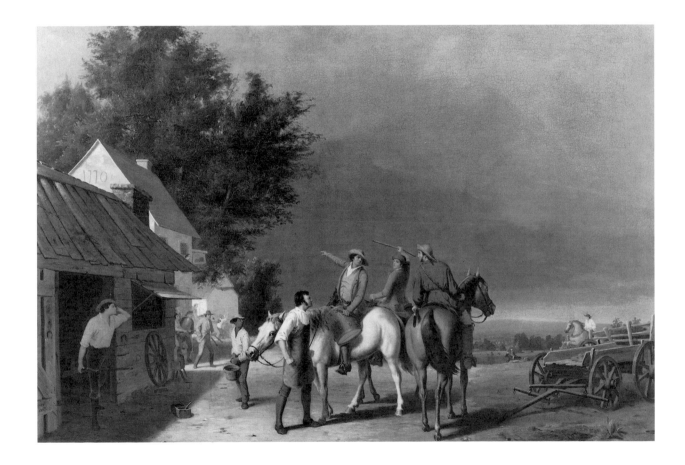

WILLIAM TYLEE RANNEY *American, 1813-1857*

First News of the Battle of Lexington, 1847

OIL ON CANVAS, 44¹/₁₆ X 63⁵/₁₆ IN. (111.9 X 160.8 CM.)
PURCHASED WITH FUNDS FROM THE STATE OF NORTH CAROLINA
52.9.25

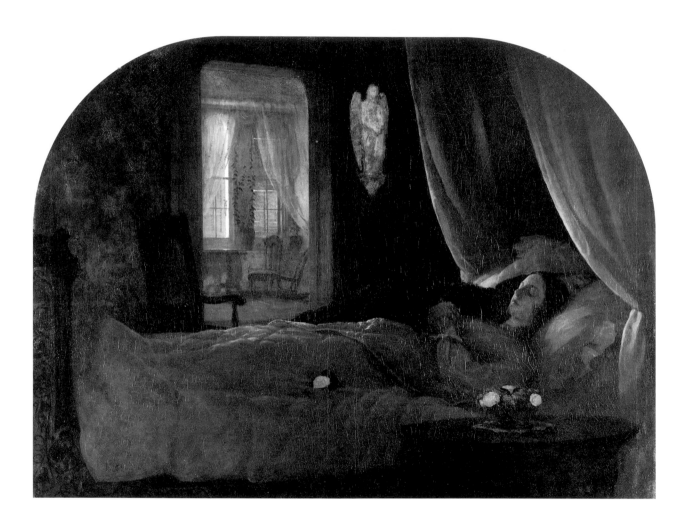

George Cochrin Lambdin *American, 1830–1896*

The Last Sleep, c. 1858

Oil on canvas, 40 x 54¾ in. (101.6 x 140.6 cm.)
Gift of Peter A. Vogt
79.4.1

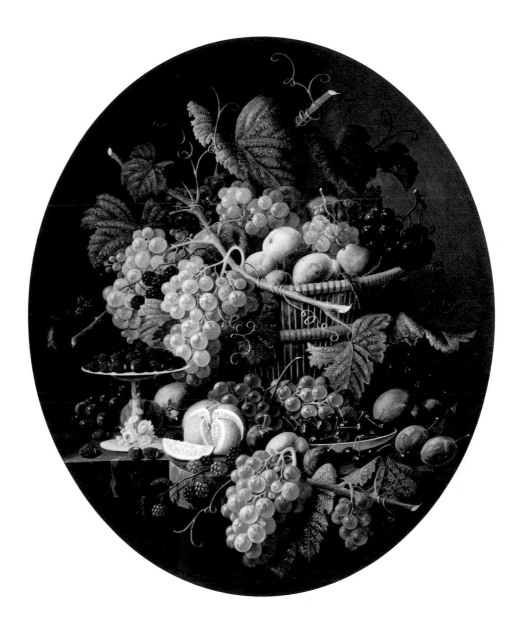

SEVERIN ROESEN *American,* born Germany, 1814/15–1872

Still Life with Fruit, c. 1855–60

OIL ON CANVAS, 30¼ x 25 IN. (76.8 x 63.5 CM.)
PURCHASED WITH FUNDS FROM THE NORTH CAROLINA ART SOCIETY (ROBERT F. PHIFER BEQUEST),
IN HONOR OF MRS. CHARLES LEE SMITH, JR. AND THE LATE MR. CHARLES LEE SMITH, JR.
77.8.1

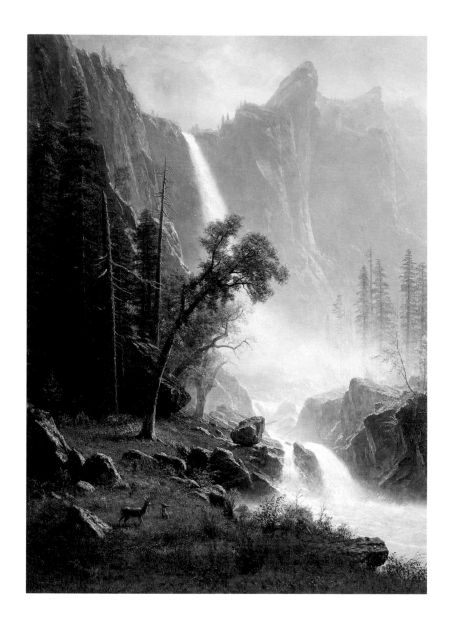

ALBERT BIERSTADT *American,* born Germany, 1830-1902

Bridal Veil Falls, Yosemite, C. 1871-73

OIL ON CANVAS, 36⅛ x 26⅜ IN. (91.7 x 67.0 CM.)
PURCHASED WITH FUNDS FROM THE NORTH CAROLINA ART SOCIETY
(ROBERT F. PHIFER BEQUEST) AND VARIOUS DONORS, BY EXCHANGE
87.9

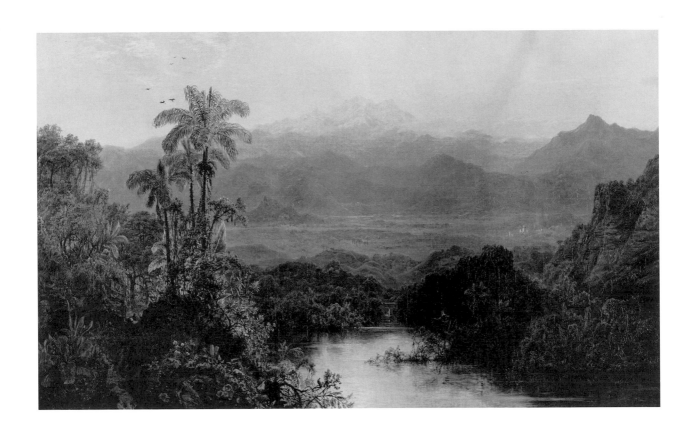

Louis Rémy Mignot *American,* 1831-1870

Landscape in Ecuador, 1859

Oil on canvas, 24 x 39½ (61.0 x 100.3 cm.)
Purchased with funds from various donors, by exchange
91.2

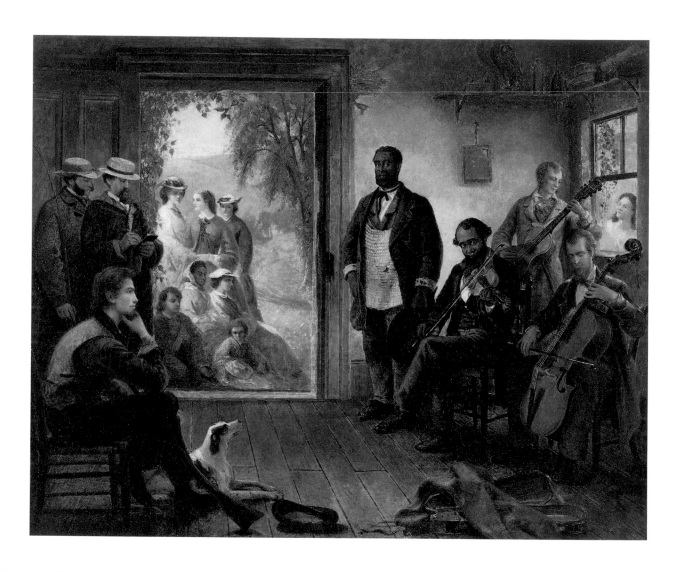

Thomas Hicks *American, 1823-1890*

The Musicale, Barber Shop, Trenton Falls, New York, 1866

Oil on canvas, 25 x 30⅛ in. (63.5 x 76.3 cm.)
Purchased with funds from the State of North Carolina
52.9.15

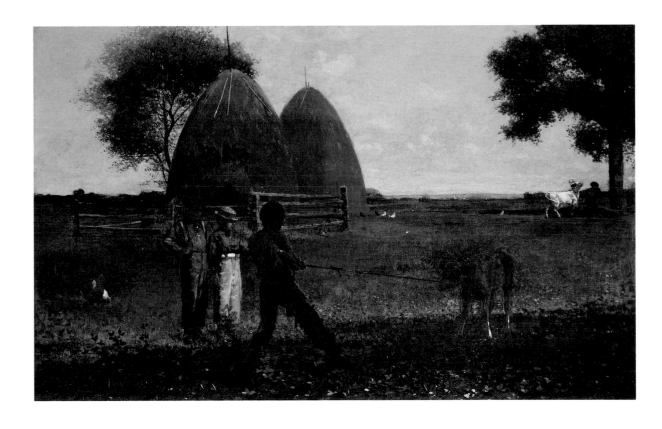

WINSLOW HOMER *American, 1836-1910*

Weaning the Calf, 1875

OIL ON CANVAS, 24 X 38 IN. (61.0 X 96.5 CM.)
PURCHASED WITH FUNDS FROM THE STATE OF NORTH CAROLINA
52.9.16

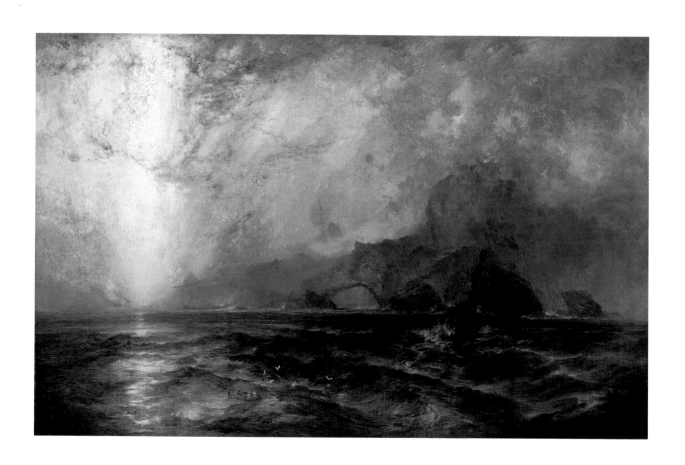

THOMAS MORAN *American,* born Great Britain, 1837-1926

"*Fiercely the red sun descending/Burned his way across the heavens,*" C. 1875

OIL ON CANVAS, 33⅜ X 50¹/₁₆ IN. (84.8 X 127.1 CM.)
PURCHASED WITH FUNDS FROM THE NORTH CAROLINA ART SOCIETY (ROBERT F. PHIFER BEQUEST)
52.9.34

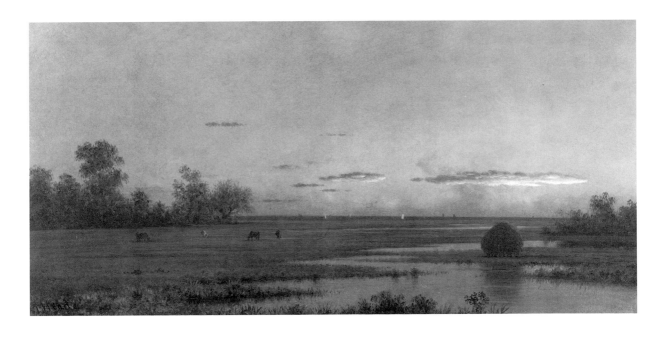

MARTIN JOHNSON HEADE *American, 1819-1904*

Salt Marsh at Southport, Connecticut, c. 1875-81

OIL ON CANVAS, 9⅞ x 20⅛ IN. (25.1 x 51.4 CM.)
PURCHASED WITH FUNDS FROM THE STATE OF NORTH CAROLINA AND VARIOUS DONORS, BY EXCHANGE
87.10

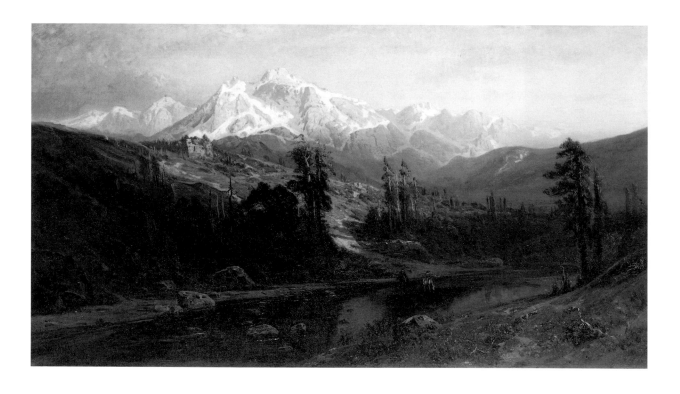

WILLIAM KEITH *American,* born Great Britain, 1839-1911

Mono Pass, Sierra Nevada Mountains, California, 1877

OIL ON CANVAS, 40 X 72 IN. (101.6 X 182.9 CM.)
PURCHASED WITH FUNDS FROM THE STATE OF NORTH CAROLINA
52.9.20

GEORGE INNESS *American, 1825-1894*

Under the Greenwood, 1881

OIL ON CANVAS, 36½ x 29¼ IN. (92.7 x 74.4 CM.)
PURCHASED WITH FUNDS FROM THE STATE OF NORTH CAROLINA
52.9.17

AUGUSTUS SAINT-GAUDENS *American,* born Ireland, 1848–1907

The Puritan, modeled 1886; reworked, reduced, and cast after 1899

BRONZE, H. 31 IN. (78.7 CM.)
GIFT OF MR. AND MRS. FABIUS B. PENDLETON
71.40.9

Frank Duveneck *American, 1848-1919*

Mrs. Mary E. Goddard ("The Crimson Gown"), 1879

Oil on canvas, 58½ x 31½ in. (148.6 x 80.0 cm.)
Purchased with funds from the State of North Carolina
52.9.11

JOHN GEORGE BROWN *American,* born Great Britain, 1831-1913

A Tough Story, 1886

OIL ON CANVAS, 25 x 30 IN. (63.5 x 76.3 CM.)
PURCHASED WITH FUNDS FROM THE STATE OF NORTH CAROLINA
52.9.5

JOHN HENRY TWACHTMAN *American, 1853-1902*

In the Greenhouse, C. 1895

OIL ON CANVAS, 25 X 16 IN. (63.5 X 40.7 CM.)
PURCHASED WITH FUNDS FROM THE STATE OF NORTH CAROLINA
73.1.3

WILLIAM MERRITT CHASE *American, 1849-1916*

The Artist's Daughter, Alice, c. 1899

OIL ON CANVAS, 19¼ X 15¼ IN. (48.9 X 39.0 CM.)
GIFT OF THE NORTH CAROLINA ART SOCIETY (ROBERT F. PHIFER BEQUEST)
28.2.7

Thomas Eakins *American, 1844-1916*

Dr. Albert C. Getchell (1857-1950), 1907

Oil on canvas, 24 x 20¹/₁₆ in. (61.0 x 51.0 cm.)
Purchased with funds from the State of North Carolina
67.6.1

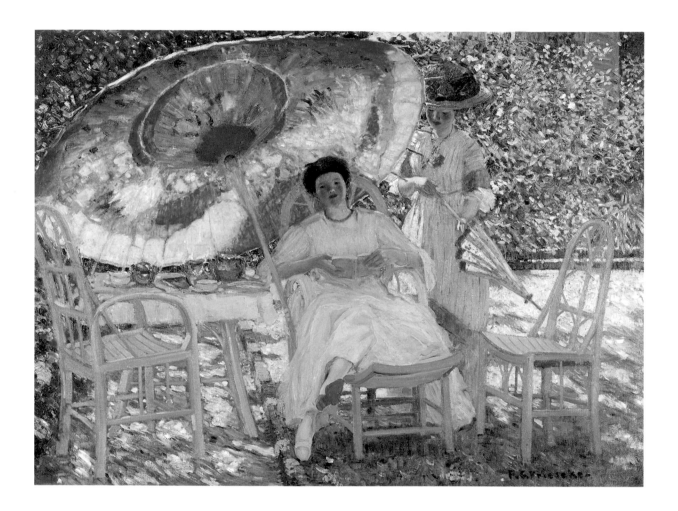

FREDERICK CARL FRIESEKE *American, 1874-1939,* active in France from 1898

The Garden Parasol, C. 1910

OIL ON CANVAS, 57 X 76⅝ IN. (144.8 X 194.6 CM.)
PURCHASED WITH FUNDS FROM THE STATE OF NORTH CAROLINA
73.1.4

WILLARD LEROY METCALF *American*, 1858-1925

June Pastoral, 1910

OIL ON CANVAS, 26⅛ X 29 IN. (66.8 X 73.7 CM.)
GIFT OF CHARLES M. REEVES, JR. AND FAMILY, IN HONOR OF MRS. CHARLES M. REEVES, JR.
78.23.1

ELLIOTT DAINGERFIELD *American, 1859-1932*

The Grand Canyon, C. 1912

OIL ON CANVAS, 36¹/₄ X 38¹/₄ IN. (92.0 X 97.1 CM.)
PURCHASED WITH FUNDS FROM THE STATE OF NORTH CAROLINA
52.9.202

MAURICE BRAZIL PRENDERGAST *American,* born Newfoundland, 1858-1924

Two Nudes with Swan, C. 1910-13

OIL ON PANEL, 22 X 16 IN. (55.9 X 40.6 CM.)
ANONYMOUS GIFT
80.16.2

Twentieth Century

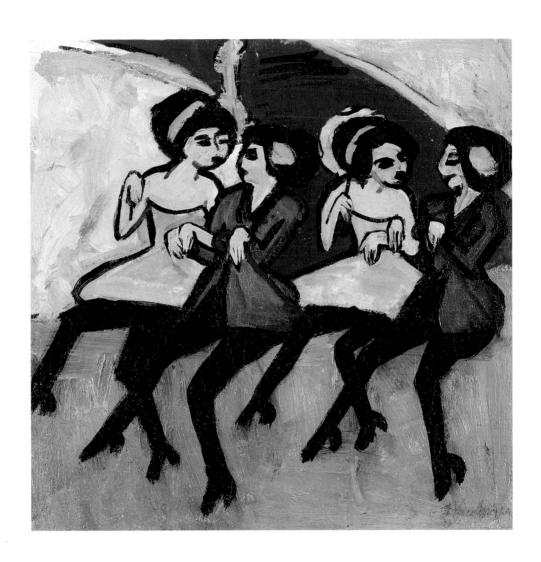

ERNST LUDWIG KIRCHNER *German, 1880-1938*

Panama Girls, 1910

OIL ON CANVAS, 19⅞ x 19⅞ IN. (50.5 x 50.5 CM.)
BEQUEST OF W. R. VALENTINER
65.10.30

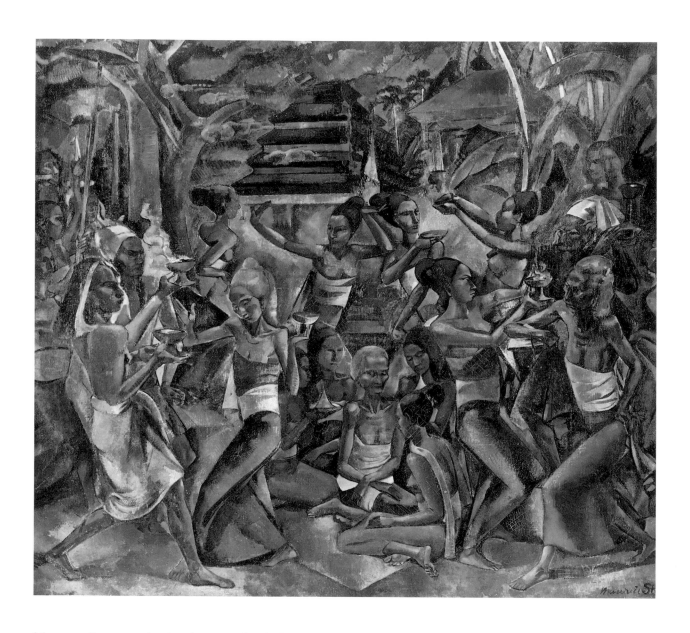

MAURICE STERNE *American,* born Latvia, 1878-1957

Dance of the Elements, Bali, 1913

OIL ON CANVAS, 56¾ x 65½ IN. (144.1 x 166.4 CM.)
PURCHASED WITH FUNDS FROM THE STATE OF NORTH CAROLINA
52.9.28

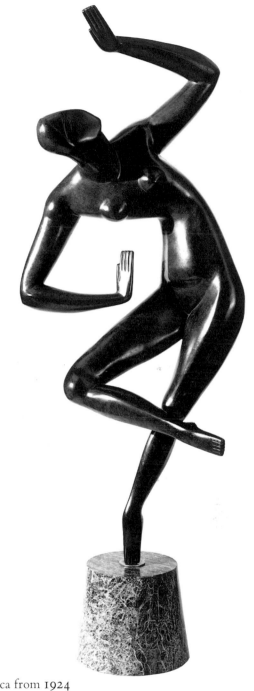

ALEXANDER ARCHIPENKO *Russian,* 1887-1964, active in America from 1924

Blue Dancer, modeled 1913-18, cast after 1961

BRONZE WITH BLUE PATINA, H. 41 IN. (104.1 CM.)
PURCHASED WITH FUNDS FROM THE STATE OF NORTH CAROLINA
76.1.8

MARSDEN HARTLEY *American, 1877-1943*

Indian Fantasy, 1914

OIL ON CANVAS, 46¹¹/₁₆ X 39⁵/₁₆ IN. (118.6 X 99.7 CM.)
PURCHASED WITH FUNDS FROM THE STATE OF NORTH CAROLINA
75.1.4

OTTO MUELLER *German, 1874-1930*

Two Nude Figures in a Landscape, C. 1915

OIL ON CANVAS, 47½ X 35½ IN. (120.7 X 90.1 CM.)
BEQUEST OF W. R. VALENTINER
65.10.48

LYONEL FEININGER *American,* 1871-1956, active in Germany 1887-1937

The Green Bridge II, 1916

OIL ON CANVAS, 49³/8 X 39¹/2 IN. (125.4 X 100.4 CM.)
GIFT OF MRS. FERDINAND MÖLLER
57.38.1

KARL SCHMIDT-ROTTLUFF *German, 1884-1976*

Portrait of Emy, 1919

OIL ON CANVAS, 28¹⁵/₁₆ X 25³/₄ IN. (73.5 X 65.5 CM.)
BEQUEST OF W. R. VALENTINER
65.10.58

Erich Heckel *German, 1883-1970*

Berlin Landscape with Canal, 1920

Oil on canvas, 32⅞ x 38 in. (83.5 x 96.7 cm.)
Gift of Mr. and Mrs. S. J. Levin
60.4.1

ALEXEJ VON JAWLENSKY *Russian,* 1864-1941, active in Germany from 1896

Head, 1924-25

OIL ON PAPERBOARD, 17¼ X 13¹⁵/₁₆ IN. (43.9 X 35.4 CM.)
BEQUEST OF MRS. CONSUELO SIDES
66.29.1

Jean Hélion *French*, 1904-1987

Untitled, 1934

Oil on canvas, 50¹⁵/₁₆ x 63⁵/₈ in. (129.4 x 161.6 cm.)
Gift of Peggy Guggenheim
57.40.1

GEORGIA O'KEEFFE *American, 1887-1986*

Cebolla Church, 1945

OIL ON CANVAS, 20¹/₁₆ X 36¹/₄ IN. (51.1 X 92.0 CM.)
PURCHASED WITH FUNDS FROM THE NORTH CAROLINA ART SOCIETY
(ROBERT F. PHIFER BEQUEST), IN HONOR OF DR. JOSEPH C. SLOANE
72.18.1

Josef Albers *American,* born Germany, 1888-1976

Kinetic V, 1945

Oil on masonite, 21¾ x 27¾ in. (55.2 x 70.5 cm.)
Anonymous gift
63.2.1

Thomas Hart Benton *American, 1889-1975*

Spring on the Missouri, 1945

Oil and tempera on masonite, 30¼ x 40¼ in. (76.7 x 102.2 cm.)
Purchased with funds from the State of North Carolina
77.1.3

EUGENE BERMAN *American,* born Russia, 1899-1972

"Sunset" (Medusa), 1945

OIL ON CANVAS, 57⅝ X 45 IN. (146.3 X 114.3 CM.)
PURCHASED WITH FUNDS FROM THE NORTH CAROLINA ART SOCIETY
(ROBERT F. PHIFER BEQUEST), IN HONOR OF MRS. GEORGE W. PASCHAL, JR.
74.8.2

MILTON AVERY *American, 1885-1965*

Blue Landscape, 1946

OIL ON CANVAS, 34¹/₄ X 53¹/₈ IN. (87.0 X 135.0 CM.)
GIFT OF ROY R. NEUBERGER
57.1.1

Andrew Newell Wyeth *American*, born 1917

Winter, 1946, 1946

Tempera on composition board, 31⅜ x 48 in. (79.7 x 121.9 cm.)
Purchased with funds from the State of North Carolina
72.1.1

ROBERT MOTHERWELL *American,* 1915-1991

Young Girl, 1947

OIL ON MASONITE, 48⅞ X 21⅝ IN. (124.1 X 54.8 CM.)
GIFT OF THE OLSEN FOUNDATION OF NEW HAVEN, CONNECTICUT
58.21.1

RICHARD DIEBENKORN *American,* born 1922

Berkeley No. 8, 1954

OIL ON CANVAS, 69⅛ x 59⅛ IN. (176.0 x 150.0 CM.)
GIFT OF W. R. VALENTINER
57·34·3

Franz Kline *American, 1910–1962*

Orange Outline, 1955

Oil on paperboard, mounted on canvas, 38 x 40 in. (96.5 x 101.6 cm.)
Gift of Mr. and Mrs. S. J. Levin
58.8.8

Joseph Cornell *American, 1903-1972*

Suzy's Sun (for Judy Tyler), 1957

Mixed media, 10³⁄₄ x 15 x 4 in. (27.3 x 38.1 x 10.2 cm.)
Purchased with funds from the State of North Carolina
78.1.1

WALTER TANDY MURCH *American,* born Canada, 1907-1967

Car Heater, 1957

OIL ON CANVAS, 21½ X 16½ IN. (54.6 X 41.9 CM.)
PURCHASED WITH FUNDS FROM THE STATE OF NORTH CAROLINA
73.1.1

Paul Delvaux *Belgian,* born 1897

Antinoüs, 1958

Oil on panel, 49¹/₈ x 75¹/₈ in. (124.8 x 190.8 cm.)
Gift of John L. Loeb
62.22.3

MORRIS LOUIS *American, 1912-1962*

Pi, 1960

ACRYLIC ON CANVAS, 103 X 175 IN. (261.6 X 444.5 CM.)
GIFT OF MR. AND MRS. GORDON HANES
82.15

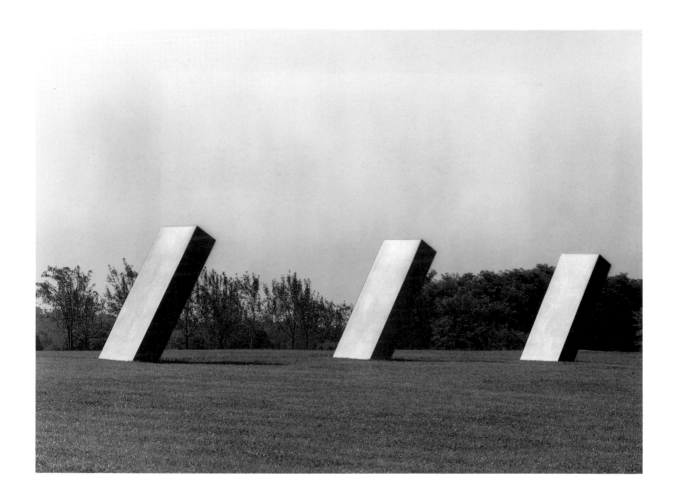

Ronald Bladen *American,* born Canada, 1918-1988

Three Elements, 1965, fabricated 1966-67

Painted and burnished aluminum, each 120³/8 x 48³/8 x 21¹/2 in. (305.8 x 122.8 x 54.6 cm.)
Purchased with funds from the North Carolina Art Society
(Robert F. Phifer Bequest), in honor of Mr. and Mrs. Gordon Hanes
88.6

HENRY SPENCER MOORE *British, 1898-1986*

Large Spindle Piece, modeled 1968-69, cast 1974

BRONZE, 128 X 127 X 77¼ IN. (325.1 X 322.6 X 196.2 CM.)
GIFT OF MR. AND MRS. GORDON HANES
80.6.3

Jacob Lawrence *American*, born 1917

Forward, 1967

Tempera on panel, 25¼ x 37¼ in. (64.1 x 94.6 cm.)
Purchased with funds from the State of North Carolina
70.8.1

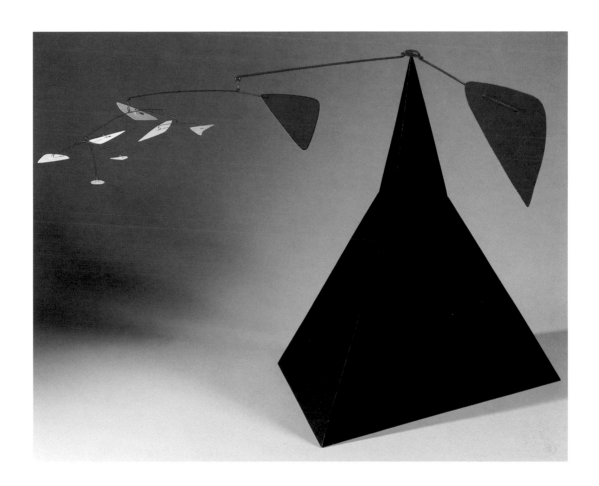

ALEXANDER CALDER *American, 1898-1976*

Tricolor on Pyramid, 1965

PAINTED SHEET METAL AND STEEL WIRE, 48 X 78 IN. (121.9 X 198.1 CM.)
PURCHASED WITH FUNDS FROM THE NATIONAL ENDOWMENT FOR THE ARTS
AND THE NORTH CAROLINA ART SOCIETY (ROBERT F. PHIFER BEQUEST)
69.12.1

FRANK STELLA *American,* born 1936

Raqqa II, 1970

SYNTHETIC POLYMER AND GRAPHITE ON CANVAS, 120 X 300 IN. (304.8 X 762.0 CM.)
GIFT OF MR. AND MRS. GORDON HANES
82.16

MOSHE KUPFERMAN *Israeli,* born Poland 1926

Untitled, 1974

OIL ON CANVAS, 51⅜ x 64 IN. (130.5 x 162.6 CM.)
PURCHASED WITH FUNDS FROM THE NORTH CAROLINA ART SOCIETY (ROBERT F. PHIFER BEQUEST)
90.4

ALEX KATZ *American,* born 1927

Six Women, 1975

OIL ON CANVAS, 114 X 282 IN. (289.6 X 716.3 CM.)
PURCHASED WITH FUNDS FROM VARIOUS DONORS, BY EXCHANGE
91.5

Neil Welliver *American,* born 1929

Breached Beaver Dam, 1975

Oil on canvas, 95¹⁵/₁₆ x 96¹/₈ in. (243.6 x 244.3 cm.)
Gift of Lee and Dona Bronson, in honor of Edwin Gill
77.7.2

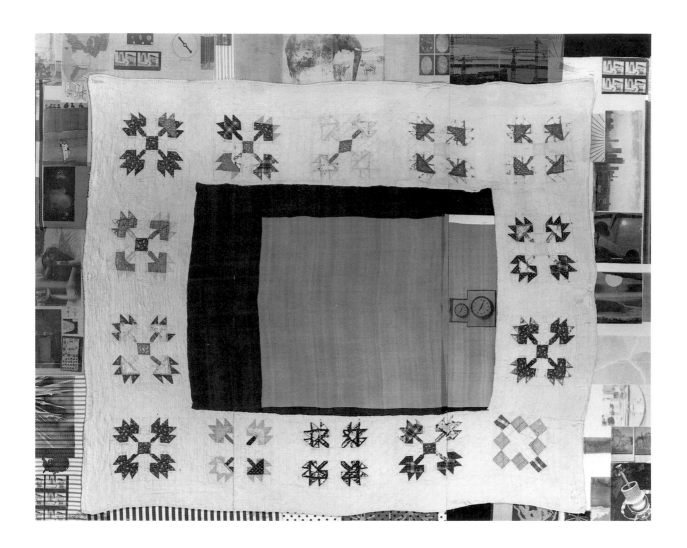

Robert Rauschenberg *American,* born 1925

Credit Blossom, 1978

SOLVENT TRANSFER ON FABRIC, PIECED FABRIC QUILT, APPLIED TO WOODEN PANELS, 84 X 108 IN. (213.4 X 274.3 CM.)
PURCHASED WITH FUNDS FROM THE NATIONAL ENDOWMENT FOR THE ARTS,
THE NORTH CAROLINA ART SOCIETY (ROBERT F. PHIFER BEQUEST),
AND THE STATE OF NORTH CAROLINA
79.2.6

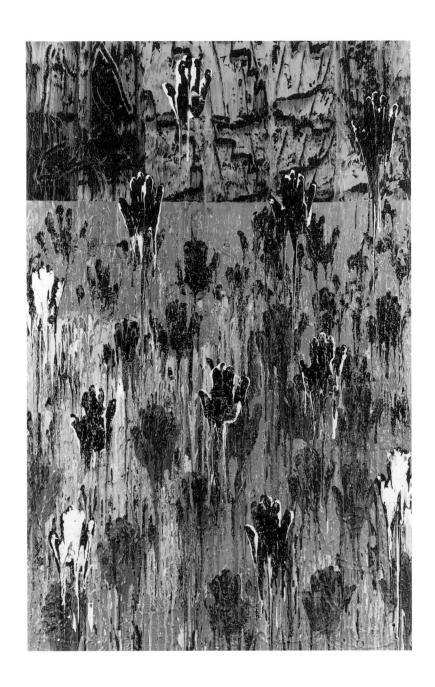

WILLIAM T. WILLIAMS *American,* born 1942

Double Dare, 1984

ACRYLIC ON CANVAS, 84 x 54½ IN. (213.3 x 138.4 CM.)
PURCHASED WITH FUNDS FROM THE NORTH CAROLINA ART SOCIETY (ROBERT F. PHIFER BEQUEST)
91.9

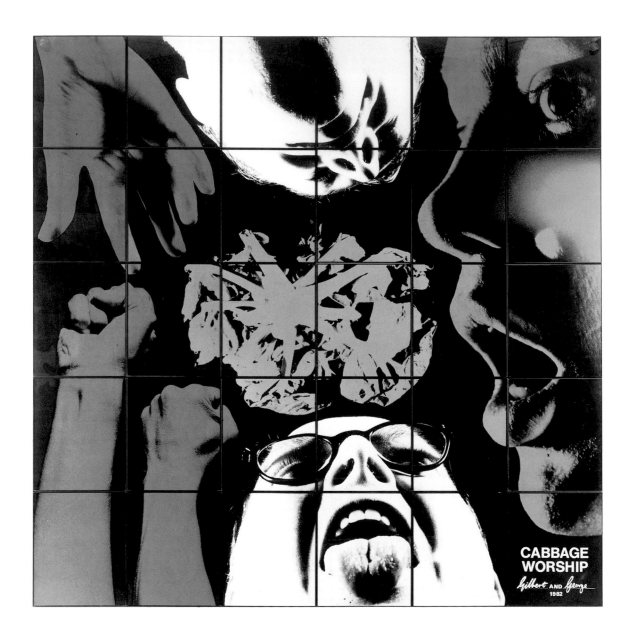

GILBERT AND GEORGE *British,* GILBERT born Italy 1943, GEORGE born 1942

Cabbage Worship, 1982

HAND-COLORED GELATIN SILVER PRINT PHOTOGRAPHS, 118¾ x 120 IN. (302.0 x 305.0 CM.)
PURCHASED WITH FUNDS FROM THE MADELEINE JOHNSON HEIDRICK BEQUEST
84.5

Roger Brown *American*, born 1941

American Landscape with Revolutionary Heroes, 1983

Oil on canvas, 84 x 144 in. (213.4 x 365.8 cm.)
Purchased with funds from the Madeleine Johnson Heidrick Bequest
84.2

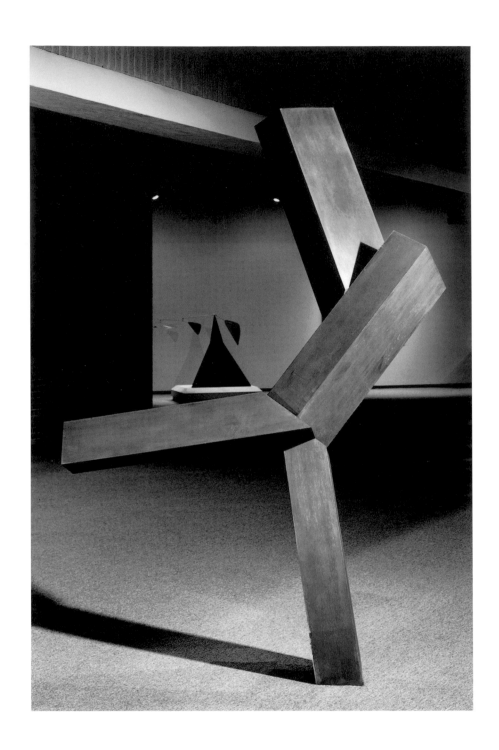

JOEL SHAPIRO *American,* born 1941

Untitled, 1989-90

CAST BRONZE, 102½ x 43 x 78 IN. (160.3 x 109.2 x 198.1 CM.)
PURCHASED WITH FUNDS FROM VARIOUS DONORS, BY EXCHANGE
90.3

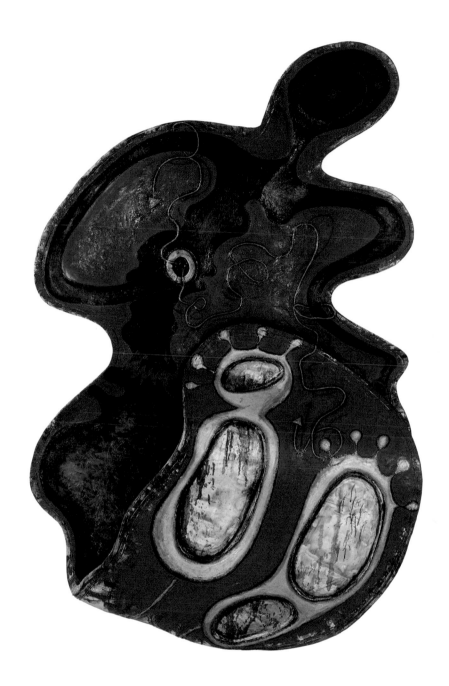

ELIZABETH MURRAY *American,* born 1940

Pigeon, 1991

OIL ON CANVAS, 95³/₄ x 62⁵/₈ x 13⁵/₁₆ IN. (243.0 x 159.0 x 33.8 CM.)
PURCHASED WITH FUNDS FROM VARIOUS DONORS, BY EXCHANGE
92.3

Index of Artists

Designed by Lida Lowrey, Raleigh, North Carolina

Typeset in Berthold Bembo by LewisType, Raleigh, North Carolina

Printed by Harperprints, Henderson, North Carolina